W9-BEG-928

A History of Lettering

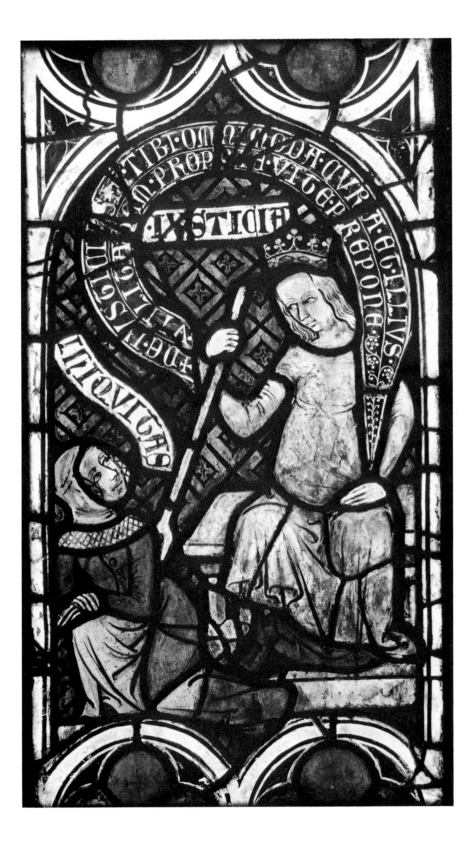

A History of Lettering

CREATIVE EXPERIMENT AND LETTER IDENTITY

Nicolete Gray

DAVID R. GODINE · PUBLISHER · BOSTON

First U.S. edition published in 1986 by
David R. Godine, Publisher, Inc.
Horticultural Hall, 300 Massachusetts Avenue,
Boston, Massachusetts 02115

Originally published in the U.K. by Phaidon Press Limited
Copyright © 1986 by Phaidon Press Limited

All rights reserved. No part of this book may be used or
reproduced in any manner whatsoever without written
permission, except in the case of brief quotations
embodied in critical articles and reviews.

LC 85–81016
ISBN 0–87923–612–4
First printing
Typeset in 9 point Palatino by Peter MacDonald
Printed in Great Britain by The Bath Press, Avon

Frontispiece: Justice and Iniquity and Gothic lettering
in a stained-glass window from Niederhaslach.

Contents

Foreword 7

Introduction 9

1 The Origins of the Roman Alphabet 12

2 The Roman World: The First Three Centuries AD 15

3 The Christian Empire: The Mid-Fourth to the
Mid-Sixth Century 29

4 Contributions from the New People: Focus on
the Far North West 43

5 The Carolingian Renaissance 67

6 Starting Again: The Mid-Tenth to the
Mid-Eleventh Century 78

7 A Time of Experiment: The Romanesque 88

8 A New Alphabet: The Gothic Capital 109

9 The Fifteenth Century and the Italian Revolution 122

10 A Time of Division: 1500–1650 137

11 The Triumph of the Classical 151

12 The Advent of Commercial Letter-Design 164

13 Experiment Unlimited: 1870–1910 175

14 Yesterday and Today 192

Appendices 219 Select Bibliography 229
Charts 236 Glossary 248 Index 250
Acknowledgements 256

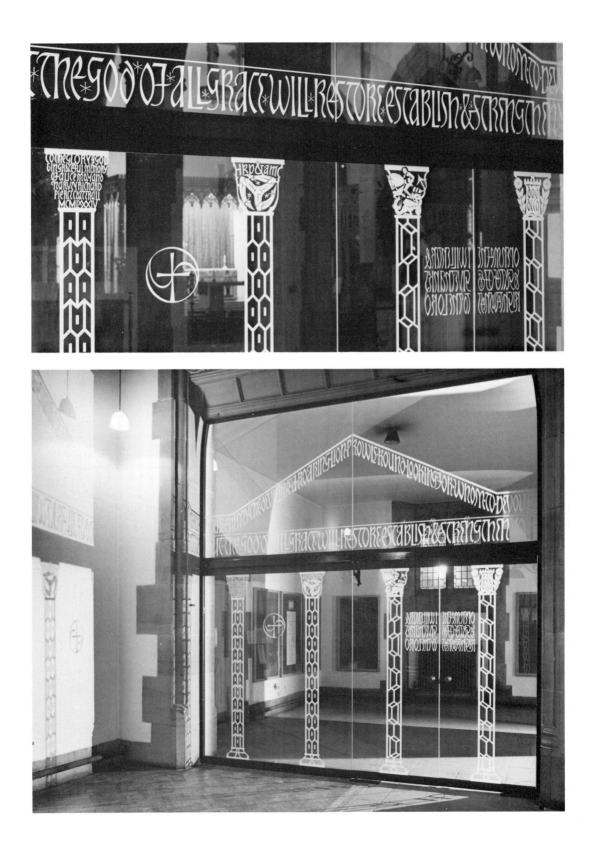

Foreword

The immediate cause of the writing of this book was the making of an exhibition called 'Lettering and the March of History'. I was asked with my colleague at the Central School of Art and Design, Nicholas Biddulph, to make an exhibition by the Association Typographique Internationale; we chose to show the art of lettering from this point of view, as an index to history. I must acknowledge a debt to the Association both for their initiative, and for their financial support for this exhibition.

I see art as the result of man's perennial need to attempt to entrap his intimation of reality in some concrete, intelligible form. This attempt is necessarily conditioned by the society in which the artist lives, the ideas and forms which he inherits, and the medium which he chooses. In the case of a medium such as lettering—or architecture—where the artist creates not just in order to express himself, but also to meet a social need, the relation between himself and the world in which he lives is particularly close. The history of lettering, even when viewed from a formal standpoint, disregarding the textual connotation, provides an illuminating sidelight on the course of history. This was the subject of our exhibition.

I had often thought of trying to sum up the conclusions of a lifetime's study of the subject of lettering in a book, but the scope of the idea was daunting. With this exhibition, however, two-thirds of the work was done. I was therefore tempted by the invitation of the Phaidon Press to complete the job by writing this book. My study focuses specifically on the history of the changing forms of letters. It is not concerned, primarily, with the related subjects of type-design, calligraphy and hand-writing.

I have to thank the Central Lettering Record, the collection of photographs of lettering from all periods, in all media, at the Central School of Art and Design, in London, for the generous loan of the majority of the photographs reproduced in this book. I should like also to thank the BBC for the loan of negatives of digital letters and Mr Ruari McLean for his photograph from the Victoria Psalter of Owen Jones. I am particularly grateful to Professor T. J. Brown for kindly reading and commenting on the first half of the text; also to Professor Michael Twyman for reading the book. I should like to thank Richard Southall for his advice on digital typography and Nicholas Biddulph for constant help. The errors which may remain are of course my own responsibility. Finally I should like to thank Rosemary Amos and Marie Leahy of the Phaidon Press for the trouble they have taken with this book.

Long Wittenham, 1985 N. G.

Sand blast inscription by David Peace in the church of Our Lady and St. Nicholas, Liverpool. The lettering has been designed so that the inscription is legible from the inside and forms a pattern from the outside.

Introduction

Writing is for communication. It uses visible signs to enable us to pass on and receive messages to and from people who are separated from one another by time, space, or both. Its essence is therefore legibility. Many scripts have been evolved at different times and in different places. In this book I am concerned only with the alphabetic script evolved by the Romans.

Lettering is a sub-division of writing. I should define it as writing in which the visual form, that is the letters and the way in which these are shaped and combined, has a formality and an importance over and above bare legibility. It can therefore be an art. The quantity of lettering in existence is vast. In chronicling its history one has to select examples which are significant, and in order to do this one has first to consider the elements involved and the nature of the letters themselves.

Letters spell out a text. The content of this text has an immense range of possibility: it may advertise the advantages of some cosmetic, or it may be a proclamation of the word of God. The artist may be indifferent, or professionally interested, or the text may be a statement of his deepest personal convictions. This is a factor which cannot be ignored. It normally sets the key to the work. It may be that the artist is so interested that the work will be primarily an expressionist exercise. He may on the other hand be more interested in the formal side of his work, in the shape of the letters and the way in which they can be combined into a significant design. Here we have two poles of potentiality in the art of lettering.

These are the ends towards which this art is directed; but we are also concerned with the means used, the elements from which the work is made—letters. Are these fixed shapes to be learnt, or are they capable of variation? If so, how far can they be varied? For what reasons? When, for example, is an A not an A? In what way does it have to be altered in order to become meaningless, or a shape with some other meaning? Many people in the past (and also some today) have answered that A is A in so far as it conforms to the Roman model; in so far as it departs from that model, it is deformed. In fact they have endorsed a Platonic idea that there is a perfect form for each letter, towards which all designers should strive. At the Renaissance designers did in fact produce a series of alphabets in which Roman forms were drawn in a square and constructed with a compass with the aim of producing such ideal forms (see Ch. 10, Fig. 180). More recently the same idea has been applied to lower-case letters, except that in this case the geometrical basis is given even greater emphasis (see Ch. 14, Figs. 272, 273, 274).

As an historian of lettering I do not find the idea that the letter has only one, or two, majuscule and minuscule precise forms tenable. One has only to look through the illustrations and Charts reproduced in this book to see that letters are recognizable in a wide variety of shapes, some only remotely related to the Roman—indeed the Romans themselves used a number of different alphabets, and there is wide variation in the design of roman capitals.[1] In my opinion the criterion as to whether a

9

letter is an 'A' is whether the writer thought of it as such. This does not mean that all such 'A's are aesthetically good, but that neither identity nor goodness are derived solely from conformity to the Roman letter. A letter must have identity to be recognizable, but this identity refers to a composite, flexible idea in the mind.

All the same, because it has been analysed theoretically so often, and because historically it has been dominant for so much of our history, the Roman capital has a special place in the history of lettering. This history indeed can be seen as a history of recurrent revivals of the Roman letter—under the Carolingians, at the Renaissance and at the beginning of this century.[2] These revivals have also coincided with revivals of classical culture, a factor which has given the letter additional prestige. The effect has undoubtedly contributed to the continuity of our western tradition and to the maintenance of a very beautiful letter. But there are other beautiful, elegant, forceful letters in our tradition: for instance rustic, uncial, italic, slab-serif and, above all, Gothic. Balanced proportions are a quality which may create beauty, but there are other qualities which make for interesting letters to be seen, for instance, in Expressionist and Art Nouveau work (see Chapter 13). Between the periods of revival came periods of experiment and invention. In my opinion all letters designed with skill and sensibility, where the intention of the artist is meaningful, are contributions to the range of the art of lettering. An important function of the historian is to chronicle change.

We do not normally use letters in isolation, but in combination. The combination may, for example, be the opening page of a manuscript, an inscription, a shop fascia, and therefore demonstrates the unique relation between given letters in a given order with a particular meaning. By and large this is the relationship with which this book is concerned. Apart from this there are the many different styles of lettering which have been worked out by generations of craftsmen at different periods for different requirements and different techniques; particularly for the writing and for the printing of books. A few examples of these have been reproduced here, as background illustration, but in general they fall outside the scope of this book, except in cases where an artist is deliberately experimenting with the

form of letters, as in some Art Nouveau and twentieth-century type design. (See Figs. 255–8, 272–4, 279–82.)

The social and historical circumstances under which the art of lettering has developed are a necessary factor in its history; and reciprocally it provides illuminating and hitherto little regarded testimony of shifting cultural values and changing taste. Twenty years ago there was a memorable exhibition called 'Printing and the Mind of Man', which chronicled the impact of the printed word. My book is thought of as a complementary study. It is concerned with the relation between words and the way in which they are written; and so with their visual form instead of with their relation to thought. One is immediately aware of a striking dissimilarity. Apart from the effect of the invention of printing, the emphasis is now on a different period, for different reasons. Lettering was at its most impressive, and was valued most highly, in the seventh and eighth centuries, a period of illiteracy and insecurity, but one when European civilization was being painfully remade. The word was valued and adorned because it was precious.

Letter-forms have changed because of the designer but also because of changes in the materials, tools and technology which he has to use. Today he is faced with the technology of digital letter design, that is with the task of designing within the limitations of a grid, for computer generation. Questions of changes in form and of letter-identity have become urgent in a new way. If we want to maintain legibility should we not draw on the immense variety of ideas offered by the past? There is no need to embark on designing a new alphabet.

This book covers creative lettering made in all sorts of media—painted, carved, engraved, woven, made in mosaic. Examples are scattered in libraries (jealously guarded by librarians), in museums, in churches, in churchyards, on buildings, in streets; they are seen momentarily on television screens, or printed in ephemera, in books or magazines, all over the western world. Of all this material some has been collected and published, but generally not from the point of view of lettering, collections of inscriptions are usually more concerned with the text; reproductions of manuscripts frequently show the pictorial initial, omitting or truncating the lettering beside it. Some of

the material has only been collected from par-ticular localities, much has not been collected in all. I have spent many decades collecting, studying, photographing lettering in many media and in many countries, under varying conditions. I am well aware that there is still much to be done, many areas where detailed work is required. Even so this work is, I hope, a reasonably balanced and comprehensive history of this art. There are many books on the history of type design, on palaeography, on calligraphy, on historiated initials, but the central subject of lettering is normally by-passed, even by art historians. That is what this book is about. It is about the art of letter-ing; about letters used as a medium of expres-sion and of design. It is about the means itself —that is, the letter-form, the ways in which it can be thought of, and the ways in which it has been altered and re-formed; and about the human context of this story, the social factors which have conditioned its changes and development.

Notes

1. The word 'roman', used in the context of letter design, is ambiguous. In this book I have used 'Roman' spelt with a capital to mean 'related to the Roman people'; so the Roman 'square' capital is the letter which they invented, of which the letters on the Trajan column in Rome (Fig. 5) are usually taken as typical examples. 'Roman', on the other hand, when spelt in lower-case letters, is a classification used to describe type designs and inscriptional letters which may vary very considerably in detail from the Roman letter, and which cannot be precisely defined.

2. James Mosley has pointed out in 'Trajan Revived', *Alphabet*, 1964, that 'it is only in twentieth-century England and sixteenth-century Rome that the lettering on the Trajan column has been selected as a standard roman letter.' I think that the Carolingian intention was the same, though since there had not then been the proliferation of romans which has occurred since in the intervening centuries, their revival was not so doctrinaire.

The Origins of the Roman

Alphabet

The Roman alphabet was derived from the Greek, but not directly, nor from the classic Greek lettering of fifth-century inscriptions. The Greeks learnt to write from the Phoenicians, probably in the eighth or seventh century BC. Both peoples were sailors and traders: they met in the Aegean, in Sicily and Asia Minor. The Greeks altered the Phoenician system in two fundamental ways: they introduced characters representing vowels (other early alphabetic scripts only represent consonants), and they altered its visual appearance. Phoenician script slopes forward with ascenders and descenders; it looks rapid and business-like, orderly but not beautiful. The inscriptions of fifth-century Athens are very different: they are constructed and arranged geometrically, and they are beautiful (Fig. 1). From the beginning the evolution of writing reflected the character of the people by whom it was formed. These classic Greek letters however were evolved only gradually; to begin with there were primitive experiments and local variations.[1] In 403 BC the Ionic or Eastern alphabet was officially adopted in Athens; but long before this the Etruscans had learnt to write from Greek colonists in South Italy, who used a western version of the Greek alphabet; and it was from the Etruscans that the Romans learnt writing, probably in the period when Etruscan kings ruled in Rome; that is from about 616 until 509 BC. The script which they learnt was rude and unformed (Figs. 2 and 3); the few early examples which we have are very rough, scratched on stone or pottery.

The traditional date for the foundation of

Rome is 753 BC. Then it was just a collection of huts. There were other older and more advanced centres of culture in Italy. In the first centuries of her development, after the period of the Etruscan kings, Rome was preoccupied with establishing her supremacy in Italy. Then, in the third century BC she was involved in the Punic Wars against the Carthaginians. It was not until the next century, after Roman military intervention in Greece and the Aegean, that Greek culture began to dominate the Roman world. By then Greek inscriptional letters had changed. Hellenistic letters have a strong wedge-serif—an idea perhaps derived from the cuneiform inscriptions which the Greeks would have known through the conquests of Alexander the Great. The sanserif geometric letter of the fifth century was obsolete. There is no reason to think that it had any influence on the formation of the Roman capital letter. It is indeed interesting to note that whereas in other arts the Romans imitated the Greeks, in lettering, by the Roman period, Greek inscriptions are Roman in style and scale, serifed and using a modulated line moving from thick to thin in width.

The primitive forms of Greek, Etruscan and Roman letters are similar. The Romans took over twenty-one of the twenty-six Etruscan letters; they added the letter G, and in the first century BC the letters Y and Z for use with Greek words. Latin retained F and Q from early Greek and Etruscan—letters which were dropped in classical Greek. K, most often found in the word *kalendae*, is a Latin letter, but one with short arms which reach neither to the

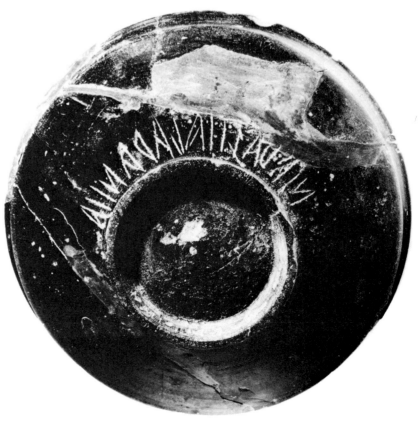

1 A Greek inscription of the classical period. It is unlikely that the Romans would have known this developed style of Greek lettering. From a squeeze. Fifth century BC. Athens, Epigraphical Museum.

2 An Etruscan inscription, found in Rome, dating from the period when the Etruscan kings were ruling the city. *c*.616–509 BC. Rome, Capitoline Museum.

3 Greek letters scratched on a bowl found in Italy on the Island of Ischia. This is the sort of Greek script that the Romans might have known when they started to use writing. Eighth century BC. Rome, German Archaeological Institute.

4 An early Roman inscription, from the tomb of L. Cornelius Scipio Barbatus. Probably third century BC. Vatican Museums.

upper nor to the base line. The round form U is found in early pen-formed letters. W was introduced to spell Germanic names in the early Middle Ages. J was not finally distinguished from I until the seventeenth century.

The Romans were very slow to produce a mature script, but by the third century BC their letters were square in the sense that their inscriptions show horizontal instead of diagonal members to letters such as E, F and L, so forms based on right not acute angles, verticals and horizontals, with a more or less circular O, and reading from left to right. The examples which we have are in rough soft stone, crudely cut. There is no question of precise width, or variation of width of line, or of definition of terminations in inscriptions such as those on the sarcophagus of Lucius Cornelius Scipio Barbatus (consul in 298 BC) or that of his son L. Cornelius Scipio in the Vatican Museum (Fig. 4).

By this time there must also have been writ-

ings on materials which have long perished; it is only from finds in Egypt, where the dry climate has preserved fragments of the papyrus-rolls which were used for the earliest form of Roman book, as well as for documents and letters, that evidence survives.[2] Egypt did not become part of the Roman empire until the first century BC, but Roman literature goes back to the third century BC. Even so, these comparatively late examples of pen writing are still unformed. It begins to be possible to trace the evolution of Latin letters towards the beginning of our era, but one should not forget that by then the Romans had been writing for some four or five centuries.[3] Although the scanty remains which survive seem unformed, they show that different forms of script were in use, evolved for different purposes and from the use of different writing instruments. As well as capitals, the Romans were using a book-hand, which can be called 'rustic', and a cursive.

Notes

1. For variations, see L. Jeffery, *The Local Scripts of Archaic Greece*, 1961.

2. For reproductions of early examples of Roman script, see J. Mallon, R. Marichal, Ch. Perrat, *L'Écriture latine*, 1939.

3. Wooden writing tablets dating from around AD 100 were found in 1973 in England at Vindolanda and published by A. K. Bowman and J. D. Thomas in 1983. The publication includes a useful discussion of current work on early Roman cursive script (see Ch. 2).

The Roman World:
The First Three Centuries AD

The archetypal Roman letter is usually taken from the inscription on the base of the column of Trajan in Rome, erected in the year AD 114 (Fig. 5). It has been much reproduced, often from the cast in the Victoria and Albert Museum—though this has been corrected in detail by Father E. M. Catich[1]—and copied by many artists and students. It is a very beautiful and easily accessible example of the mature Roman capital, and includes most of the letters of the alphabet (not K, H, Y, Z or the later letters J, U, W). It was, however, evolved quite late in the history of Rome, and was at no time the only letter used by the Romans. Before considering this type, it is important to get an idea of earlier types of Roman letter.

As we have seen, there is very little surviving from the earliest centuries, but we can get a vivid picture of the situation in AD 79 from the ruins of Pompeii, destroyed by the eruption of Vesuvius in that year. There are large brush-written notices on the walls of houses and shops advertising gladiatorial shows, elections and shop wares (Fig. 6). There are various graffiti and, at the other end of the spectrum, a number of well-executed stone-carved inscriptions. In a wall-painting a child reads from a scroll: this will be a papyrus-scroll, the normal form of Roman book. All these forms of writing are different, though all are still capital—except that the graffiti have long, straggling extensions.

These graffiti are similar to the writing found on surviving wax tablets, which were used in schools for taking notes, and for informal writing. In both cases the resistance of the material

to the writing tool makes for a straightening-out of curves and a simplification of strokes. This, combined with the fact that such writing is naturally quick and often careless, produces an unformed, often illegible style. Better examples are found in the fragments of pen-written letters and documents which have survived (Fig. 7). In this style, known as Old Roman cursive, the letters are still detached and built up by more than one pen-stroke. There is considerable variation between individual examples, but in general it still seems unformed and transitional. It is the basis from which the cursive minuscule finally developed, some time before the fourth century (see p. 36, Fig. 31).

For books a more formal hand known as rustic seems to have been used (Fig. 8). The term 'rustic' dates from the eighteenth century and denotes rather the attitude of that period, when clearly they found this informal compressed hand primitive, than that of the Romans themselves. These letters were written, not with the pointed pen used to write cursive, but with a pen cut obliquely so that the widest stroke is made by diagonal, not by vertical movements. Letters are built up with several strokes and finished off with serifs drawn across the verticals.

The finest pen-written rustics which survive are all later, fourth and fifth century (Fig. 32), but the style was clearly developed earlier, for the brush-written notices on the walls of Pompeii are painted in swiftly-drawn, skilled rustics, and it is here (Fig. 6) that one sees the essential qualities of this letter, its verve, its

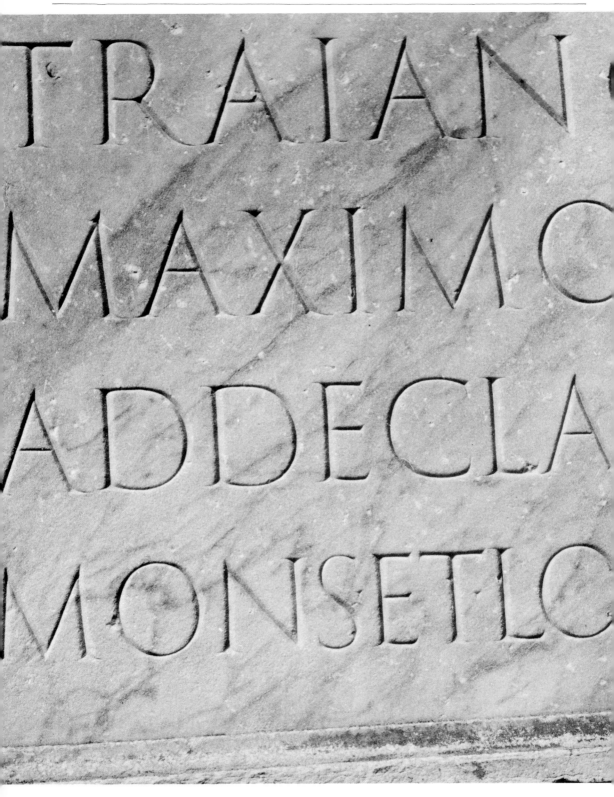

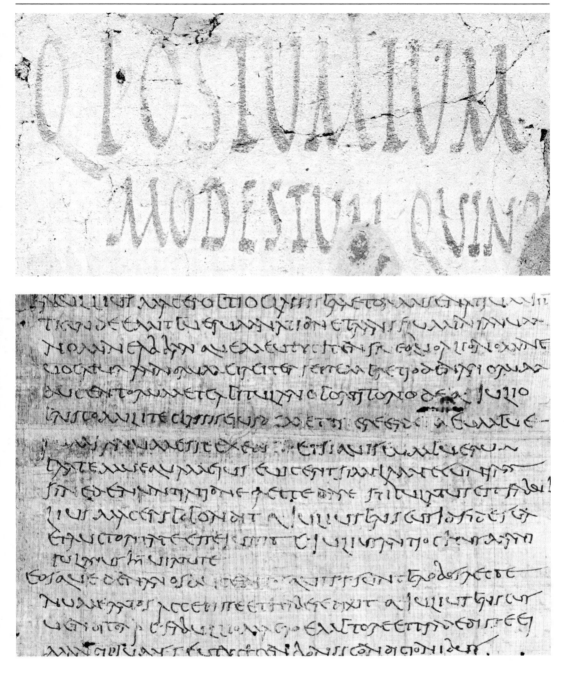

OPPOSITE 5 Detail from the inscription on the base of the Trajan column in Rome. AD 114. From a photograph of the original.

ABOVE 6 Brush-drawn rustic lettering from Pompeii. Before AD 79.

BELOW 7 Old Roman cursive. An early surviving example of informal Roman writing. AD 166. London, British Library, Papyrus 229.

ABOVE LEFT **8** The sort of rustic script used in early Roman books. London, British Library, Papyrus 2723.

LEFT **9** An inscription carved in an extremely compressed rustic style. A dedication to the Emperor Commodus. AD 192. Sousse Museum, Tunisia.

ABOVE **10** A rustic inscription from the Antiquarium, Carthage. Probably second century AD.

ABOVE **11** An inscription
from the Republican
period from Aquileia,
Italy. The wide circular
O and splay-legged M are
typical.

LEFT **12** A detail from the
inscription on the Ponte
Fabricio, Rome. Note the
wide M and the lack of
line-width modulation.
62 BC.

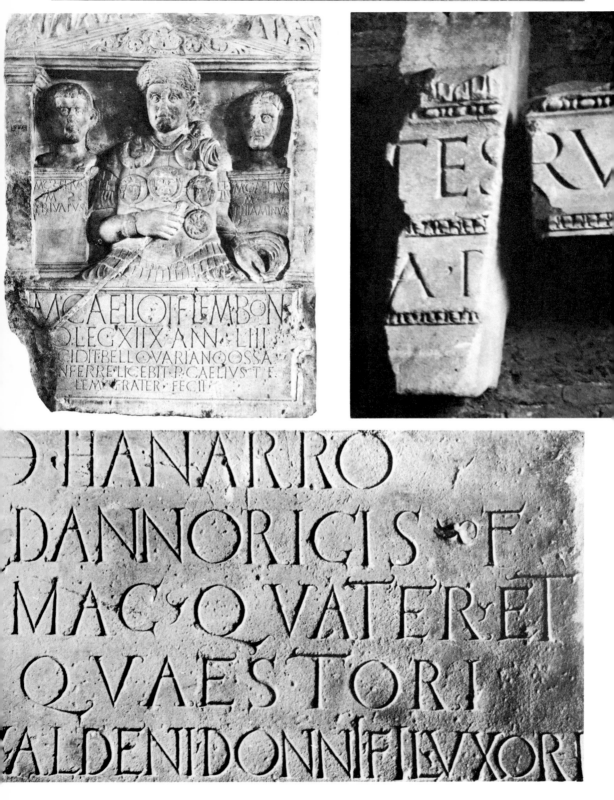

speed and movement, and the importance of the relation between one letter and the next, creating liveliness of texture and pattern. Rustics were also carved, though later it seems; examples before the second century are rare, and the finest in my experience are from the third century and North African. In some cases the degree of compression is fantastic (Fig. 9). In one example the chisel seems to have been held almost flat, and used like a brush (Fig. 10). One feels that it is essentially a brush-devised letter.

The makers of Roman mosaics also modified rustic forms to suit their technique. Their lettering is, however, meagre, usually confined to one or two descriptive words, and is seldom interesting at this period.

Rustic ceased to be used for writing books after the sixth century, but it continued as a script used for section titles in manuscripts and was eventually the root from which broken Gothic capitals were derived. Many books must have been produced in the Roman period in cursive or rustic; we know that the Romans had libraries both private and public and there is indeed a very large Roman literature, though this has only been preserved in later copies made by Late Antique and Carolingian scribes writing on vellum. We know however that Roman scribes were a recognized professional class, producing books in editions, normally writing on papyrus.

OPPOSITE ABOVE LEFT **13** The inscription on the base of the cenotaph of M. Caelius, the Roman General defeated and killed in Germany in AD 9. The letters are deliberately irregular in proportion, creating a unique pattern. Note the circular O and B with separate bowls. Bonn Museum.

OPPOSITE ABOVE RIGHT **14** Detail from an inscription from the Arena, Vicenza. Serifs are minimal and there is little difference in the width of line. Second century AD. Italy, Vicenza Museum.

OPPOSITE **15** An inscription from St-Lizier, Southern France. The curls given to some terminations are unusual, possibly due to Greek influence—note the opening letter theta—this country had been a Greek colony. The inscription dates from the time of Julius Caesar. Toulouse, Musée St-Raymond.

Finally we come to the stone-carved lettering at Pompeii. In the inscriptions still on the site one sees stages in the transition from late Republican to early Augustan characteristics. Some words on the best-known of the painted inscriptions[2] are painted not in rustic but in a compressed style, with the line moving from thick to thin on a vertical rather than a diagonal axis, and with bracketed serifs—a third style which is common on later carved inscriptions (see Fig. 21).

One cannot really write of a Republican style, because examples are very varied (Figs. 11–14). Many inscriptions are carved on rough, unpolished stone, some with a pointed tool making a crude round-section line instead of the V-cut made by a sharp chisel. Sophisticated detail is not in question. The line is even and unmodulated, and serif terminations are minimal. Certain letter-forms do however seem to recur, though not necessarily together: circular O—truly circular because the inner and outer outline move together, since the line is even width—was often clearly drawn with a compass. R has a straight leg, often starting from the stem, not from the bowl. M may be wide, with the central v reaching to the base line, and splayed legs. C is often very open; G also, with a very low spur. The bowl of P may be open; D, S, N, E are often wide and in D and S the curves may be angular. In some cases all letters are wide, creating a very open pattern; in others the letter width may be very irregular, stressing the circular O and making a unique design, as in the epitaph of M. Caelius, the centurion who was defeated on the Rhine in AD 9 (Fig. 13). In fact, unlike later Roman inscriptions, design may be very individual. One which seems to have no parallel is that from St. Lizier (Fig. 15), now in Toulouse, where some letters have delightful curled terminations, making a pattern which is free and airy, probably owing something to Greek influence in a country which had been colonized by the Greeks long before. The bifurcation and curling of terminations, a characteristic which recurs through the history of lettering, seems to be found earliest in Greece, for instance at Eleusis c. 50 BC.[3] Greek influence, from changing forms of Greek lettering, keeps cropping up in the history of Latin lettering.

The classic Roman 'square' capital, typified by the letters on Trajan's column, was evolved

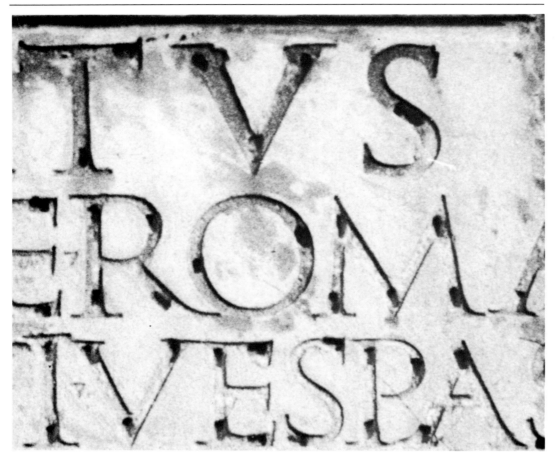

16 The arch of Titus, Rome, showing the sockets made to hold metal letters such as that shown in Fig. 17. Late first century AD.

17 A metal letter from an inscription such as that shown in Fig. 16. France, Nancy Museum.

18 An inscription of the Emperor Constantine Chlorus (the father of Constantine). One of the last examples of the use of classical square capitals. AD 305–6. Trier, Landesmuseum.

19 An inscription from Birrens, Dumfriesshire. The fort at Birrens was established by Hadrian (AD 117–38). The wide spacing is typical of this locality, otherwise unusual. Note the curl termination to G and narrow E. Edinburgh, Museum of Antiquities of Scotland.

some time in the mid-first century (Fig. 5). It can be seen in the final stages of evolution in the Mausoleum of Augustus in Rome, or in the inscription to the Emperor's adopted son Marcellus in the Museum in Trier. Characteristic are the modulated width of letter-line, the small bracketed serifs, and the proportions, approximately 10:1:½ for the relationship between the height, and the widest, and the narrowest, width of the letter-line. These capitals are often called square; actually, each letter has its own width, some approximately square, but most somewhat narrower. The bowls of R and B have now been modified to accentuate the movement into the join of the leg of R, and of the lower bowl of B, so making a much subtler line than when bowl and leg meet on the stem. S is narrow, O and Q are no longer circular because the line changes its width; Q has a very long tail. The only letter which seems inelegant is N with its three strokes of equal weight, found in the Trajan inscription, but not always in other examples. There are sensitive curves and movements in the contours and serif inclination of almost all letters.[4] The sophistication of construction is demonstrated in L. C. Evetts' elaborate drawings of each letter in his book *Roman Lettering*, 1938. This lettering is classic in the sense that the perfection of a Roman inscription consists in the perfection of the drawing of each letter, and in the order and clarity of the spacing. The formal canon for the design of each letter is normally maintained in all inscriptions in this style, but the apexes of A and M may be square or tilted to the left, instead of being pointed; G occasionally has a curled lower termination instead of a spur, and the serifs on the horizontal member of T may be vertical or tilted; the bowl of P may be closed or slightly open. The depth of the v-section, the extent of the contrast between thick and thin in stroke

width and the length of the serif can all vary slightly (Fig. 14).

These letters, which are the origin of our capital letters and remain a standard for their design, are not based on fixed principles of proportion, but on the hand and eye of the craftsman. This was demonstrated at the Renaissance, when alphabets were drawn within a square using a compass for curves (see Fig. 180). It is also clear in the changes made to Republican forms, for instance the rejection of two semicircular bowls to B as well as circular O. There is certainly some relation between these letters and geometrical forms, but it is not doctrinaire; it is flexible, and it is surely this flexibility which has made for the permanent value of this letter. It can be altered in detail to fit many uses and new techniques; the compass of its design is extended without loss of character. We see this in the great variety both of type design and of inscriptional letters which have been designed since the Renaissance.[5]

Since this Roman alphabet is basic to our whole lettering tradition it is important to consider how it was formed. We know from literary evidence that there was an *ordinator*, presumably the man who made the layout. All large-scale lettering must first have been drawn and the text spaced on the stone: an example of one such layout, brush-drawn rustic letters on papyrus, exists in the Ashmolean Museum, Oxford. Smaller and less important pieces were often laid out in a more summary way, sometimes misjudging and running out of space at the bottom. At the moment, however, we are only discussing the finest examples of 'Trajan' lettering. Was this alphabet formed by the *ordinator* or by the man who carved it? Father Catich, in his book *The Origin of the Serif*, argues that its design derives from the square-cut reed pen of the *ordinator* and owes nothing to the chisel of the carver. In his view the serif is a Roman invention, drawn or carved from the point inwards towards the stem of the letter. This seems to me to be an unnecessary and unproven simplification.

There is no reason why the *ordinator* and the carver should not have been the same person. Techniques of letter-cutting have changed little since the time of the Romans, and as recently as the early twentieth century Eric Gill and Reynolds Stone and John Howard Benson all

OPPOSITE ABOVE **20** The stele of a pagan priestess. The long horizontal of C and split stem of L are characteristic of Tunisian inscriptions. Second century AD. Tunis, Bardo Museum.

OPPOSITE BELOW **21** An inscription from Volubilis, Morocco. A style between rustic and the square capital, compressed, with rustic characteristics in the formation of A, M, L, E.

carved their inscriptions, only in later years providing drawings to be executed by assistants. The change in line width was no doubt suggested by the broad-edged pen, but it is also natural to the right-handed carver, who builds up the beauty of his curves with repeated tapping on his chisel. The thickening of the lower stem in L, B, D and E may be due to the influence of the pen, but the crucial changes to the bowls of B and R seem to me to be due to the carver's preference for a meeting between the slightly straightened lower bowl with a straight horizontal from the stem, to the more awkward meeting of two in-turning curves. The idea of terminating stems with a slight thickening is undoubtedly a Hellenistic Greek idea, though the Roman version with its curved bracket is more elegant. It is natural, when the end of a letter-stem has been cut, to turn the chisel into the corner and elongate the v-cut into a serif; one can in fact see that in many inscriptions the serif is very short and pointed and appears to have been made in this way; that is from the stem outwards and not from the point inwards. The 'Trajan' alphabet was evolved by master craftsmen who were probably both *ordinators* and carvers, perhaps in the same workshops, surely working together. It does not seem to me profitable to try to eliminate or even to separate the relative contributions.

The alphabet met with official approval. It was used for grand imperial and senatorial inscriptions and it epitomizes the grandeur, the order and uniformity of the Roman empire. It was far more important than any official lettering today, and it is indeed, apart perhaps from the portrait bust, the greatest original contribution of the Romans to European art. In other arts they copied the Greeks. Here, although certain Greek ideas have been adopted, they have been transformed into something different and far more impressive.

Even grander than their carved inscriptions were the bronze, probably gilded, letters on the great triumphal arches (Figs. 16, 17). None of these survive today in their original state; the letters have fallen out and now we see only the sockets cut into the marble background—though occasionally metal letters have been restored in modern times, as on the Pantheon in Rome. Assuming that the metal letter conformed to the sockets which we see, these letters were stronger and cruder than carved letters, with less variation of thick and thin, and stronger, blunter serifs. Differences may be noted between forms at the beginning and the end of the first three centuries AD and those used in the intervening classical period. The arch of Augustus at Aosta of the first century, and even more that of Gallienus (260–8) at Verona, both have shorter, more wedge-shaped serifs.

These dates more or less define the period when imperial and other important inscriptions all over the empire were executed in the 'Trajan' style. One of the last is that of the Emperor Constantius Chlorus (293–305) in Trier, a particularly beautiful and individual example with its elegant tapering of the thin strokes (Fig. 18). During all this period there is normally very little from a palaeographical point of view to distinguish either the date or the place of origin of such inscriptions.[6] Considering the mobility of the emperors, and of the governors and other officials who served for fairly short terms in widely scattered parts of the empire, this is not surprising. In less important inscriptions one can perhaps see some local style, for instance in the layout of some of the examples found in Scotland, now in the National Museum in Edinburgh (Fig. 19), with their very open spacing.

With inscriptions which do not conform to the strict 'square' Trajan canon the situation is different and fluid. In North Africa there is a definite style of semi-rustic letter with a very long, projecting upper movement (Fig. 20) to C, forked L, and G with a double curve instead of a spur. Here the style is identifiable; elsewhere it seems more individual. The great majority of Roman inscriptions scattered through the once Roman world, from Portugal to Anatolia, from Scotland to Syria, are neither in the 'Trajan' nor in the rustic style, but somewhere between the two. Most are of no aesthetic interest, ill-cut on local stone and roughly laid out; one has the impression that every legion had a man who could turn his hand to letter-cutting. Some, however, are very beautiful, definitely narrower than 'Trajan', and in the same stylistic category as the lettering on the painted inscription at Pompeii described earlier: elegant, but less formal than classic lettering. Others introduce a tilt or a slight curve in the serif, giving a certain lightness and movement in contrast to

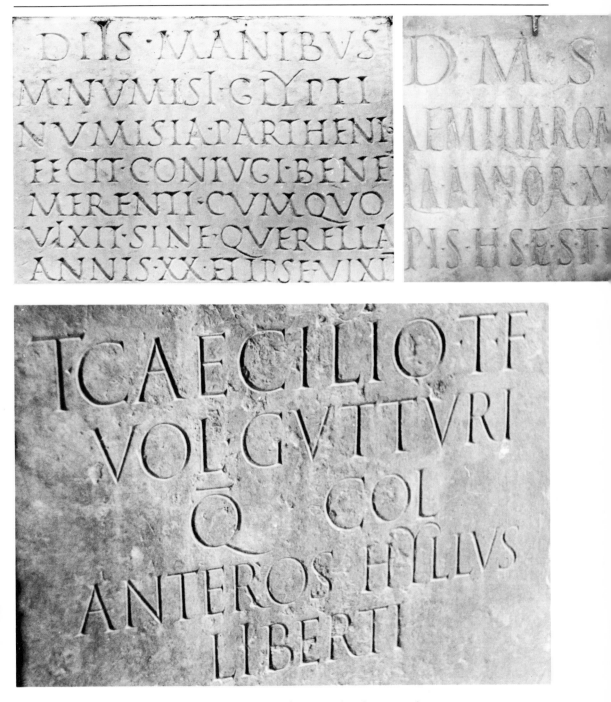

TOP LEFT 22 An inscription from Rome. Here it is the movement in the serif formation which gives the inscription its character.

TOP RIGHT 23 A type of layout combining square capitals and rustic which is found quite often. Granada, Granada Museum.

24 Another normal type of layout with lines of different length, centred. From the pedestal of a statue. Nîmes, Nîmes Museum.

the serenity and stability of the square capital (Fig. 22). In fact, between this and the fully formed rustic there is an infinite gradation of experiment in proportion and serif formation but no formulated norm. There are a very few examples of the use of cursive forms, but these are exceptional and without influence in this period.

Sometimes an inscription in rustics is prefaced with an initial line of square capitals (Fig. 23). There are indeed a number of styles of layout used by the Romans. Lines may be of unequal length, carefully centred, the size of the letters also perhaps varying from line to line (Fig. 24). Memorials often begin with the letters D M (an abbreviation for *Dis Manibus*: 'to the Spirits of the Dead'). The space between lines varies; in some cases the text may fill the whole area of the stone, closely packed. Some letters are occasionally extended above the upper line, for example I, T, Y—sometimes apparently because the carver has run out of space. Smaller-sized letters are occasionally used, particularly small O inserted into the bowl of C. Occasionally also letters are ligatured. Letters carved in relief are very rare.

The Romans bequeathed to us a capital alphabet which in its finest form is worked out in every detail; its letters are individually beautiful, collectively co-ordinated. They established lettering as an art with a place in public as well as in private life. They gave us the idea that letters have more than one form and can be components in more than one style. They also invented an informal pen-written script which in contrast they passed on in an embryonic state, but which is the foundation of our cursive handwriting and of our lower-case type design. As in so many other fields, they laid foundations and created models which are basic to the history of this art.

Notes

1. E. M. Catich, *The Trajan Inscription*, 1961.

2. This inscription is reproduced in M. Henig (ed.), *A Handbook of Roman Art*, 1983, and D. Jackson, *The Story of Writing*, 1981. It shows the only example of this style to be seen on the site. The numerous other painted inscriptions are all rustic, as indeed is the rest of the painted lettering on this wall.

3. For the recurrent influence of Greek letterforms, see Ch. 4, p. 71.

4. It is important to distinguish between the Trajan letter interpreted as an inflexible canon and the capital letter which we know in so many related forms. (See Introduction, note 1 and Ch. 14, p. 229–33)

5. Evidence for the technique of Roman lettercutting is discussed by G. Susini in *The Roman Stonecutter*, 1973.

6. The question of whether dating is possible to estimate from palaeographical evidence is discussed by A. E. and J. S. Gordon in *Contributions to the Palaeography of Latin Inscriptions*, 1957.

The Christian Empire:

The Mid-Fourth to the Mid-Sixth Century

After the middle of the fourth century grand Roman inscriptions and examples of fine 'Trajan'-style lettering virtually disappear; that on the arch of Constantine seems to be the last example of a metalled inscription. The senatorial and imperial inscriptions which survive in the Roman forum, or that in Latin commemorating the great Emperor Theodosius (379–95) in the Hippodrome at Constantinople, are surprisingly poor and badly executed: the sensitive line modulation and elegant serifs have disappeared. On one or two fifth- and early sixth-century senatorial records there is however a new vigour of quite a different sort, irregular and rough (Fig. 25), and there is one artist, who was also a magnificent craftsman (or an employer of such craftsmen) who invented a completely new letter (Figs. 26, 27). If from one point of view the fourth century was a period of decline, from another it was a time of change, innovation, new life. Apart from the inscriptions commissioned by the establishment there is a whole new class: the modest early Christian epitaphs of the catacombs (Figs. 28, 29, 30). In the writing of documents a new style appears, the New Cursive (Fig. 31), far more sophisticated and formed than its precursor (Fig. 7). In books the change is even more remarkable. The papyrus-roll is finally abandoned for the vellum codex, and magnificent books in fine formal script, some with numerous illustrations, are produced: apparently the first books made for bibliophiles (Fig. 32). In Rome and other Italian cities this is also a period of important church building; these were now decorated with mosaics which included much lettering. Hitherto mainly known on pavements and floors, mosaic is now used to cover wall and apse (Fig. 34).

That there should be radical change is scarcely surprising in view of the political vicissitudes of the later Roman empire. After the Antonine emperors (138–92), ordered succession lapsed, and from 192 to 294 the emperors, usually installed by the army, were mostly undistinguished and short-lived (often assassinated), unable to cope effectively with the internal social and economic problems of their vast domain, and under constant external threat on their eastern and northern frontiers from various barbarian peoples who were often employed as mercenary troops but were always hungry for lands on which to settle. However the empire survived more or less intact, and revival began under the Emperor Diocletian (284–305), who re-established order and security through administrative, military and fiscal reforms. The revival continued under Constantine (306–37) and Theodosius (379–95). The empire was again producing great men, and not only in politics: this is a period of great thinkers and scholars such as Augustine, Jerome and Ambrose and, in the East, Basil, Gregory of Nazianzen and John Chrysostom. And it had adopted a new religion.

After Constantine defeated his rival Maxentius at the Battle of the Milvian Bridge in 312 under the standard of the symbol chi-rho (the initial letters of the Greek word Christos), persecution ceased and Christianity came to supersede the official religion of ancient Rome. It was an immense change. Rome had

EVTYCHIVSMARTYRCRVDELIATVSSATYRAN
CARNIFICVMQ·VIASPARITERTVNCMILLENOENI
VINCREQVODPOTVITMONSTRAVITGLORIACIR
CARCERISINLVVIEMSEQVITVRNOVAPOENAPERAF
TESTARVMFRAGMENTAPARANNESOMNVSADI
BISSENITRANSIEREDIESALIMENTANEGANT
MITTITVRINBARATHRVMSANCVSLAVIOMNIASAN
VVLNERAQVAEINTVLERATMORTISMETVENDAPOT
NOCTESOPORIFERATVRBANTINSOMNIA·MEN
OSTENDITLAEBRAINSONTISQVEMEMBRATENE
QVAERITVRINVENVSCOLITVRFOVETOMNIAPRE
EXPRESSITDAMASVSMERITVMIVENERARESEPVLCR

TOP LEFT **25** The inscription erected by Marius Venantius Basilius in the Colosseum in Rome. A new style of official inscription, rough but with a certain vigour. 508.

26 and **27** An inscription designed by Filocalus, from the catacomb of San Callisto, Rome. This style of lettering was invented by Filocalus for verses written by Pope Damasus (366–84) commemorating the martyrs after the end of the persecutions. Mid-fourth century AD.

assimilated many religions from different parts of her empire; this one was different. It superseded all other religions; it was God's final revelation, sealed with the blood of the martyrs. For this very reason it was not easily adopted. Paganism had been an integral part of the Roman state and its ritual observances and institutions. The emperor and the aristocracy had to come to terms with this new religion and separate church organization; while that religion was itself engaged in the task of absorbing into the interpretation of its theology the insights of classical philosophy.

For the educated Roman it must have been an exciting and a difficult time in which to be alive: a time of reassurance, but one also beset with radical problems. The emperor might be stronger, but the barbarian menace remained. Christianity was triumphant, but it had to cope with pagan reaction and its own bitter theological controversies.

With all these changes in the air it is neither surprising that we find a revolution in the practice of lettering, and in taste; nor, perhaps, that the results are so diverse.

The new group of inscriptions which is most easily identified is that of the early Christian epitaphs, found in great numbers in the catacombs of Rome (Figs. 28, 30) and other cities. Characteristic of these is the text, usually very short, giving the name of the deceased and usually the month and day—but not the year—of death, possibly also the name of the relation who had caused it to be made (*filiae carissimae*, to a most dear daughter), and some formula such as *in pace, bene meriti, hic requiescit*. Very often there are also incised symbols: a bird with a palm in its beak, an anchor, a fish, a praying figure; and sometimes the tools of the deceased's trade. The stones are quite small and the execution is usually extremely amateur; often they are just scratched, and sometimes the carver is obviously illiterate. From the point of view of lettering they are diverse, many differing little from contemporary pagan inscriptions of similar simplicity (Fig. 33); a number of the earlier examples are in Greek, the language of the early Church.

Two tendencies can be distinguished. In some the letters are tall and thin—without any variation in width of line—and close together (Fig. 30). Sometimes the lines themselves are close together. Certain letter-forms are common: A with its right limb projecting at the top, F or L with diagonal instead of horizontal members, R with a small bowl and leg starting from the stem, M with right-hand members projecting at the top, as in a rustic inscription, and with splayed outer limbs; but such letters are not used consistently. Some are derived from rustic, but the style is not rustic: serifs are small and wedge-shaped. Other letters are derived from the cursive script in which the text would have been given to the carver (e.g. in forms of G) (see Chart 2). The best of these inscriptions have a certain modesty, simplicity and grace. The compressed proportions seem to represent the general taste of the period.

A second group is more dynamic (Fig. 28). In the first group movement is more important than regularity, and letters may vary in height; but in the second, layout may be unashamedly irregular: letters are not regimented into lines but organized into patterns. It is above all the dynamic diagonals which appeal to the designer and which he stresses in L, K, X and R, and also the unruly curves of S and G. There are not many which succeed in making a living pattern; but it is a different idea of lettering from the orderly Roman inscription and one with potential. I am reminded of the writing of young children just learning their letters: sometimes one sees the same pleasure in making letters as individual shapes, treating them not as signs to be read but as things to be drawn. One wonders who the people were who carved these stones. These inscriptions are usually described as 'early Christian' and undoubtedly most were definitely made for Christians, but one wonders whether there is anything particularly Christian about the style. In some ways it harks back to some Republican inscriptions with their irregular patterns,[1] but one also finds the same feeling in the late third-century milestone (Fig. 33). There are other examples which are different again, some with curling serifs or concave stem-terminations. In some, guide-lines may be scratched, but not always adhered to; in others such lines may be treated as a decorative element with the text inscribed between them. These inscriptions are scattered over the Roman world (Fig. 29)—there are interesting collections at Arles and Trier, both at one time seats of government in this period, as well as in Rome. In North Africa again one sees the local pre-Christian style

surviving (Fig. 20). The Spanish inscriptions are the only ones which are dated with any frequency; elsewhere linguistic evidence and that of changing formulae in the text are probably safer guides in dating than palaeography.[2]

In all this heterogeneous material, and particularly in the idea of creating irregular patterns, one can distinguish the making of a new tradition which continues at least up to the Carolingian period (see Chapter 4, Figs. 45–8). The style grows rather more coherent, cutting is more confident (though seldom skilled), distribution is still wide, suggesting that carvers or patrons, or both, were provincial Romans.

The carvers who worked to this new idea in the fourth and fifth centuries also introduced new practices in the letter-forms which they used. As we have noted, they mixed forms taken from different styles of writing: cursive, rustic, uncial, square capitals. The results were seldom masterpieces, but the two new ideas are very important in the history of lettering. On the one hand we have had the classic Roman practice, highly-skilled and masterly work in a style, or in two distinct styles, evolved by generations of craftsmen into a consummate co-ordination of letter-forms. Now we have the alternative idea that an artist may use any known form to suit the requirements of his design or the feeling which he wishes to convey in a personal creation. It is an idea which is fundamental to much succeeding work, from that of the Insular artists in the eighth to that of David Jones in the twentieth century. Chart 1 indicates the range available by about AD 600.

Early Christian inscriptions are humble memorials to private people. In complete contrast are the magnificent contemporary inscriptions of the verses of Pope Damasus I composed in praise of the martyrs (Figs. 26, 27). With the end of persecution the catacombs, though still places of burial, became also places of pilgrimage, and these inscriptions were designed to honour the tombs of the saints. The letter-cutting is highly professional, and the style, which is very consistent, is completely different from that of any classical Roman letter. An innovation is the extreme contrast in proportion: 10:3:½ for the height, width of thick stroke and width of thin stroke. These proportions mean that all letters except B, E, F and L are wider than a square, and O

and Q wider than a circle. The serifs are also revolutionary: uprights and most horizontals end in a rounded termination flanked by branching curls; but the curves of C, S and G end with plain serifs, mitigating the flamboyance of the design. Bifurcated serifs are found earlier, particularly in Greece, but not skilled and sophisticated versions such as these.[3] The construction of R with its round bowl and straight leg, and the thin bowls of R, B and P are also unorthodox. The skill with which the verse lines have been justified to equal length has occasioned the use of ligatures and inserted letters in some cases—a device much used by later carvers. The spacing is always skilled, making a new sort of pattern of light and shade and undulating rhythm.

Two of these inscriptions, of which about thirty survive whole or in part, are signed 'Furius Dionysius Filocalus scribsit'. Damasus was Pope from 366 to 384, so we know both the patron and date, as well as the designer.

The importance of these inscriptions has long been recognized. R. Krautheimer, in his recent book on late classical and medieval Rome, *Rome: Profile of a City 312–1308*, 1980, page 40, writes that Filocalus 'created a new neo-classical script trying to revive in a new version the lettering of Augustus' time.' Stanley Morison, with a better eye for lettering, calls it 'an absolute and unique departure from anything ever seen before in Rome or, it should be emphasized, elsewhere.' He sees it as a conscious symbol of the complete independence of the Church from the state, and special status of the Bishop of Rome. Even if one does not accept this extreme position there is surely no doubt that we have here an intentionally expressive script, like that of the triumphal arches of earlier emperors, but now intended for the glorification of the Church and her martyrs.

We do not know whether Filocalus carved his lettering or whether he was only the *ordinator*—the cutting must certainly have been laborious. We do however know that he was also a calligrapher, possibly also an artist. He signed an illustrated manuscript, which is known as the 'Calendar of 354', *Furius Dionysius Filocalus titulavit*; the inscriptions are signed *scribsit*. Unfortunately the manuscript survives only in a sixteenth-century copy of a Carolingian copy now in the Royal Library,

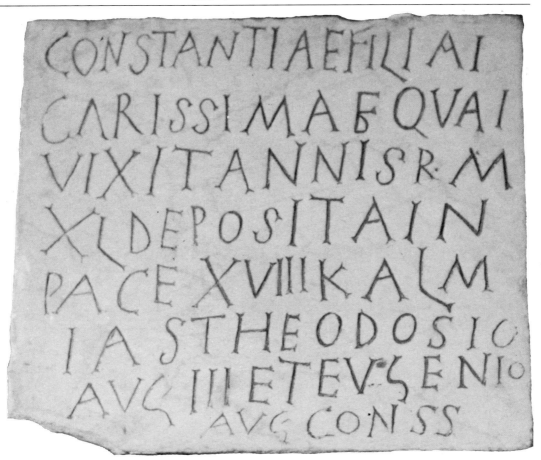

28 The epitaph of Constantia. The inscriptions commemorating early Christians, mainly found in the catacombs in Rome, are modest. AD 393. Vatican Museums.

29 A later example of a modest Christian epitaph dated 587. Lisbon, Ethnological Museum.

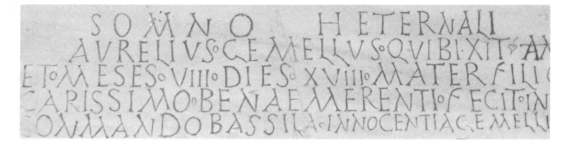

SOMNO HETERNALI
AVRELIVS GEMELLVS QVI BIXIT AN
ET MESES VIII DIES XVIII MATER FILI
CARISSIMO BENAE MERENTI FECIT IN
ONMANDO BASSILA INNOCENTIAE MELL

Q VISSINECPOTVERESERINECSVRGEREMESSIS
VOMISETINFLEXIPRIMVMGRAVEROBVRARATRI
TARDAQ ELEVSINEMATRISVOLVENTIAPLAVSTRA
TRIBVLAEQ TRAHAEQ ETINIQVOPONDERERASR
VIRGEAPRAETEREACMELEIVILISQ SVPPLEX

SCALAEIMPROVISOSVBITVSQVEAPPARVITIGNIS
DISCVRRVNTAIIIADPORTASPRIMOSQVETRVCIDANT
FERRVMALIITORQVENTETOBVMBRANTAETHERATELI
IPSEINTERPRIMOSDEXTRAMSVBMOENIATENDIT
AENEASMAGNAQVEINCVSATVOCELATINVM
TESTATVRQVEDEOSITERVMSEADPROELIACOGI
BISIAMITALOSHOSTISHAECALTERAFOEDERARVMPI
EXORITVRAEPIDOSINTERDISCORDIACIVES
VRBEMALIIRESARAAEIVBENTETPANDEREPORTAS
DARDANIDISIPSVMQVETRAHVNTINMOENIAREGEM
ARMAFERVNTALIIPERAGVNTDEFENDEREMVROS
INCIVSASVTCVMLATEBROSOINPVMICEPASTOR

IMP D N
M AVR
VALERIO
MAXENTIO
P IO FELIC IN
AC PERPETV
AVC

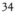

Brussels, ms 7543; this does however show that the original included drawings very classical in style and a title page with square capitals of some sort. And this immediately brings us to the consideration of book-script.

The fourth century is here again a time of change, but in this field one of indubitable advance. The new book is a codex instead of a roll, on vellum instead of papyrus, apparently more elaborate than ever before. Saint Jerome, who was used to copying his own books, and who was certainly more interested in their content than in book production, complained of new books with letters an inch high which were burdens rather than books. A number of books survive which answer to this description, though we do not know where or for whom they were made. Most important are three copies of Vergil now in the Vatican Library, two of which are in very large grand rustics (Fig. 32a), and the other (of which a few pages are also in Berlin) in square capitals (Fig. 32). It used to be thought that the latter were the original Roman pen-letters, derived from inscriptional capitals (thereby assuming the Romans to have been illiterate for much of their history). The manuscript is still known as the *Vergil Augusteus* because it was once thought that the book might have been made for Augustus;[4] we now know more about early Roman script and there is controversy instead as to whether it may not be the work of Filocalus. Certainly these letters are highly arti-

ficial and difficult to form, and only two other manuscripts at all similar are known (now in the St. Gallen and Cairo Libraries); but they do not have the peculiarities of the *Augusteus*, the thin stem to R and slight bifurcations on horizontal, not vertical, terminations. These are not the peculiarities of the Filocalian inscriptions, although they show a similar type of experiment. The inscriptions were designed probably late in the reign of Damasus, about 370–83, so they are some twenty years later than the Calendar. We know that Filocalus was an inventive designer, and no doubt he could write in different styles: one might expect that he would try different ideas for pen and chisel. He is, in any case, an important figure in the history of lettering. We know that he was on friendly rather than servile terms with his patrons: he describes himself as *'cultor atque amator'* ('reverencer and friend') of Pope Damasus, and he dedicates his Calendar by name to one Valentine, probably a Roman aristocrat. It is interesting that the text gives traditional pagan celebrations as well as Christian feasts.

There is another innovation in the *Augusteus* manuscript: the first letter of each page is treated as an initial (regardless of sense). The surviving pages give us the letters A, C, E, I, N, M, O, Q and T. These are the first known initials in a manuscript; they are followed by countless medieval examples, but not, as far as we know, before the sixth century. These first examples are made with ruler and compass and two, T and N, have curl-ended serifs of a more elementary form than those in the Filocalian inscriptions. Curl-endings are also found in uncial penmanship, and for these reasons some scholars date the *Augusteus* to the fifth or sixth century;[5] but lettering artists of originality are rare, and when we know that there was one working at a time when the manuscript, with its two innovative ideas, could have been produced, it seems reasonable to assume that it was his work. There is, I think, a tendency among historians to assume that scribes and carvers never changed their style. This is no doubt true of many letterers, but not all: some experimented. Without documentary evidence, who would have dared to attribute to Edward Johnston, the scribe, the design of his lettering for the London Underground? (Figs. 261, 276.)

The square capital was never used as a standard book-hand, but fine books were now

OPPOSITE TOP **30** The epitaph of the Christian Aurelius Gemellus. Vatican Museums.

OPPOSITE SECOND FROM TOP **31** The New Roman cursive, developed in the fourth century in the provincial chanceries. A sophisticated style introducing ligatures; the style of contemporary Greek script is similar. 552. From Ravenna.

OPPOSITE CENTRE AND BOTTOM LEFT **32** A page of the *Vergil Augusteus*, possibly fourth century, and written by Filocalus, but possibly as late as the seventh century. Vatican Library, Vat. lat. 3256. f. 2r. **32a** Formal rustic script in a very grand copy of Vergil. Fourth or fifth century AD. Vatican Library, ms pal. lat. 1631.

OPPOSITE RIGHT **33** A Roman milestone dated AD 307–12. Vatican Museums.

produced not only in rustic but also in uncial script. The origin of uncial is obscure. By the sixth century its classic form had been developed, wide and lucid, written with a broad-edged pen held so that the vertical strokes are wide and contrast with thin horizontals (Fig. 37). Earlier it was written with a slanted pen, like rustic, and is less precise and ornate: the pen-strokes are short and words are not separated (Fig. 36). Uncial looks easier both to write and to read than rustic. The early form is delightfully fluid; the later one is majestic, one of the most beautiful of pen-scripts. It is surprising but significant that this highly-civilized style was invented and used to produce books to a very high standard in the precarious world of the sixth century, when we think of civilization as already swamped by the barbarian invasions.

It has been suggested that, like the Filocalian inscriptional letter, the uncial letter was a conscious choice made by the Church dissociating itself from the pagan tradition. Certainly it supersedes rustic, and was influenced by Greek uncial, but the reasons may be more complex and also more practical. First however we must return to the last of the innovations of the fourth century: the New Roman cursive (Fig. 31). This informal writing developed out of Old Roman cursive capitals (Ch. 2, Fig. 7) and was used for letters and documents written on papyrus with a pointed pen. Earlier forms had crystallized in the script reserved for the Imperial Chancery known as *litterae caelestes*, a beautiful script, hard to read and no doubt hard to forge. The provincial chanceries meanwhile evolved the new script, introducing ascenders, descenders and ligatures. Individual hands differ, some are sloping, some upright; but the letter-forms are distinctive. Ligatures are seldom of more than two letters, sometimes between part of one letter and part of the next—no doubt the pen required frequent dipping in the ink. The result is a real cursive: flowing, rapid, sophisticated. Much of the surviving material is comparatively late and comes from Ravenna, the administrative centre of Theodoric, King in Italy 493–526, and later that of the Exarch, the representative of the Byzantine emperor in Italy. It is a style written in Greek as well as Latin: no doubt many if not most officials were bilingual. Indeed the division between East and West is at this period still ill-defined. This is the writing which must have been known and used by all literate people in daily life, including lettering craftsmen. It is the background, largely disappeared, against which changes in script developed, a source from which letter-forms were borrowed to be incorporated into the new styles which were being formed. Most important of these was the minuscule, the four-line script with ascenders and descenders, which was going to make for quicker writing and easier reading. In this period, apparently mainly developed from this cursive source, we get the appearance of the book-script misleadingly called half-uncial—its letter-forms are more cursive than uncial, although the ductus is formal and upright (Fig. 35). In the next chapter we shall come to the evolution from these beginnings of various forms of minuscule.

We have however already left the great period of revival of the fourth century for the succeeding centuries. We need to return and to reconsider that revival. The contrast between the humble early Christian epitaphs and the grand Filocalian inscriptions is easily explained. The former were for individuals, often simple people; the first Christians were poor and often slaves, though by now they were joined by more converts from the upper classes. The latter were specifically made in celebration, to the order of the Pope. What, however, is the explanation of the new production of grand and expensive books? Were the skilled craftsmen diverted from letter-cutting to book-production by changes in taste and patronage? Partly it may have been a change in reading habits—earlier books were often read aloud by slaves or freedmen—or the more durable vellum may have encouraged greater pleasure in the actual handling of books. There had long been great libraries in Rome, both public and private, and the production of books was an organized industry; but the

OPPOSITE ABOVE **34** Mosaic on the west wall of the Church of Sta Sabina, Rome. *c.*430.

OPPOSITE **35** Half-uncial script (lines 3-5 uncial). The name is misleading, as it is more nearly related to cursive than to uncial in the forms of the letters (see Chart 1). Sixth century. Bamberg, Bib. His. Hs. B. IV 21 (Patr. 87).

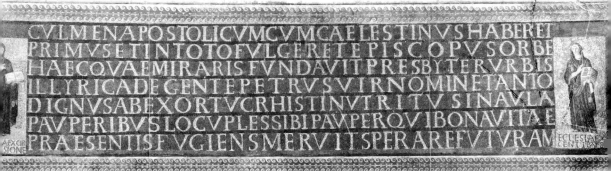

CVLMEN APOSTOLICVM CVM CAELESTINVS HABERET
PRIMVS ET IN TOTO FVLGERET EPISCOPVS ORBE
HAEC QVAE MIRARIS FVNDAVIT PRESBYTER VRBIS
ILLYRICA DE GENTE PETRVS VIR NOMINE TANTO
DIGNVS AB EXORTV CHRISTI NVTRITV SIN AVLA
PAVPERIBVS LOCVPLES SIBI PAVPER QVI BONA VITAE
PRAESENTIS FVGIENS MERVIT SPERARE FVTVRAM

AEXCIR
SIONE

ECLESIAE
CENTVR

obliuisci profecto interrogacionis tuae
mea responsio defuisset

EXP EPISTULA · SANCTI AUGUSTINI DE

CURA PRO MORTUIS GERENDA

INCP EIUSDEM LIB ENCHIRIDION

I	hic ostendit fide spe et caritate dm esse colendum
II	hic ostendit de natura boni
III	hic ubi exponit hierusalem caelestem
IIII	hic ostendit adam cum peccaret
V	ut si dem habeat homo udo concedi
VI	quia populi uel te ado est
VII	arbitrii uoluntas quod ad dm sit
VIII	In eam die ex consuetudine locationis uin dicta intellexi
X	de perpetua uiriginitate beatae mariae
XI	de expo quod filius dei sit atque hominis
XII	quod dns xpi de spu sco sit natus
XIII	quod canoxpi non est natus sed facta insilia uoluntate patris
XIIII	appellatione xpi pro nobis peccatum factus
XV	quod cum peccat on at eam remorianus
XVI	peccatum aduae quod generaliter nocuit ait omnes
XVII	quod unctebap ta sumpa parentum filiis in obligat i peccato

37

adornment of the papyrus-roll was on the stick round which it was wrapped, rather than on the roll itself. Nordenfalk, in his book *Die spätantiken Zierbuchstaben*, 1970, has suggested that the change might have been due to the importance of the new religion of the Book, the Christian Bible. But one wonders whether the patronage of the Roman aristocrats was not as important. These families were very rich, large landowners, living comparatively leisured lives combining a modicum of public duties with the pursuit of literature, writing poetry and exchanging letters with one another in elaborate and highly cultivated Latin. They may have been divided in religious adherence —some like Symmachus, the conservative senator, supported the pagan revival which had a brief flowering under the Emperor Julian the Apostate—but they were also bound together by traditions of education and social life. The Valentine of the Calendar of 354 was, as we have seen, interested in both Christian and pagan celebrations. Three of the great manuscripts which have been discussed are Vergils, but Vergil was approved by the Roman Church (his Fourth Eclogue was interpreted as a prophecy of the coming of Christ), so this does not reveal anything either way. By the late Roman empire the middle classes were ruined.[6] It was the still prosperous aristocrats who played a major role in preserving the culture of the West in Italy, and in those parts of the empire which were still more or less unaffected by the barbarian invasion, Southern France, Spain and North Africa. They were the sort of people to appreciate fine books and who could afford to commission them. It seems probable that it was they who were primarily responsible for maintaining the production of grand manuscripts through the fifth and sixth centuries, a period which is so often, and not without reason, considered the most disastrous in Western history.

In 410 Rome was sacked by the Visigoths; but this was more a psychological than a political disaster. The Goths did not stay; life was resumed, and in fact the senatorial (that is the aristocratic) class maintained itself as the hereditary governing class and guardian of the great Roman tradition. The emperor was in Constantinople: he had long ceased to visit Rome. Other cities—Milan, Trier and Ravenna —were the seats of imperial administration.

The western provinces suffered many vicissitudes, being invaded not only by Goths but also by Franks, Vandals, Burgundians and the other peoples who were pushed westwards by the pressure of the Huns and Slavs from the East. They established themselves on the Rhine, and in France, Spain and Britain; but Rome, though it was sacked also by the Vandals, was never conquered. Indeed, it had acquired new status. It was no longer capital of an empire, but the city of the apostles and martyrs, the see of Peter, chief Bishop of the Roman Church. It was also still the seat of the Senate. Barbarian army commanders, and the fainéant emperors whom they made and unmade came and went, but through it all the senators retained their land and power and made themselves indispensable to the administration. When the nominal line of Western emperors ended (in 476), control by the wealthy senators continued much as before, in some respects their power even being enhanced by the removal of the Emperor.[7]

One sign of this was in the building of churches. Constantine had begun with the foundation of St. Peter's and St. John Lateran. In the fifth century Sta Maria Maggiore, S. Paolo fuori le Mura, Sta Sabina on the Aventine and many other of the most famous churches in Rome were built, as well as others in Naples and Milan; they were decorated with superb mosaics.

In the pagan empire mosaic was used above all on the floor, a very different purpose calling for a very different treatment, and marble rather than glass tesserae was used. The fascinating mosaics on the pavements of the aristocratic villa of the fourth century at Piazza Armerina in Sicily are seemingly casual in

OPPOSITE ABOVE **36** An early uncial with the pen held so that diagonal strokes are thickest. Probably sixth century. This style was however evolved considerably earlier. Paris, Bibliothèque Nationale, ms lat. 17225.

OPPOSITE **37** Uncial script written in Rome. An example of a developed uncial written with a wide nib held so that the vertical strokes are thickest. *c.*600. Troyes, Bibliothèque Municipale et Archives Anciennes, ms 504. f. 55.

OS ADTENDITENOBIS
ABSCRIBISQUIUOLŪ
AMBULAREINSTOLIS
ETAMANTSALUTATIO
NISINIORO ETPRIMΛS
CATHEDRASINIORO
ETPRIMOSDISCUBI

PRAEMATURQUATENUS ADSEMETIP
SUMREDEAT, ETCUMPRAEPOSITAE
POTESTATIDELIQUERIT ETUSCONTRA
SEIUDICIUM AQUOSIBIPRAELATAEST
PERORRESCAT, NAMCUMPRAEPOSI
TISDELINQUIMUS ETUSORDINIQUIEOS
NOBISPRAETULITOBIAMUS; UNDEMO
SESQUOQUECUMCONTRASETARON
CONQUERIPOPULUMCOGNOUISSET
XIT, NOSENIM QUIDSUMUS NECCONTRA
NOSESTMURMURUESTRUM SEDCŌ
TRADOMINUM
ATQUEALITERDOMINI, SERU

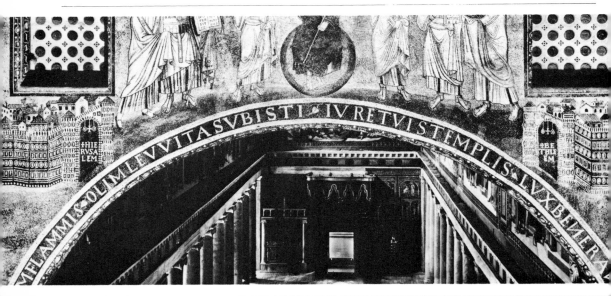

EXSVLTATEPIILACRIMISINGAVDIAVERSI
ETPROTECTORI ? REDDITEVOTADEO
CVIVSSICTENVITRESOLVTVMDEXTERATECTVM
INVACVVMVTCADERET ? TANTARVINASOLVM
SOLVSETINVIDIAEPRINCEPSTORMENTASVBIRET
QVINVLLVMEXAMPLA ? STRAGETVLITSPOLIVM
NAMPOTIORANITENTREPARATICVLMINATEMPLI
ETSVMPSITVIRES ? FIRMIORAVLANOVAS
DVMXPIANTISTESCVNCTISLEOPARTIBVSAEDES
CONSVLITETCELERI ? TECTAREFORMATOPE
DOCTOREMVTMVNDIPAVLVMPLEBSSANCTABEATVM
INTREPIDESOLITIS ? EXCOLATOFFICIIS
LAVSISTA FELIXRESPICITTEPRAESBITER
NECTELEVITESADEODATEPRAETERIT
QVORVMFIDELISATQVEPERVIGILLABOR
DECVSOMNETECTISVTREDIRETINSTITIT

design: the floor is scattered with gladiators, wild beasts and dancing girls. The mosaics of the Roman churches are in contrast on walls and apse. They are designed to image the transcendent glory of Christ and his saints, to glow with the richness of gold. Almost all include inscriptions.

The most important surviving example is that in the Church of Sta Sabina (Fig. 34). The inscription runs the length of the west wall, finishing at each end with figures of the Church and the Synagogue. It records the foundation of the Church by Peter, a priest from Illyria, in the pontificate of Celestine I (422–32). The length is approximately 13.30 m, the height 4 m. There are seven lines, each letter perhaps 40 cm in height. A similar inscription apparently originally existed in Sta Maria Maggiore.

The design is grand, but not orthodox. Main strokes are four tesserae wide, the horizontals two, decreasing on curves to one. Most, but not all, serifs are curled, that is, one or more final tessera is added at right angles. Freedom, not consistency, is the guiding principle. The second diagonal of V is wide, rather than the conventional first, and in S the stress is vertical rather than diagonal. The bowls of P and R are small, and the leg of R straight and serifed. The apex of A is also serifed. The designer must undoubtedly have been familiar with the work of Filocalus and other artists of the time. The magnificence of the mosaic lies not in classical regularity, nor in the perfection of the individual letters, but in the spacing and movement between the forms, in the texture and the colour, gold on dark blue. It has the scale, the dignity, the Roman *gravitas*, the seriousness of the great figures at either end. As far as I know the whole conception was a new idea.

The usual place for mosaic inscriptions

became the apse. Two or more rows of lettering would be added below the figural design, providing a stable base, and this practice continues throughout the long series of Roman mosaics into the thirteenth century; though other lettering, elsewhere, sometimes incorporated into the representation, also occurs.

The inscription recorded at Sta Pudenziana has disappeared, but that at SS. Cosma e Damiano is still visible below the most impressive of all Roman mosaics, erected by Pope Felix IV (526–30). Here, the forms are more classical, though A has a broken cross-bar and the leg of R is straight. Very classical also is the inscription on the triumphal arch of S. Lorenzo al Verano, despite M with vertical side-strokes and short central diagonals, and N reversed (Fig. 38). One is reminded of the constant awareness in the City of Rome of her unique history. This lettering is paralleled by a number of inscriptions imitating Filocalian serifs and liberal spacing, though not the wide proportions and without the fine craftsmanship. There is one for instance on the Lateran baptistery of the time of Pope Xystus, and others of the time of Pope Leo I (440–61) (Fig. 39), and Pope Vigilius (537–55). These bifurcated serifs occur sometimes also in the rare examples of titling in capitals in manuscripts of the sixth century[8] and in uncial manuscripts of Roman origin. Were they thought of as symbolic of Rome and the papacy? We shall meet them again in later manuscripts.

We have reached the sixth century, a watershed in European history. From 493 to 526 most of Italy was ruled by the Ostrogothic King Theodoric, with the support of the Roman aristocracy, including men such as the highly civilized Cassiodorus, and Boethius, author of *The Consolations of Philosophy* which was probably written shortly after 520. Continuity with the Roman tradition was not yet broken. But Theodoric was Arian. The Roman Church had long been involved in theological controversy with Byzantium. In 519 this was resolved and schism ended—though the accord was superficial. Justinian, who succeeded his uncle as emperor in 527, turned his attention first to the heretics in the East and then to the Arian Gothic heretics ruling in Italy. In 533 he set about recovering the lost Roman provinces of the West. The reconquest of Italy involved twenty years of devastating war, a war which

OPPOSITE ABOVE **38** A detail of the mosaic in San Lorenzo fuori le Mura, Rome. Between 578 and 590.

OPPOSITE **39** Inscription of Pope Leo I (440–61). Are the bifurcated serifs a deliberate reminiscence of the Roman tradition of Filocalus? Rome, San Paolo fuori le Mura, Museo Lapidario.

ended the power both of the Ostrogoths and of the secular Roman nobility. The great estates were devastated and many of their owners, together with their children, were massacred by the Goths. The survivors mostly emigrated to Constantinople.

For some, however, their final allegiance was not to their class but to their faith. Cassiodorus retired to his native South Italy, to Squillace where he founded a monastery in which his monks continued the work of preserving the classical heritage by the copying of texts; Sidonius, after holding distinguished political office, became Bishop of Clermont Ferrand. Increasingly, popes were drawn from distinguished Roman families: the first probably

Felix III (483–92), the most important, Gregory the Great (590–604).

This period in the history of lettering is crucial. It was not only a period of revival and innovation, and one which produced one of the most remarkable of lettering artists, it was also, in its later phase, the time when these innovations, together with the classical inheritance, were preserved and passed on. The whole social composition of Europe was changed: it was occupied by new peoples, divided up into new states. The one unifying institution surviving, maintaining the link between the Old World and the New, was the Church with its language, Latin, and its writing. For the next six centuries, writing was in the hands of monks.

Notes

1. Also in the form of B with bowls separate where they meet the stem. (See Appendix 1)

2. For possible evidence for dating see N. Gautier, *Recueil des Inscriptions Chrétiennes de la Gaule*, vol. 1. Première Belgique. For Spanish inscriptions see J. Vives, *Inscripciones Cristianas de la España Romana y Visigoda*, 1942.

3. For early examples of bi- and trifurcated serifs see my article on 'The Filocalian Letter', *Papers of the British School at Rome*, vol. XXIV, 1956.

4. The various dates between the fourth and the seventh centuries which have been proposed

for the *Augusteus* manuscript have been discussed in detail by Professor A. Petrucci in his contribution to *Miscellanea in Memoria Giorgio Concetti*, 1973.

5. See A. Petrucci, 'L'Onciale Romana', in *Studi Medievali*, series 3a, XII, 1, 1971.

6. For the social revolution in the Roman Empire in the fourth century see Peter Brown, *The World of Late Antiquity* (London, 1971).

7. H. Chadwick, *Boethius*, p. 1.

8. For instance in *Corpus Agrimensorum Romanorum*, facsimile edited by H. Butzmann, 1970.

Contributions from the New People:

Focus on the Far North West

By AD 600 the Roman empire no longer existed in the West. The only area which still acknowledged the emperor in Constantinople was Ravenna (which finally fell in 751); a narrow corridor of territory connecting it with Rome, the toe and heel of Italy; and the more or less independent ports in the south: Naples, Salerno, Amalfi. The reconquest of Justinian had barely been established when the Lombards, a Germanic people who, unlike the Goths, had had little previous contact with Rome, conquered North Italy. Elsewhere other barbarian peoples had established their kingdoms: the Visigoths in Spain, the Franks in France and on the Rhine, the Saxons in Britain. But, as we have seen, while this was happening Roman culture and Roman book-making had survived for long enough, though in an ever-dwindling area, for it to be inherited by the new masters and peoples of Europe.

The Roman empire had done its job. In the Christian interpretation of history, its function had been to provide a world order through which the Gospel could spread and, through classical culture, a philosophical discipline by means of which Christian theology could be developed and defined.

The copyists of the Roman world were replaced by monks. The first pioneer houses had been established: Ligugé, near Orleans, in about 360, Lerins about 410, St. Victor at Marseilles about 415, and Vivarium, Cassiodorus' foundation in South Italy, in 540. Saint Columba (c. 521–97) had made his foundations in Ireland and Scotland; Columbanus (c. 550–615) was making his on the Continent, Luxeuil in

the Vosges in 590, Bobbio in Italy in 614, and in 610 his disciple Gallus founded St. Gallen in Switzerland. But most momentous for the future were the first foundations of St. Benedict (c. 480–c. 550) at Subiaco and Montecassino. It was under his rule, which set aside time for reading each day, that most of the great medieval manuscripts were written. Bishops and monks had taken over the cultural role of the Roman aristocrats—as we have seen, they were now sometimes the same people. The papacy still acknowledged the emperor in Constantinople, but this afforded little protection to Rome. It fell to the Pope to care for the physical as well as the spiritual needs of the people: he was not just Bishop of Rome, the last imperial outpost in the West, but pastor to the new peoples who had come into the Roman world. Gregory the Great, for example, sent missionaries to the heathen Saxons in far-off Britain; he worked for the conversion to orthodox Catholicism of the Arian heretics, the Visigoths in Spain and the Lombards in Italy; and he maintained a vast correspondence with all the churches of the West from Africa to Illyricum. An essential part of this pastoral care consisted in supplying copies of books. We know that Gregory maintained many scribes at his palace at the Lateran and probably also at his family home, which he had turned into a monastery. Saint Augustine, when he came to England, brought manuscripts such as the Canterbury Gospels, possibly the one now preserved at Corpus Christi College, Cambridge. So the fine uncial manuscripts made in the preceding centuries were preserved, and multiplied. They

were mainly copies of the Bible and of the works of the Fathers of the Church, but also included, for instance, copies of St. Gregory's own sermons taken down in shorthand as he preached.

The City of Rome, until now the chief initiator of most styles of lettering, was much impoverished. It had suffered devastating sieges during the Gothic Wars, and its population had dwindled. No church was built in the Pontificate of St. Gregory, though some were built shortly after, and pagan temples, such as the Pantheon, were now occasionally transformed into churches. The only mosaic inscription of importance is that at S. Agnese: here, the letters are reasonably orthodox and well ordered. Stanley Morison considers that a very long inscription, now in the epigraphical Museum of S. Paolo fuori le Mura, represents a gesture on the part of Pope Gregory: he believes that in using the 'square Roman capital', Gregory was symbolizing papal independence from Constantinople.[1] I wonder. The inscription in question is cramped and the lettering poorly executed, very different from a classical inscription. Moreover, Roman lettering in this sense, using Roman forms but without precision, with little line-width modulation and rough small wedge-serifs, always seems to have been current in Rome, a tradition running parallel with the early Christian type of inscription. There are rather better examples than the Gregorian stone in the fragment of Gregory's own epitaph and in an inscription of Pope Hormisdas (514–23) in S. Clemente[2], though an example in Naples is more skilled than either.[3] To my mind the inscriptions in the Filocalian tradition (Fig. 39), which continue through the sixth century, are more explicitly papal than Roman. The manuscripts produced by the scribes maintained by Pope Gregory were still written in fine uncial but also used curled terminations (Fig. 37). In Rome it is books rather than inscriptions which interested those who commissioned lettering: reading-matter rather than letter-design. It is among the new peoples in the north that we now find artistic initiative, the formation of new styles and a new approach.

In Spain the rulers were Visigothic, the same people who sacked Rome in 410, settling in Aquitaine with their capital at Toulouse and thence conquering Spain, already partly occupied by the Suevi. Justinian reconquered part of the south, but the Visigothic kingdom lasted until the Arab conquest in 711, when it was reduced to the small northern province of Asturia. There are interesting collections of inscriptions at Cordoba and Merida, many of them dated, and by the mid-seventh century these seem to have achieved a distinctive, if not very elegant, style (Fig. 40). Characteristic letter-forms are A with cross-bar projecting to the left, R and B with separated bowls, D, P, E and R with projecting stems, M with splayed legs, and F with curved upper arm starting from the join between lower arm and stem (not shown in Fig. 40). The lettering is usually slightly compressed, and exact alignment is not valued. Hübner in his collection of the Christian inscriptions of Spain also shows a diamond-shaped O and various forms of G (see Chart 4). It is remarkable that in this Visigothic kingdom the majority of the names on these epitaphs are Roman. This same style is used, however, in the enamelled letters which hang from the votive crown (Fig. 41), given by King Recceswinth (649–72) probably to the Church of Toledo (the giving of rich ornaments such as crowns to hang in churches was normal at this time). Recceswinth's coins (Fig. 42), like those of other early kings, for instance the pennies of Ecberht of Kent (802–39) and of Offa of Mercia (c. 795), are more lively and forceful in their lettering than those of the Roman emperors.[4]

The Arab conquest does not seem to have eliminated earlier styles. There is, in fact, a clear continuity between this seventh-century Spanish style and that which goes on through the ninth into the eleventh century, growing

OPPOSITE TOP RIGHT **41** A votive crown made for the Visigothic King Recceswinth (653–72). Madrid, Archaeological Museum.

OPPOSITE LEFT **42a,b** A coin of Recceswinth, 653–72.

OPPOSITE RIGHT **43** Part of the epitaph of a Lombard princess, the abbess Cunincperga, daughter of King Cunincpert, c.750. There are a number of inscriptions in this style in Pavia, the capital of the Lombard kings. Pavia, Museo Civico.

ASPER · FAMVLVS
EPI VIXIT ANNOS
LVS MENVS XXXV
CESSIT INPACE SBD
NN MGS · ERA DCXXX

40 A Visigothic inscription. The date is given according to the era used in Spain, which is derived from the Roman conquest of 39 BC. It is equivalent to the AD date of 708. Cordoba, Cordoba Museum.

† DISCE EGO VIVELLIS NOS SEGV
QVALIS ET IMAGO PRETIOS
HIC AD INSTAR NIVIS MEMB
CVM INCPERGAE MATRIS DEIA
HAGFVIT SPECIE PVLCRS INTERF
...GIT SERENA OCVLIS VERI

45

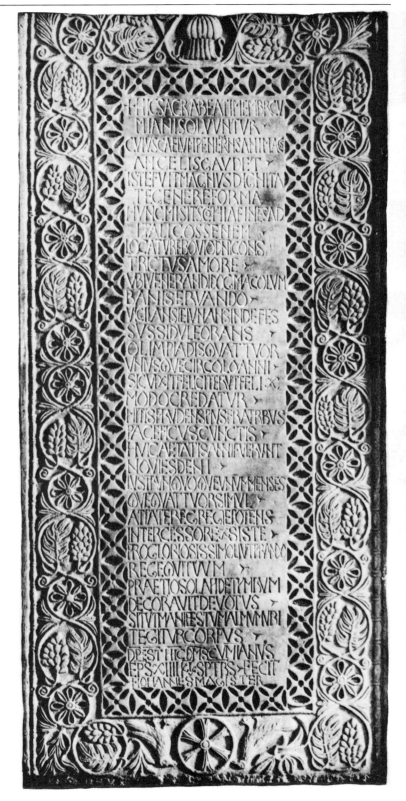

44 The epitaph of the Irish monk Cumian, who died at the Irish foundation of Bobbio, Italy, between 740 and 744. This inscription is carved in marble.

ABOVE **45a,b** A well-head. A modest inscription still more or less in the early Christian tradition. Probably eighth century. Rome, S. Giovanni a Porta Latina.

ABOVE RIGHT **46** A brooch found at Wittislingen. Seventh century. Munich, Prehistoric Museum.

RIGHT **47** A Merovingian ring, with the name of the owner.

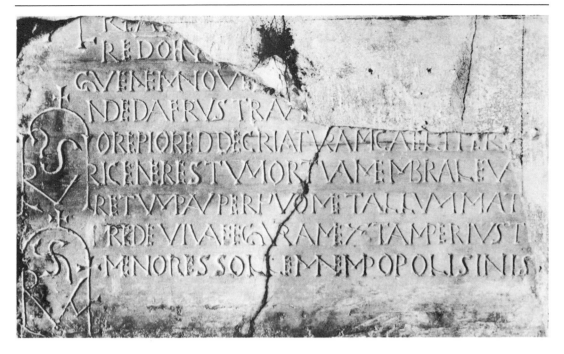

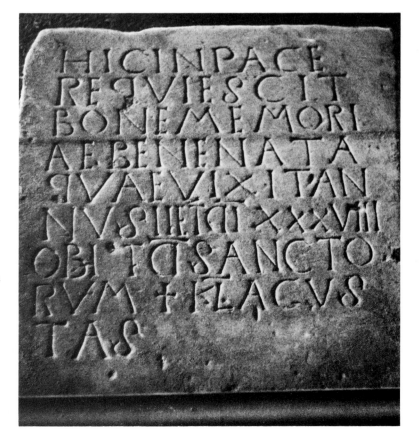

48 Fragment of an inscription, probably an epitaph. It shows the evolution of a style comparable to that of Figs. 43, 44 in the serifed prolongations of the verticals of E and R and in the form of G. Probably seventh century. Arles, Lapidary Museum.

49 An inscription in the early Christian tradition, but now carved with more assurance. Sixth or seventh century. Arles, Lapidary Museum.

more compressed and mannered, and related also to the style of the titling capitals in the Beatus manuscripts (see Chapter 6, Fig. 78). Here, as elsewhere in the new kingdoms, a distinctive book-hand was also gradually evolved, derived from New Roman cursive script but looking very different: round, neat and elegant. It lasted into the twelfth century.

In Italy, rather later, in the eighth century, at the court of the Lombard kings in Pavia, other more sophisticated and skilled inscriptions were carved (Fig. 43). The style is again compressed, but here it is neat and regular. Characteristic is the prolongation of the letter-stem above or beyond the bowl or arm of D, E, F and M, and heart-shaped O and Q, the latter with an internal tail. These inscriptions, three of which have decorative borders, were made between 750 and 765, all epitaphs of people of royal or noble birth.[5] Although a wide range of letter-forms is used, it seems likely that they were the product of one workshop, particularly since there is otherwise much diversity in the other inscriptions of this date on Lombard territory. There are, however, some others which are related; the epitaph of Cumian at Bobbio (Fig. 44) and the inscription on the balustrade of the ciborium at Cividale, both carved in marble, a material which of course allows the skill of the craftsman greater scope.

This diversity illustrates the current situation. One cannot write of any generally practised style, still less of a current alphabet. As I see it there was a persistent undercurrent—similar to the New Roman cursive undercurrent in script—deriving from the early Christian tradition, using a wide vocabulary of forms very freely, some taken over from cursive or rustic, now also from uncial. At the opposite end of the spectrum to the style of the Lombard court are inscriptions made for comparatively humble people, dedicating well-heads (Fig. 45), recording donations, etc., usually quite short. Some early forms lapse, such as A with a prolonged left limb and M with splayed legs; some grow more popular, for instance G with a detached curved spur. These inscriptions sometimes have a new vigour expressed in emphatic wedge-serifs and dynamic irregular design. One sees similar feeling in some short Christian Greek inscriptions and on metalwork, particularly the emphatic use of omega, round and short; and the same form, used in

the same way, only reversed, so becoming an uncial M in Latin examples.[6]

The survival, or rather the development, of this idea of lettering is apparent also in inscriptions and metalwork made in the kingdom of the Merovingian Franks. Figure 46 depicts a brooch made for a Frankish princess which was found at Wittislingen and is now in the National Museum, Munich; it shows how the way of thinking of each letter as an abstract form contributes towards the making of an inscription on an irregular shape into a dynamic pattern. The advantage is even more apparent on Merovingian rings, which often bear the name of the owner (Fig. 47), and sometimes also his or her monogram, another idea presumably borrowed from Greek practice. Monograms are common on Greek rings, and also in carvings, for instance on the capitals in Sta Sophia; and the chi-rho symbol had of course long been used. If political contacts with Constantinople were tenuous, personal contacts between the west and Greek-speaking people certainly still existed: many refugees came from the lands conquered by the Muslims (Hadrian, for instance, came to England from Africa, and Theodore, who became Archbishop of Canterbury 669–90, from Tarsus). Others came from Byzantium after 726 when the Iconoclastic policy was initiated: no doubt there were craftsmen as well as monks and theologians. Contemporary Greek influence is certainly an element in the continuation of the early Christian condition, but working in erratic ways: strong in metalwork—which travelled; less clear in inscriptions, depending perhaps on the personal taste or circumstances of the craftsman or patron—waning therefore in centres, such as Pavia, where a definitive local style begins to be formulated.

Early Merovingian inscriptions are mostly crude and undated.[7] By the seventh century, however, a more mature style begins to appear, longer inscriptions, better-executed, as in the altar at Le Ham near Cherbourg and at Arles (Figs. 48, 49), and on the sarcophagus of Abbess Theodlechelde at Jouarre (Fig. 50). These show letters which are formed and regular, with a taste for characteristics which have now become common throughout Europe: E, F, R and P with projecting stems, G made with two curves, and snail-shaped Q. Here however, as in Pavia, they are given a distinctive character.

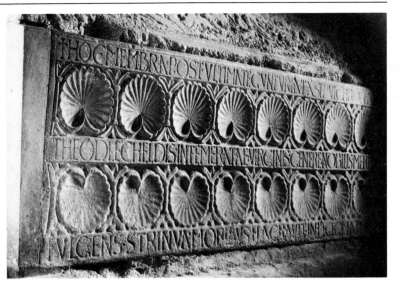

50 The inscription on the sarcophagus of Theodlechelde, Abbess of Jouarre. This is one of the most accomplished of Merovingian inscriptions. 680.

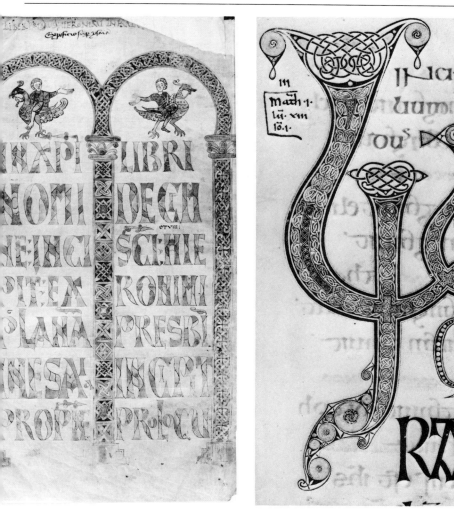

OPPOSITE BELOW **51** A page from a seventh-century lectionary, probably written at the monastery of Luxeuil, in Merovingian script. Paris, Bibliothèque Nationale, ms lat. 9427, f. 180v.

ABOVE LEFT **52** A page from a manuscript written at the monastery of Corbie. The page design and capital letters are typically Merovingian. Eighth century. Paris, Bibliothèque Nationale, ms lat. 11627.

ABOVE RIGHT **53** The first page of the Gospel of St Matthew from the Echternach Gospels. Insular, probably written in Northumbria. Late seventh or early eighth century. Paris, Bibliothèque Nationale, ms lat. 9389.

As with the metalwork, the patron, and so presumably the taste, is barbarian; but the formal tradition goes back to Roman times, just as the script of the charters of Merovingian kings goes back to Roman cursive, and was written by Gallo-Roman scribes or the successors whom they trained. Perhaps the letter-cutters were also Gallo-Roman? This is not known, but one should not forget that the Merovingian laity was normally illiterate. The great variety of current letter-forms is shown in Chart 2.

There were, however, many monasteries in France (some of Irish foundation) where monks were now producing manuscripts: copies of texts written in the fifth or sixth centuries in Italy, Southern France, Spain or North Africa in uncial, or perhaps half-uncial, script. Some of the Merovingian manuscripts are also written in uncial, but others use a new script (Fig. 51) developed out of the cursive used in the royal chanceries (Fig. 31). It is a tortuous script with a fascinating complicated rhythm which seems to suggest the involved and violent tenor of life in Merovingian France as portrayed by the *History* of Gregory of Tours, written between 573 and 594.

These manuscripts are also decorated with initials, lines of lettering, and even full pages of motifs in which letters are an important element (Fig. 52). The artists would have found both initials and lines of letters in the manuscripts which they copied;[8] but now these are elaborated. Two ideas found in earlier Italian initials—the making of curved letters with a compass and the turning of the stem of the letter into a bird or fish—now proliferate.

Some letters lend themselves to compass construction, but in Merovingian initials the compass is dominant. It is not used as an aid to the construction of a known form; instead, the form is made to fit the construction. With C, D, Q and P (Roman or uncial) the problems are fairly simple. O can be even-line, or made of two overlapping circles (as in the *Vergil Augusteus*); more controlled are uncial M and S (Fig. 51), made of overlapping circles side by side or on top of one another; more contrived is round V or U, in which the upright stems are made from arcs which cross the open circle which defines the letter. Stems so created are then fish-filled. The spur of G becomes a long-tailed bird; uncial D branches out into fantastic

leafage, and the diagonals of A may be peacocks pecking at a vine stem. In the Lectionary of Chelles, however, geometry has almost disappeared; N is composed of an animal suspended by its tail between two standing birds; C I is a snake-tailed creature encircling its little one.

There is not, as far as I can see, any geometrical theory of letter-forms as in constructed Renaissance alphabets behind these fantasies, nor is there any feeling of organic principle, as in later medieval representational letters. The drawing is in most cases fairly crude, but it is lively and popular. One of the earliest examples is in a Roman manuscript of one of Pope Gregory's sermons (Fig. 37), which may reflect his attitude to language: he rejected the convoluted Latin of the fifth-century literary aristocrats, and spoke in simple language to be understood; indeed, his Dialogues were obviously written to give comfort and encouragement to the simple, although his other works are sophisticated in thought.

The initials in Italian and, even more, in French manuscripts are frequently accompanied by rows of capital letters; again a development of the titling found in some earlier books.[9] In the seventh and eighth centuries these capitals are usually embellished with curled terminations, or they are outline letters: that is, the stems are drawn with a double line and the serifs again curled. Figure 51 shows these two types of letter from the Luxeuil Lectionary, now in the Bibliothèque Nationale (ms Lat. 9427). The effect is rather spindly and spiked, but it suits the text-hand. The outline idea was taken one step further in letters which are built up and the enclosed areas colour-filled (Fig. 52). This is a new idea of a letter: no longer a structure, it is now a two-dimensional form on the page. In the most elaborate manuscripts, such as the Gelasian Sacramentary now in the Vatican (ms reg.lat.316), the Sacramentary of Gellone in the Bibliothèque Nationale (ms lat. 12048), both of the eighth century (also other Paris and Oxford manuscripts, Bibliothèque Nationale ms lat.11627, ms lat.12155, and ms lat.12135, and Bodleian ms Douce 176), we find whole pages with designs built up out of symbols, crosses, arcades, birds, fishes, and even a human representation, together with more elaborate letters.[10] In the Oxford manuscript some letters are entirely composed of creatures, and some seem to be made of enamelled metal,

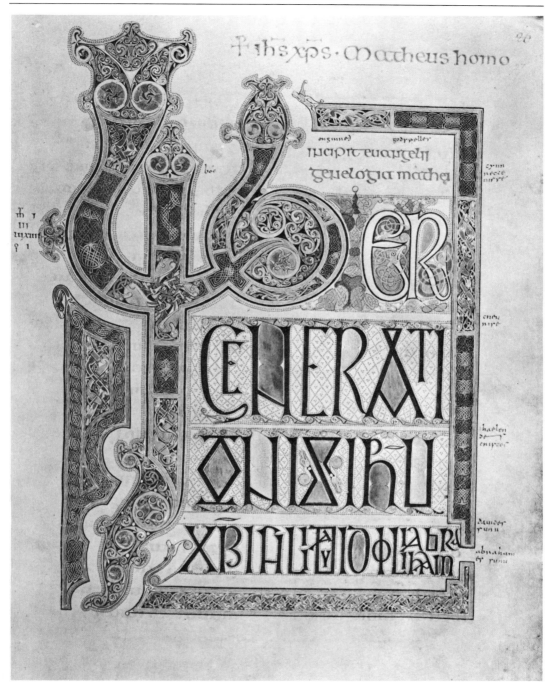

54 The first words of the Gospel of St Matthew. Lindisfarne Gospels, f. 27. *c.*698. London, British Library.

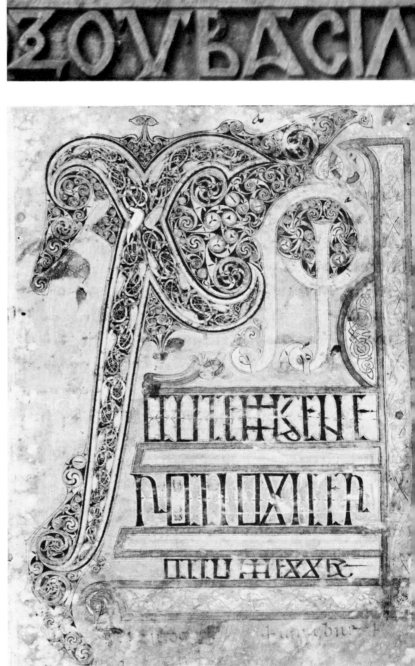

ABOVE 55 An inscription from Tarbat, East Ross. A rare example of an inscription with the same sort of layout as that of the manuscript pages in that the lettering is divided by bands. Eighth century. Edinburgh, National Museum.

TOP RIGHT 56 Part of Greek inscription, in relief, of Constantine Copronymos (740–75). Santa Sophia, Istanbul. There is a very similar inscription in Rome of Pope John VII, a Greek, 705–8. Did such inscriptions give Insular monks ideas of proportion and layout?

ABOVE 57 The genealogy of Christ. A page from the Gospels of St Chad, Lichfield Cathedral. Probably second quarter of eighth century.

in another the enclosed surface is pattern-filled. The idea of such decorative pages is new, at least in western Europe.

The repertory of letter-forms used in these books is fairly consistent, but particularly with pattern or colour-filled letters, the thin stroke which should logically be just a single line is instead doubled so that the letter is entirely composed of wide wedge-ended ribbons: an O can be made of two concentric circles, so even-line. A manuscript in Essen Cathedral Treasury[12] shows yet another version: letters made from even-line strokes which burgeon erratically into fronds and trefoils.

While these very original, sometimes fantastic, but always rather crudely-drawn manuscripts were being produced in France, work of infinitely higher quality had reached its zenith in Ireland and England. This school is usually called 'Insular'. Its works are distinctive but their place of origin is often disputed. The first beginnings were certainly in Ireland; thereafter some manuscripts were produced in English or possibly Scottish,[11] and some in Irish monasteries; there were certainly Irish monks in England and Scotland, and vice-versa. Here we are not concerned with sorting out the relative national contributions (and indeed one wonders whether contemporaries would have thought this particularly relevant); rather, we are concerned with describing and assessing the achievements of these artists, who are undoubtedly of pre-eminent importance in the history of lettering.

Ireland was never part of the Roman empire. In the centuries when that empire flourished, its people maintained a different sort of life. The country was divided into five, later seven, kingdoms, with trading and raiding connections with Gaul, Spain, Brittany and Britain. In the fifth century AD they established the kingdom of Dal Raida in Western Scotland. The Irish were Celts inheriting the Celtic art of La Tène with its repertory of wonderful swirling spirals. Many examples of fine metalwork and fragments of stone-carving survive from this period.

In the fifth century, raids on the coast of Britain were common. On one such raid the boy Patrick, the son of a Romano-Briton, was carried off to Ireland as a slave; after six years he escaped, but returned in 432 to fulfil the vocation to which he had been called in his years of slavery, to preach the Gospel to his captors. In the meantime he had been trained to the priesthood, probably in France. Undoubtedly he would have brought books with him when he returned to Ireland; other missionaries were probably already there and they also would have had books. Presumably these were written in the book-hands current in Britain and Gaul in the late fourth and fifth centuries, half-uncial and uncial. One of the earliest manuscripts known to have been made in Ireland is the Cathach of St. Columba, now in the Library of the Royal Irish Academy in Dublin.[13] It was probably written in the early seventh century—so a century and a half after the death of St. Patrick, when the dynamism of Irish Christianity had already led to the foundation of missionary abbeys on the Continent at Bobbio in Italy, St. Gallen in Switzerland and Luxeuil in France. The Cathach shows an early stage in the formation of the Insular script, the finest of all pre-Carolingian book-hands; very different from the Merovingian type formed at Luxeuil (Fig. 51), which shows no Insular influence. The formal Insular hand, sometimes called 'majuscule', which is at its finest perhaps in the *Book of Kells* (Fig. 64), is majestic, rivalled only by Textura many centuries later. Typical are the very wide measure and short ascenders and descenders, counterpoised by the swelling but controlled curves of l, g and p, with the heavy serifs moving upwards to make a very strong upper limiting line. This stately script, and its variants in other manuscripts, is different from Insular minuscule, also Irish in origin, which is varied, free, spiky and irregular in rhythm, full of movement rather than controlled and stable. Insular scribes also perfected a very formal and open uncial, derived from the Italian books brought to England by Anglo-Saxons such as Benedict Biscop. But here we have jumped a century or so from Ireland, whence came the first impetus.

Saint Columba (521–97), himself reputed a famous scribe, founded Iona on the south-west coast of Scotland in 563, as well as many monasteries in Ireland; this part of Scotland had already been colonized from the Irish kingdom of Dal Riada. Thence Irish missionaries spread the faith amongst the Saxons, and in or about 635 the monastery of Lindisfarne, on Holy Island off the coast of Northumberland, was founded from Iona.

Meanwhile, far away to the south, St. Augustine, sent by Pope Gregory, had landed in Kent in 597. He converted the Kentish King Ethelbert, and in 625 sent Paulinus as a chaplain to the Princess Ethelburga when she journeyed north to be married to Edwin, King of Northumbria. The two Christian missions, bringing different customs but the same faith, met.

The Irish tradition had developed outside the framework of the Roman world: the southern mission stemmed from Rome, and the Anglo-Saxon Church continued in close contact with the papacy. In 664 at the Synod held at the Abbey of Whitby, differences were resolved in favour of Roman practices and, though some dissidents returned to Ireland, henceforth the distinction between the two influences becomes blurred. Irish script continued to be used in England, although uncial derived from Italian manuscripts was also used. The great English monasteries such as Wearmouth-Jarrow and Lindisfarne, and later southern monasteries such as Canterbury, undoubtedly produced some of the greatest of the astonishing series of manuscripts, in which a background of abstract art has inspired an approach to lettering which is completely different from that of the classical tradition.

The great Insular manuscripts have been much studied over many years. Here I propose only to consider the pages of capital letters which they contain, which present special problems and are of crucial importance in the history of lettering. These pages transcribe the opening words of the four Gospels; some books also include the genealogy of Christ (Matthew, Chapter 1) and the opening words of the letter of St. Jerome to Pope Damasus, in which he recalls the commission given to him by that Pope to revise the translation of the Bible, a letter often included in manuscripts as a preface to the Bible. These pages are commonly called 'incipit' from the Latin 'here begins'. The idea of opening sections with such pages of decorative lettering is also found in contemporary Merovingian manuscripts, though these seem on the whole to be later and possibly of different (eastern?) inspiration. The latter have neither the skill, nor the devotion in execution, nor the manifest seriousness of purpose and extraordinary originality of letter design of the Insular books. In these we seem at first sight to get a whole new alphabet with many variants; but letters are never new, for how then could they be read?

Already in the Cathach of St. Columba there are vigorous initials, freely pen-drawn, so following in the tradition of decorative letter-drawing which we have traced from the Vergil *Augusteus*. These initials are followed by intermediate-sized letters, a device also used in the headings of early charters.[14] The next development is seen in the *Book of Durrow*, probably produced about 675, and the earliest surviving Gospel book with elaborate incipit pages. The opening pages of each Gospel are now embellished with several lines of coloured and decorated letters as well as a much more elaborate initial. The pages become progressively more elaborate with each Gospel, until the initial to that of St. John reaches the whole length of the page.

The letters used in the *Durrow* pages are decorated versions of Insular majuscule,[15] coloured and sometimes given delightful spiral extensions. Only on the St. John page are different forms of A, D and M introduced. The book has also 'carpet' pages of abstract patterning and pages with representations of the symbols of the Evangelists. One must remember that the monk making this and later manuscripts had necessarily before him some other manuscript from which he copied his text and also such of the decorative and pictorial elements as he may have thought important, or useful, for his purpose. His book, upon which so much time and effort was expended, was not just for private reading, but for manifestation, for showing in church upon the altar, for the edification of the illiterate as well as the literate.

In the next group of manuscripts the Insular style has already reached maturity: in the Echternach Gospels, now in Paris (Bib.Nat.ms lat.9389) (Fig. 53), the fragmentary Gospels now in Durham (Cathedral Library ms A.II.17) and the Lindisfarne Gospels (Fig. 54), written at Lindisfarne in about 700. In these manuscripts we get a different sort of capital (or display) letter. In the Echternach and Durham manuscripts this is a very strong, definite letter with terminations wedge-shaped and slightly concave. In both manuscripts capital A with the cross-bar curving down to a central point, and a bar terminating in a short vertical across the apex to the left or to both sides, is used, as well as B with a square lower bowl, square C,

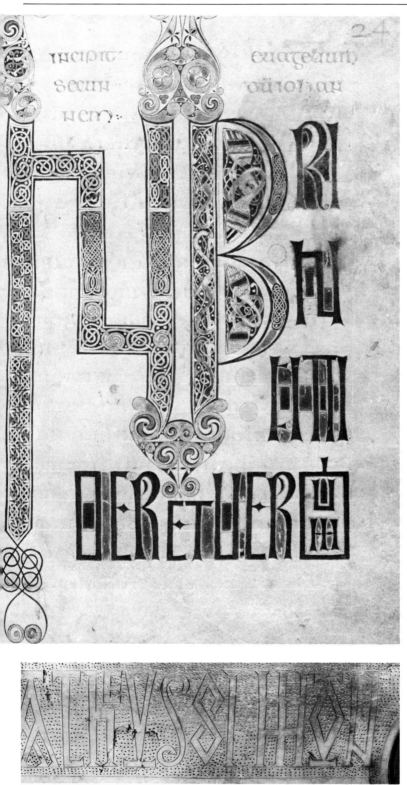

58 The opening words of the Gospel of St John. Late seventh or early eighth century. Cambridge, Corpus Christi College, ms 197 B f. 2.

59 A detail of the lettering on the Ardagh chalice found in County Limerick. Second half of eighth century. Dublin, Dublin Museum.

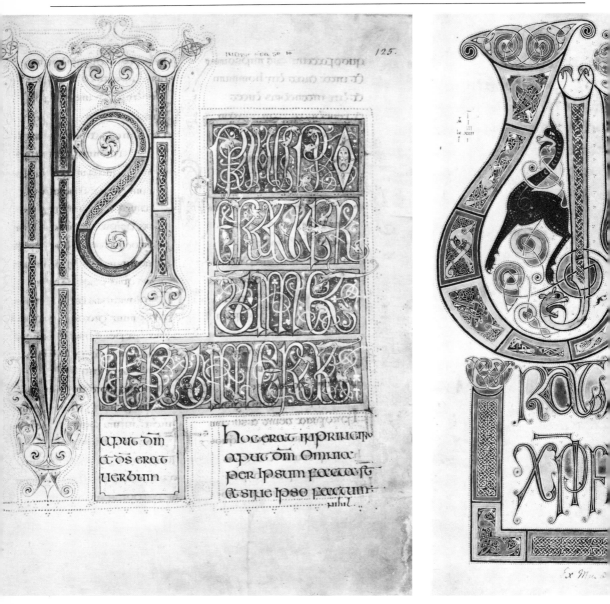

ABOVE LEFT **60** The first words of the Gospel of St John. The most organic type of Insular lettering. Second half of eighth century. Rome, Vatican Library, Barberini ms 570.

ABOVE **61** The opening words of the Gospel of St Matthew. Late eighth century. Leningrad, Public Library, cod. F.v.1.8 f. 18.

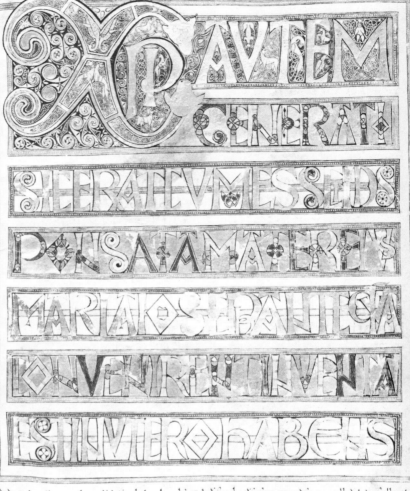

ABOVE RIGHT **62** The genealogy of Christ. This and Fig. 63 show the most classical types of Insular lettering. Mid-eighth century. Stockholm, Royal Library, ms A. 135, f. 11.

HIC GABRIEL AN
GELVS ZACHARIE
SACERDOTI IN
TEMPLO DONIAP
PARVITALMVMQ
RRAE CVRSORE
MAGNIREGIS EI
NASCITVRVHI
PRAE DIXIT

square E with top and bottom arms prolonged vertically inwards, and M composed of three vertical strokes with a line across. The Echternach book also has L like a step, that is, with a downwards projection, a diamond-shaped O with a bracket shape top and bottom, and T with a right-angled stroke added to the bottom. The Durham book, of which only one incipit page survives, also has an angular S, square-topped M, and another with curious bulges at the top. The letters in these manuscripts are all fairly consistent in drawing and might be by the same hand. The Lindisfarne Gospels have the same sort of lettering on the portraits of the Evangelists, but the incipit pages are much more elaborate: five of the six have borders, filled with ornament, and in all six the whole page has been worked out as a design in which the letters, arranged in rows against a partly patterned background and themselves some-times colour- or pattern-filled, are the compo-nent elements, the great initials creating the dominant theme. The capital letter-forms are much the same as those of the Durham and Echternach manuscripts, but the rounded 'majuscule' forms (E, U, O, Q and sometimes M) which have been retained are more promi-nent, and above all each page has been worked into a unique pattern quite different from any-thing before. The design is the artist's expres-sion of the tremendous import of the words which he is inscribing, words of which the transcription would surely, in an illiterate society, have had a magical quality. This is transmuted by the artist: the elaboration of the execution matches the immense seriousness of the theme. As Peter Brown writes in his book *Society and the Holy*, page 218, the northern contemplative did not gaze eye to eye into the face of an icon, like his Byzantine contempor-aries. It was in the pages of the Gospels that he hoped to find his God; he crouched in rapt attention over an open page. The art of letter-ing had acquired a new status.

The influences which can be found in the decoration of these manuscripts have been traced to various sources, Celtic, Classical and Oriental, by art historians. Here I want to consider the origin of the letter-forms which are the elements out of which the great incipit page compositions are created. We need first of all to rid ourselves of the idea of a basic Roman canon. This was clearly not a conception in the mind of the monk-artist. Indeed, he was almost certainly aware that the roman was only one of several alphabets in current use. In Ireland inscriptions were almost all in Ogham, a script in which letters are represented by parallel horizontal lines related to a central vertical.[16] Among the Anglo-Saxons runic letters were used (often mixed with roman),[17] again a linear alphabet, but more complicated, composed of verticals and diagonals, probably originally developed as signs cut in wood—so using diagonals cut across the grain rather than horizontals.[18] Greek letters were also known: the Lindisfarne Gospels include a theta, the Durham manuscript a pi. Roman capitals would have been known as titling in the Italian and other manuscripts which were copied by the monks, but—judging from those which have survived—these would often have been rustic or semi-rustic, seldom carefully drawn, square capitals.[19] Initials were certainly an idea developed by the Insular artists—the facsimile edition of the *Book of Kells* includes classified reproductions of the great variety used in that manuscript—but this tradition was not varied enough to provide all the ideas already in use much earlier in these first incipit pages (see Chart 3). Ideas were surely also drawn from the study of inscriptions.

The most likely inscriptional source was contemporary work on the Continent. Classical inscriptions must still have been visible, not in Ireland, where Ogham was normal, but some rough examples survive in Scotland from the fifth century, the time of St. Ninian (now in the National Museum, Edinburgh), and there were many in England on Hadrian's Wall and else-where, and more and much finer examples in France and Italy. There is, however, no sign that this tradition appealed to Insular artists in the way that it did to the Carolingians a century later. Instead they seem to have used later examples with their mixed and varied repertory of letter-forms as a quarry from which to extract the particular shapes which they needed to express their purpose, or to

OPPOSITE **63** A page from the Gospel of St Luke. The letters are executed in alternate lines of gold and silver. The silver has unfortunately oxidized. London, British Library, Royal ms 1.E.VI f. 44.

build up their design (see Chart 2). Thence also they would have derived the idea that each letter, while it has its own individuality, can also express this in a variety of forms. In Wales the material is continuous from after the end of the Roman occupation, but the examples are rough, and letters ill-defined.[20] The Continental inscriptions are more numerous, better carved and more creative. It seems more likely also that these monks, some of whom were great travellers, should have been drawn to journey to Continental monasteries and to Rome, rather than to Wales.

One idea that they would have found in such inscriptions was the concept that capitals, minuscule, and cursive are not necessarily three separate alphabets. So, to return to the three early manuscripts, we find minuscule forms of B, G, L, M, T and E; a cursive G; and forms of A (with a broken cross-bar), C (square), N (with a short diagonal), and O (diamond-shaped), all letter-forms which are Greek in origin, though by the end of the seventh century these origins had been forgotten. The new taste for squaring bowls (B and D) and for adding right-angled extras (as with T, L and N) suggests a nostalgia for runic or Ogham angularity. This is a taste which is developed in later manuscripts such as the MacRegol Gospels. The only runic letter which is actually used, however, is the M found in the Gospels of St. Chad (Fig. 57).

The most puzzling letter found in the Insular repertory is the M composed of three parallel uprights crossed by one or occasionally two horizontals; in some examples this is not horizontal but diagonal. Is this related to Ogham? Or to a Greek xi? The latter is the same sign but turned on its side, with the horizontal stroke upright. This sign does in fact occur in this form, meaning M, in the Lindisfarne Gospels on the incipit pages to Mark and Luke. Or is this M derived from the half-uncial form, in a squared, flat-topped version, a form found in Wales? Or were the artists influenced by all three ideas?[21]

Finally, was this repertory of letter-forms invented by the illuminators of manuscripts or by the carvers of inscriptions? The epigraphic material is more scarce, and mostly undated. It has been collected by Elisabeth Okasha,[22] and the letter-forms which she finds in examples that can be dated to the seventh, eighth and ninth centuries are shown in Chart 4. Many of the characteristic letters used in manuscripts occur, and in these inscriptions the text is often in both Latin and runic characters—as on the Ruthwell Cross. It is possible that the initiative in introducing new or unusual letter-forms was with the letter-carvers; there is no evidence either way, but from the works which survive, it is clear that the manuscript artists were the more inventive. We need also to remember that the originality and creative genius of these artists lies not only in their concept of the letter as having its own persona, as being an entity which could, as it were, wear different clothes while remaining always itself, but also in the ways in which they combined these forms, expressing the seriousness of the Divine Revelation which they spelt out through complex and unique formal design. The letters themselves are created out of more or less even-line ribbons or strips, coloured, and often outlined, sometimes with a border of dots, finished with strong terminations. The letter-stuff itself, or the bowls, or the interstices, or the background, may be patterned. As manuscripts multiplied invention proliferated. The proportions of the letters, that is the relation between the width of line and the height, and the basic arrangement, one or two great initials with lines of smaller capitals below, divided by positive strips, or framed in rectangles, remained characteristic.

Did the Insular artist get the idea of these elements and proportions from any previous source? Coptic manuscripts have been suggested,[23] but these are known only from later examples, and in them the line-stroke moves from thick to thin, suggesting the use of a pen and a way of thinking which seems foreign to the Insular work. Arabic Kufic inscriptions have also been suggested; the proportions are similar, but these are definitely later. A possible prototype, which might have initiated the idea of using these proportions and the positive interlinear strips, are Greek relief inscriptions, such as those to be seen in the narthex of Sta Sophia, and in the Museum at Istanbul (Fig. 56), and also in Rome around the altar dedicated by the Greek Pope John VII (705–7).[24] Surviving examples of this style are again later than Lindisfarne (c. 700), but only just, and the carvers may have been following earlier examples. Undoubtedly the Irish and the Anglo-Saxons travelled, and the latter at least came

home with books and music and, no doubt, ideas from abroad: men such as Benedict Biscop (628–92) who escorted the Greek Theodore of Tarsus from Rome to be Archbishop of Canterbury. Even if the travellers went no further south or east than Rome, there was Greek to be seen in Rome, and many diverse Latin inscriptions along their route. In any case, wherever they may have picked up ideas, the use to which they put them was new.

It has been necessary to spend so long in describing and seeking the origin of the letter-forms used in this earliest group of manuscripts because these provided the framework and basic vocabulary out of which the creators of later work developed an astonishing range of lettering design, some elaborating geometric, and others organic ideas, and some re-introducing the classical element.

To take first the most coherent development, the taste for angular geometric forms. This line is pursued in a number of manuscripts: Gospels at Corpus Christi College, Cambridge (Fig. 58) (late seventh or early eighth century), the Gospels of St. Chad (Fig. 57) (second quarter of the eighth century), a Collectio Canonum, which is now in Cologne (early eighth century), two manuscripts at St. Gallen (mss 51 and 1395) (later eighth century) and the Mac-Regol Gospels (early ninth century), now in Oxford. In almost all, the round letter-forms have been eliminated or squared up, creating new forms but ones of recognizable derivation and consistent use: for instance S, O, Q and G. Greek pi becomes usual as a form of P. In these pages of geometric letters we can see that the artists took the particular forms which they liked, verticals and diagonals, and created out of them the patterns which they wanted.

Possibly this style shows Irish taste. Several of these manuscripts are known to have been made in Ireland, and the same forms are used on the Ardagh chalice, found in County Limerick (Fig. 59) (see Chart 4).

At the opposite end of Insular experiment are those books which delight in the organic element in their vocabulary. Of these the most extreme is the Gospel book in the Vatican Library (ms Barberini lat.570) (Fig. 60). Here the artist has intertwined his snake-like forms into a complex interweave, though on one incipit page uncials are used. The Gospels now in Leningrad (Fig. 61) show an even more devel-oped idea of letters as fluid two-dimensional surface shapes in the opening page of Matthew; other forms on this page recall the Echternach Gospels. Two of the other incipit pages use different, smaller letters, outlined and colour-filled, similar to the lower lines of the Matthew page. In the St John page rounded forms are emphasized, interlinear bands are omitted and the effect is different. By now in the later eighth century a very extensive range of ideas and forms were available to the letter-ing artist.

In two other manuscripts, both made at Canterbury, classical influence is, in comparison, uppermost. In the *Codex Aureus*, now in Stockholm (Fig. 62), the influence of metal-work, which is apparent in all these pages, is particularly strong: the letters appear as if cut out in metal. Though the composition looks almost classical, many letters are very different from the Roman canon: broken cross-bar, apex-serifed A, square C, lozenge-shaped O, N with low diagonal, and S with its terminals rolled up into wheels. The same is true of the British Library Royal ms I.E.VI (Fig. 63), but here the concept itself is classical, lucid and straightforward. The beauty of the drawing— sensitive and precise—is unfortunately marred in some of the alternate lines, which were painted in silver which has oxidized. Even so, it is one of the most beautiful of all these manuscripts.

Finally, I come to the *Book of Kells* (Fig. 64). By far the most impressive lettering page is that with the great chi-rho symbol, triumphant and superbly rich, composed from only three letters—more presences than letters. In the other incipit pages the initials have become great structures, while the other letters, mostly geometric, are small and confined in boxes. Most interesting, but not completely success-ful, is the page for Luke IV.1, with its mixed organic and geometric letters. Folio 124 experi-ments with a new type of layout; but to my mind it is the text script and the profusion of dynamic initials on every page which are the greater contributions to lettering art, and also some of the one-line designs, such as one where all the letters are interlaced.[25]

The school of Insular letter-design is the most inventive in the history of western letter-ing, if indeed one can call it a school. It would be interesting to know how far these artists

knew one another and one another's work, how much was learnt from a master, and how much new ideas were valued. Certainly the books were valued and treasured.

English and Irish monks went to the monasteries on the Continent, many of which were of Insular foundation. There are manuscripts made in these monasteries which show Insular inspiration and invention and the capacity of this school to generate new ideas. The Gospel book in the St. Gallen Library (ms 348) (Fig. 65) has letters the ends of which roll up into delightful curls, like scrolls. There are similar scroll-ended letters in the British Library (ms Royal 1 b VII). The Bibliothèque Nationale St. Augustine manuscript (ms lat.12168), probably written at Laon, has pages which are Merovingian in design and colour, but more sophisticated. In the most elaborate the outlined letters, mounted on parti-coloured frames, are mixed with pattern-filled initials, with a dragon and many dragon heads, to make a very successful design. The artist of the Gospel of St. John (Bib.Nat.ms nouv.acq.lat.1587) drew his letters with idiosyncratic vigour and freshness, filling or partially filling the bowls with erratic colour. These are not so serious as the great books, but they are individual and alive (Fig. 66).

Much of all this invention was to be taken over and used in a very different way by the monks who made the manuscripts which are an important part of the Carolingian Renaissance.

Notes

1. Stanley Morison, *Politics and Script*, 1972, p. 104, where the inscription is reproduced.

2. The inscriptions of Hormisdas and the fragment of the epitaph of Gregory are reproduced in H. Grisar, *Analecta Romana*, tavola 4 and 11.5, 1899.

3. The Naples inscription is reproduced in Silvagni, *Monumenta Epigrafica Christiana*, vol. IV, fasc. 1, 1943.

4. See M. Dolley, *Anglo-Saxon Pennies*, 1970.

5. For an analysis of Lombard letter-forms, see my thesis on the palaeography of Italian inscriptions 700–1000 in *Papers of the British School at Rome*, vol. XVI, 1948. For other Lombard inscriptions see R. Soriga, 'Le lapide longobarde del monastero Pavese di Sant' Agata al Monte', *Bib. della Soc. Storico Subalpino*, vol. CXXX, 1932. Also Silvagni, op.cit., for reproductions.

6. See N. Gray, 'The Palaeography of Latin Inscriptions in Italy, 700–1000', *Papers of the British School at Rome*, 1948, nos 14 and 31 for this type of M.

7. See P. Deschamps, 'Étude sur la paléographie des Inscriptions lapidaires de la fin de l'Époque mérovingienne aux dernières années du XII siècle', *Bulletin Monumental*, 1929. See also the publications of the University of Poitiers now in progress, *Inscriptions de la France médiévale 750–1300*.

8. For an analysis of pre-Carolingian initial letters, see Nordenfalk, *Die spätantiken Zierbuchstaben*, 1970. Many are also reproduced in Zimmermann, *Vorkarolingische Miniaturen*, 1916.

9. For examples see A. E. Lowe, *Codices Latini Antiquiores*, for refs. see Ch. 5, note 1.

10. See Zimmermann, op.cit., for reproductions.

11. Professor T. J. Brown suggests eastern Scotland as a probable origin for the *Book of Kells* in his Jarrow Lecture, 1971.

12. Reproduced in H. Dembowski, *Initium Sancti Evangeli*, tafel 4.

OPPOSITE ABOVE **64** A detail from the *Book of Kells*. Eighth/ninth century. Dublin, Trinity College.

OPPOSITE LEFT **65** A page from a Sacramentary. Probably eighth century. St Gallen, Stiftsbibliothek, cod. 348.

OPPOSITE RIGHT **66** The opening words of the Gospel of St John. Possibly written in Brittany. Paris, Bibliothèque Nationale, ms nouv. acq. lat. 1587.

13. See J. J. G. Alexander, *Insular Manuscripts*, 1978. The dates given in my text are taken from this book.

14. Early Merovingian charters show a tendency to write the opening words of the text slightly larger than the rest, but diminishing in size towards the end of the line (e.g. the Charter of Clovis II of 654). This tendency is accentuated in the Charters of Charlemagne, e.g. those of 775 and 777; see *Chartae Latinae Antiquiores*, vols. XII and XIII.

15. The book-hand of these books is usually called Insular majuscule in distinction to the less formal Insular minuscule text-hand.

16. For Irish inscriptions see R. A. S. Macalister, *Corpus Inscriptionum Insularum Celticarum*, 1945, 1949.

17. For inscriptions in Scotland see Romilly Allen and J. Anderson, *Early Christian Monuments of Scotland*, 1903. Later ones may be relevant, see p. 17. See also J. Stuart, *Sculpted Stones of Scotland*, 1856.

18. For runes in Britain see R. I. Page, *An Introduction to English Runes*, 1973. There was certainly an interest in different alphabets; they are shown also in manuscripts such as British

Library Cotton ms Domitian A.IX and St John's College, Oxford, ms 17. These are later but probably preserve earlier material. Other exotic alphabets such as 'Chaldean' are included. It is relevant to remember that the runes on the Ruthwell Cross transcribe lines from the great Anglo-Saxon poem the 'Dream of the Rood'. Vernacular poetry had also reached creative maturity.

19. See note 9.

20. See Nash Williams, *Early Christian Monuments of Wales*, 1950.

21. For a discussion of unusual forms of M see Appendix 1.

22. For Anglo-Saxon inscriptions see E. Okasha, 'Handlist of Anglo-Saxon Non-Runic Inscriptions', *Transactions of the Cambridge Bibliographical Society*, vol. IV, pt V, 1971.

23. By Peter Meyer in the Urs Graf facsimile of the *Book of Kells*, vol. III, p. 49.

24. The inscription is in Sta Maria Antiqua in the Roman Forum.

25. Seen on folio 183r. See facsimile reproduction.

The Carolingian Renaissance

In AD 800 Charles the Great, Charlemagne, was crowned emperor by the Pope in St. Peter's, successor to Constantine and to all the Roman emperors, whose title had lapsed in the West in 476. Charles had succeeded his father Pepin who, as Mayor of the Palace, replaced the last of the Merovingian kings and who became ruler of the Franks, in name as well as in fact, in 750. Charles reigned first with his brother and then, after 771, as sole king. He, and before him his father Pepin, had invaded Italy in response to papal calls for help and protection from the Lombard kings, who in 752 captured Ravenna, the last Italian outpost of the Byzantine empire, and who persistently threatened the independence of the Pope. Whether the crowning in St. Peter's was desired or expected by Charles is disputed,[1] but certainly his deliberate revival of classical letter-forms suggests that he saw himself as consciously reviving the Roman order. The epitaph for Pope Hadrian I (Fig. 67), inscribed at Tours on Charles's personal commission five years before his coronation, is carved in Roman capitals, which were not at that time a current type of letter. It can be seen today in the atrium of St. Peter's, though unfortunately it is too high to distinguish clearly. It was moved from the old basilica.

This change in lettering introduced by the Carolingian emperors is dramatic. After the freedom and invention of the Insular and, to a lesser degree, the Merovingian artists, we have a return to order and tradition. For the earlier artists, the past was a quarry from which they could take ideas and use them for their own ends. Now the Roman idea is revived as the prototype of civilization. Lettering provides a particularly symbolic and clear-cut illustration of the nature of this new attitude.

To a large extent, Charles was personally responsible for the Carolingian Renaissance. He attracted scholars into his service, among them Alcuin of York, and promoted the revival of education and learning and the reform of the liturgy. He found many divergent local practices and sent to Rome for authoritative texts and saw that these were copied and distributed. There was a very great increase in the copying of books—most of the texts of Latin authors which we have now have been preserved in Carolingian manuscripts. With all this went the evolution of the new minuscule to supersede the many local styles of book-script current in different centres in Europe, and here too the impetus was towards the formation of a more uniform, clearer script. Early versions were produced in the Monastery of Corbie, and experimental versions in other monasteries in the late eighth century, but the purest examples of the new Carolingian minuscule were written at Tours, where Alcuin was Abbot 797–804 (Fig. 68). This lucid and practical script gradually superseded all others and formed the basis from which medieval book- and charter-hands developed. It was revived at the Renaissance to form the model for lower-case type design.

The Carolingian minuscule was a new creation: those who developed it based themselves partly on the late Roman half uncial (Fig. 35), rejecting the other hands, notably uncial, which must have been found in the

RIGHT 67 The epitaph of Pope Hadrian I, commissioned by Charlemagne and made in France in 795. A deliberate revival of Roman capitals, forms which had been in abeyance since the Roman empire. Rome, St Peter's.

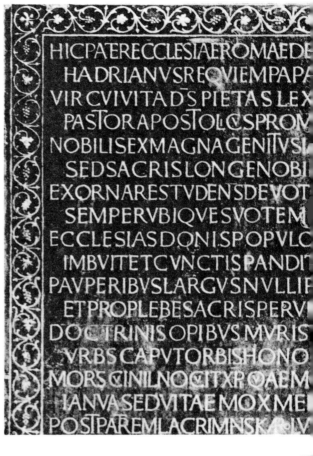

```
HICPAERECCLESIAEROMAEDE
HADRIANVSREQVIEMPAPA
VIRCVIVITADSPIETASLEX
PASTORAPOSTOLCSPROM
NOBILISEXMAGNAGENITVSI
SEDSACRISLONGENOBI
EXORNARESTVDENSDEVOT
SEMPERVBIQVESVOTEM
ECCLESIASDONISPOPVLO
IMBVITETCVNCTISPANDIT
PAVPERIBVSLARGVSNVLLIF
ETPROPLEBESACRISPERV
DOCTRINISOPIBVSMVRIS
VRBSCAPVTORBISHONO
MORSCINILNOCCITXRQAEM
IANVASEDVITAEMOXME
POSTPAREMLACRIMNSKA LV
```

ABOVE 68 Carolingian minuscule. A detail from the Grandval Bible, written at Tours c.840. London, British Library, Add. ms 10546.

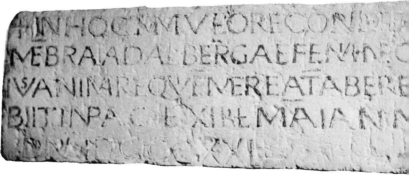

LEFT 69 The epitaph of Adelberga. The letters are leaded, possibly in imitation of metalled Roman inscriptions. c.840. Tours, Museum of the Archaeological Society of Touraine.

LEFT 70 An inscription of the time of Pope Leo III, 795–816. An example of the more modest style of Carolingian inscription. East Berlin, Staatliche Museen.

ABOVE 71 Incipit page from the Lorsch Gospels. Note the curled terminations to some letters. Early ninth century. Rumania, Alba Julia.

manuscripts which were being copied; or rather, the other hands, that is rustic and uncial, were taken, but as models for rubrics and titling, and only in exceptional cases was uncial used as a text hand. The Roman capital they must have known both from manuscripts[2] and from inscriptions. It was the second that they chose to take as a model.

There must have been inscriptions visible in France and throughout Italy, and collections of such inscriptions were made for the benefit of pilgrims and travellers to Rome in the seventh century by an Anglo-Saxon, and in the ninth by a Frank; both were much copied. These collections were primarily of Christian texts, but no doubt also drew attention to classical inscriptions, and a manuscript now in the Burgerbibliothek in Berne, ms 250, includes an alphabet which has obviously been copied from an inscription: the letters are very different from the pen capitals, usually quite rough, found in manuscripts of the sixth and seventh centuries.

The surviving Carolingian inscriptions are predominantly connected with the royal family. Most interesting perhaps is the epitaph of Adelberga at Tours of 840 (Fig. 69). The lettering is lead-filled, perhaps in emulation of Roman triumphal arches. In S. Ambrogio in Milan are the epitaphs of Charles's son Pipin, and grandson Bernard, both kings of Italy; they died respectively in 810 and 818. Both inscriptions appear to be by the same hand in very pure and sensitive lettering. More spacious and grander are the epitaphs of the Emperor Louis II (d. 875) and that of Archbishop Anspert (d. 882) also in S. Ambrogio. In the latter, though the letter-forms are classical, many very un-Roman ligatures have been introduced. Most beautiful is the inscription of Demetrius *superista* of 893 in the Villa Albani in Rome. In fact, the classical revival in epigraphy had more lasting influence in Rome, where it was taken up in the tenth century as part of the idea of Rome, the eternal city, than it did in the north.[3] Carolingian inscriptions in the classical style are in fact rare (Fig. 70).

In manuscripts the evolution is different, and there was a period of experiment. The earliest Carolingian books were produced at the royal court, and the school is sometimes known as the Ada school from the half-sister of Charles who commissioned a manuscript now

in Trier. Here the letters are wide and classical in form, but built up in outline pen-strokes like Merovingian letters and with great differentiation between thick and thin. Two other manuscripts of this group, the Godescalc Gospels (named after the scribe who wrote the book for Charles) and the Lorsch Gospels (now divided between Alba Julia in Rumania and the Vatican) (Fig. 71) have capitals with curled, bifurcated terminations. These might have been copied from Filocalian inscriptions seen in Rome, or later examples in the same tradition, or perhaps from a manuscript such as that now in Wolfenbüttel[3] which shows titling with curly serifs. Certainly there were earlier manuscripts from Italy, and probably Syria, available in the library of Charles's scriptorium at Aachen from which his scribes copied. It is interesting to speculate whether they thought that these curled serifs were the authentic Christian-Roman tradition.

Soon, however, they changed to classical inscriptional models for their capitals. The very beautiful Carolingian letter, which became a standard part of their repertory, does not exist in any surviving Roman manuscript, nor does any letter remotely similar. Its adoption seems to have been due to the scribe Berctaudus, and the finest examples were produced at Metz and Tours (Fig. 73). The most sumptuous were drawn in gold, often outlined in red. The proportions are quite near to the Roman monumental letter 25:2:1 or 34:3:1. and the forms are very pure. Serifs are short, often hair-line and unbracketed, though the stem may curve slightly towards its termination. The apex of A is usually serifed and the bowl of P open. Most beautiful, in my opinion, is the spacing, wide and open, often on a page bare of ornament and empty; or as in the Grandval-Moutier Bible, in ordered rows on a simple strip background.

Letters are also often used as the constituents of grand compositions—as in Insular manuscripts, but with a completely different feeling. The Insular pages are self-subsistent abstract creations, expressions of the power of the revealed words of God in a turbulent and alien-

OPPOSITE **72** Incipit page from the Gospel of St Matthew. *c*.800. London, British Library, Harley ms 2788, f. 14.

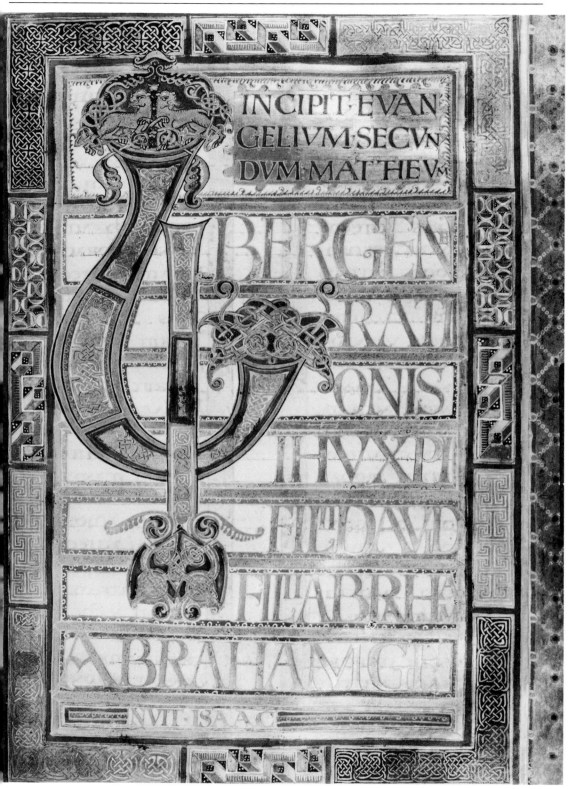

ated world. The Carolingian compositions (though not their component letters), are much more varied, not so dominated by the size and organic energy of the great initials. The Carolingians turned to the Roman tradition of order, reason and security, but it was a nostalgic turning to a world only half-known. Particularly impressive are the great pages in the British Library manuscript Harley 2788 (Fig. 72), the Paris manuscript lat.9387 and the Gospels of St. Médard (Bibliothèque Nationale ms lat.8850): these are three-dimensional in a different way, not swelling forms on the surface of the page, but a seeing through the forms on the page into an awareness of things behind, perhaps of the historic past, mysterious and half-known; colour is very important, predominantly purple and gold. It is the combination of the monumental classical letter with this romantic sense which gives these compositions a unique quality. Less haunted are the pages in the Metz Gospels with their inspired evangelist-letter-symbols and beautifully articulated letter-forms (Fig. 73).

This school lasted for hardly a century, but it produced a remarkable number of magnificent manuscripts in which one is aware of two poles, the romantic vision and the lucid classical ideal, as well as a wide range of letter-styles. The romantic tendency appears in later manuscripts in rich patterning and exuberant backgrounds, as in the Bible of San Callisto with its wonderful miniatures (Fig. 74), and in the *Codex Aureus* of St. Emmeran in Munich, the latter unfortunately so rich in gold floriation on purple that it is almost impossible to reproduce. The classic side is best represented by the book known as the second Bible of Charles the Bald. This is one of the masterpieces of lettering, its only form of decoration (Fig. 76). There are whole pages of pure roman capitals; the text is in Carolingian minuscule, with rubrics in spacious uncial; finally there are the great initials. These have stems patterned with interlace, the ends terminated with dragons or foliage. With these there are letters belonging to a new sort of alphabet characterized by its arrow-head terminations. These are often on a grid background; proportions and construction appear geometric, but this is not borne out by analysis (Fig. 75). The initials obviously owe much to Insular prototypes, but the feeling is again different. These initials are civilized and

static, concepts of an ordered world—or at least of a world striving towards order. These last three manuscripts were made for the Emperor Charles the Bald, called by a contemporary 'the philosopher king of the new Athens', a great patron of the arts and a ruthless politician. He was the last of the great Carolingian emperors; eleven years after his death in 877 the Carolingian empire disintegrated.

There were other patrons beside the emperors, and other centres besides the court: Bishop Ebbo at Rheims, the Abbots Adalhard and Vivian at Tours, Bishop Drogo at Metz, and working also for Charles the Bald, monks in the Monastery of St. Amand, where his second Bible was probably made. The Sacramentary of Drogo has letters entwined in foliage and enclosing biblical scenes, the first important examples of historiated initials—though again the idea occurs first in Insular manuscripts.[5] In the Bible of San Callisto branched serifs are reintroduced, now usually trefoil. Great interlace terminations are developed, and also a curious form of stem, ending in a sort of handle.[6] Occasionally one finds letters which are evenline and sanserif as in the Cologne Library ms 210 (Fig. 77), or in the outline letters superimposed on acrostics as in a manuscript at Bern (Bürgerbibliothek ms 212). Sanserif letters keep recurring over the centuries, but the idea was not taken up consistently till the late eighteenth century.

In all, or much, of this Carolingian versatility one sees the background of Insular invention. Its transformation reflects the genesis of the ninth-century Renaissance. Pepin and Charles built on the missionary work of the Anglo-Saxons Willibald and Boniface in south and east Germany, and inherited and took over their interest in reform within the Church, and in close contacts with Rome. In the same way Charles built on Anglo-Saxon scholarship; Alcuin was not the only Englishman to be invited; other scholars came to live and work in France and brought with them manuscripts; monasteries of Insular foundation, such as Echternach and Fulda, pioneered the revival of monasticism.[7]

The diplomas of the Carolingians are also fascinating pieces of lettering. The tortuous Merovingian script (Fig. 48), not unlike the book script of Luxeuil, is replaced after about 850 by Carolingian minuscule, but the delight-

73 Incipit page of the Gospel of St Luke from the Metz Gospels. Paris, Bibliothèque Nationale, ms lat. 9388.

74 Incipit page of the Gospel of St Luke. The Bible of San Callisto. c.870. Rome, San Paolo fuori le Mura.

75 A page showing the word 'Vere' from a sacramentary belonging to the same Franco-Saxon school of illumination as the second Bible of Charles the Bald. The squared, arrow-terminated letters are peculiar to this school; the initial shows Insular influence. Second half of the ninth century. Paris, Bibliothèque Nationale, ms lat. 2290, f. 19.

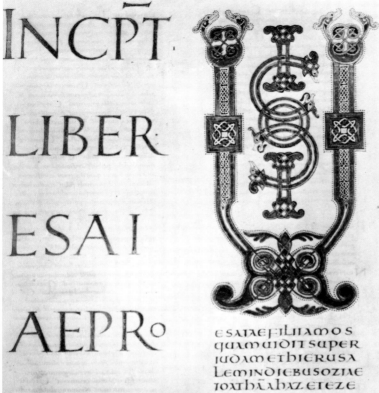

76 The opening page of Isaiah. From the second Bible of Charles the Bald. 870. Paris, Bibliothèque Nationale, ms lat. 2, f.146.

77 Collectio Canonum. Eighth century. Cologne, Cathedral Library, cod. 210, f. 2r.

ABOVE LEFT **78** The epitaph of a Lombard Duke of Benevento. Ninth century. Benevento Cathedral.

ABOVE RIGHT **79** The heading of St Paul's First Epistle to the Thessalonians. An example of uninhibited vitality. Probably ninth century. London, British Library, Harley ms. 1772.

80 An initial from a manuscript written in St Gallen, where the Insular tradition was more persistent than elsewhere. Vienna, Gottwig ms 1.

ful passages where the scribe enjoyed himself —the heading and the signature—are developed: they grow more distinctive and proliferate into swirls and curls, inaugurating an artistic tradition in charter embellishment which lasted for centuries.

The Carolingian intervention in Italy relieved the papacy from the devastating menace of the Lombards and in so doing promoted a cultural revival in Rome. The ninth-century Popes Leo III, Paschal I and Gregory IV commissioned apse mosaics with long inscriptions. The lettering, like the mosaic figures above, has a certain fragile insecurity and beauty. The comparatively spacious style still found at S. Lorenzo (Fig. 38) and S. Agnese is replaced by lettering which is rather crowded and irregular but not insensitive.[8]

South of Rome the Lombards still ruled in the duchies of Benevento and Capua. The epi-taphs of the Beneventan dukes were walled into the façade of the Cathedral; they are remarkable for their competence: the standard of skill is far higher than that of the contemporary papal epitaphs in Rome. They also use unclassical forms in a regular format which presages the Romanesque: round G, uncial E, M, H and U, and Q with an internal tail. These forms had long been current in short, modest inscriptions in the early Christian tradition; here they are used on long, ducal epitaphs in verse (Fig. 78).

The Carolingian reform did not penetrate to all monasteries, nor did it obliterate other influences everywhere. Insular influence continued, as in Fig. 80, and indeed is very apparent in grand Carolingian manuscripts in the initials. It is interesting also to be able to chronicle a wilder strain, as in the energetic disorder of Fig. 79.

Notes

1. See R. Folz, *The Coronation of Charlemagne* (London, 1974).

2. Headings in rough capitals, sometimes more or less rustic, sometimes more square, occur fairly frequently in pre-Carolingian manuscripts (see Lowe, *Codices Latini Antiquiores*).

3. Tenth-century inscriptions in the City of Rome are distinctive in style, generously spaced, and fairly orthodox roman in letter-form, for example the epitaphs in San Lorenzo fuori le Mura of Landolf, son of Theodora Senatrix, and of John, consul et dux, who died in 963. Reproduced in Silvagni, *Monumenta Epigrafica Christiana*, 1943.

4. *Corpus Agrimensorum Romanorum*, see note 7 to Ch. 3.

5. The historiated initial letter goes back to Insular examples such as British Library Cotton ms Vespasian A.1; see J. J. G. Alexander, *The Decorated Letter*, p. 10, pl. 111.

6. An example is reproduced in Van Moé, *Illuminated Initials in Medieval Manuscripts*, pl. 76, 1950.

7. See W. Levison, *England and the Continent in the Eighth Century*, 1946.

8. In the Churches of Santa Prassede, San Marco, Santa Maria in Domnica, Santa Cecilia. See W. Oakeshott, *The Mosaics of Rome*, 1967, for reproductions of the lettering on mosaics—often however only shown in part.

Starting Again:
The Mid-Tenth to the
Mid-Eleventh Century

The Carolingian empire was short-lived. By 888 it had finally disintegrated. It might seem like an ineffective interlude; yet if it had not happened, history would have been different. It was to the Carolingian example and achievement that men looked when, slowly, they started to rebuild European civilization after the disasters of the tenth century.

The devastation had begun already in the preceding century, from north, east and south. From the north came the Vikings. Their raids had already started in the reign of Charlemagne. In 793 they appeared off the coast of Northumberland and raided Lindisfarne; by 835 their armies were wintering in Ireland, in France in 843, and in England in 851. They sailed up rivers—the Loire, the Seine, the Rhine, the Garonne—and established themselves in Dublin, Normandy and eastern England. Monasteries, with their riches derived from the gifts of kings and patrons, were prime targets. Great quantities of goldsmiths' work must have been broken up, and many books destroyed. The Insular legacy seems rich, but it must have been far richer.

Meanwhile, from 862 onwards the eastern lands of the Frankish empire were attacked by the Magyars, a heathen people coming, like the Huns, from Central Asia. They were not finally defeated until 955.

In the south the great Arab expansion had conquered and settled all the southern Mediterranean: Syria, Palestine and Egypt in 633–52 and north Africa in 669–96; Spain was invaded in 711. It was halted at the Pyrenees by Charles Martel at the Battle of Poitiers in 732. Europe

was thus cut off from the eastern civilization, particularly in Egypt and Alexandria, which had provided inspiration for monasticism and for art. The sea was controlled by the Arabs, and pirates made devastating raids on the coast of southern France and Italy. They conquered Sicily in 827–78 and established private settlements at Fréjus in Provence and on the Garigliano, south of Rome. In 846 they attacked Rome itself and sacked St. Peter's, which was then outside the city walls. It was only after this sack that protecting walls were built. The Carolingian emperors were unable to cope and life in Europe contracted into local units of defence.

The recovery started from different centres,

OPPOSITE LEFT 81 Mozarabic manuscript of Beatus's commentary on the Apocalypse, written at the monastery of Silos. This is a late example of this series of manuscripts which goes back to the tenth century, but the style of lettering is consistent, growing more accomplished in the later manuscripts. Before 1109. London, British Library, Add. ms 11695.

OPPOSITE TOP RIGHT 82 An inscription dated 1004. This very mannered style of titling is typical of Spain. Granada, Granada Museum.

OPPOSITE BOTTOM RIGHT 83 An initial from a Mozarabic Antiphonal. The page shows the neat Visigothic script contrasting with the blowzy initials. Eleventh/twelfth century. London, British Library, Add. ms 30850, f. 6.

EPT PROLOGVS

BR·SCDIDECTA

TSINALOGA QVID

ROPRIE DICANTVR

TQVIS INQVA

ABITOR·ESSE

HOSETVRPLE

SSIME·lECTOR

NOS CAS

84 A detail of the carved inscription on the lintel above the door of the Church of St-Genis-des-Fontaines, Roussillon. 1020–1.

85 An Italian manuscript written in Beneventan script. The composition is, like Spanish examples, individual and lively, and it may indeed have been written in Spain. Tenth century. London, British Library, Add. ms 16413.

in Spain, England and Germany, in the mid-tenth century.

Southern and central Spain were ruled by Moslem Moors. Christian kings had hardly begun the long process of reconquest from their retreat in the extreme north-west in the Asturias, but the Moors were tolerant and highly civilized and Mozarabic art, that is, the art of Christians living under their rule, flourished. The most important manuscripts of this period are illustrations to the *Commentary on the Apocalypse* written by Beatus of Liebana in the eighth century. The earliest surviving example was written in about 920–30. The series continued into the twelfth century, retaining a remarkable coherence of style. Each chapter is prefaced by rubrics, that is by pen-drawn capital letters, extending for about a quarter or half a column on a double-column page. The lettering is mannered and consistent, growing more skilled in later examples (Fig. 81). Characteristic are square C and G. In some manuscripts (for instance British Library Add.ms 30850) the letter-stroke is continued horizontally on B, square C, D, E, F, L, M, N and R, and on the apex of A, and then serifed—in contrast to the vertical prolongations of Lombard and Merovingian letters. Narrow M with its short-ranging v (sometimes given an extension from the v-tip to the base-line), and pointed O and Q are noticeable. I and L, and sometimes P and T, are taller than the basic height. B can have separated bowls. There are occasional ligatures and smaller inserted letters.

The extremely compressed and mannered style of contemporary inscriptions is clearly related to these Mozarabic manuscripts. The complete separation of the upper bowl of B and R from the lower bowl and leg is now even more exaggerated (Fig. 82). At Elne (Pyrénées Orientales), Fig. 96, a curved form of A, angular S and waisted O are also used. This similarity between carved and drawn letters is rare: so often in the Middle Ages the two seem unrelated, as if the different craftsmen never met. Often, perhaps, they never did.

Some manuscripts include other sorts of letter, some outlined and infilled or decorated with dots, recalling Insular letters. Some are even-line and sanserif, or with very slight wedge-serifs. Most remarkable are the initials: flamboyant and untidy, they make the titling look almost prim.

These blowzy initials are related to contemporary manuscripts in the south of France and Italy. One is reminded that Aquitaine was more closely connected with Spain than with Paris. The County of Barcelona, the Spanish March, had been part of Charlemagne's empire, and was not ruled by the Moors. Navarre had close links with Gascony, where one Beatus manuscript was illustrated at the Monastery of St. Sever (Bib.Nat.Lat. ms 8378).[1] In the tenth century one of the counts of Barcelona (descended from Wilfred the Hairy) 'preserved an easy-going aristocratic life in which conservatism was tempered with certain colonial largeness and freedom'.[2] This seems to suggest the right background. Typical of the exuberance of these initials, combined with a loose and rather wild sense of form, are the letters in the British Library manuscripts Add. mss 30844 and 30850 (Fig. 83). The British Library Add.ms 16413 is written in the Beneventan script, but possibly in Spain; it has something of the same freedom and force (Fig. 85).

The important inscription on the lintel of St. Genis des Fontaines, 1020–1 (Fig. 84) in Rousillon, belongs much more to this scene than to the more ordered inscriptions of the Romanesque period. R and B are similar to these letters in Spanish inscriptions: the G with a pointed upper curve is more difficult to parallel, though it is not unlike pointed O and Q.

In England the story is quite different. The British Isles took the full force of the Viking invasions. The first raids were on Northumbria and Ireland; by the mid-ninth century a Viking king was ruling from Dublin. The Viking raids finally ended the Northumbrian Renaissance and destroyed the fruitful contacts between the Irish and the Saxons. Many of the most important later Insular manuscripts were made in southern monasteries but by the end of the ninth century these too had disappeared. Revival did not come till the next century, then it came from Wessex. The Danish conquest of England was at last stemmed when the Danes were defeated by King Alfred, and at the Treaty of Wedmore in 878, the Danish king accepted baptism. Alfred was now able to give some attention to the revival of learning, and he turned to the Continent, inviting the monk Grimbald to come from the Abbey of St. Bertin to help in the revival of monastic life, which had virtually come to an end in England. The

contacts with Carolingian culture were maintained under Alfred's descendants Edward the Elder (901–25), Athelstan (925–40), and Edgar (959–75). While the Carolingian empire disintegrated, England became once more a centre for learning and art. New monasteries, such as New Minster in Winchester, were founded, and art was promoted by Ethelwold (908?–84), Bishop of Winchester, and Dunstan (c. 909–88), Archbishop of Canterbury. Dunstan was indeed himself a famous craftsman. England became famous for much prized goldsmiths' work and embroidery; and though, sadly, this has almost all disappeared, we still have many manuscripts dating from this second golden age, of which the most famous come from Winchester.

In lettering, the English school built on Carolingian foundations. Their minuscule (which was the exemplar used by Edward Johnston when he revived calligraphy at the beginning of this century) is a version of Carolingian minuscule: very clear and open, more static and easier to read. Anglo-Saxon capitals are roman, but the artists have moved away from the inscriptional model; indeed, it is unlikely that they would have known Roman inscriptions. Some of the most beautiful capitals are those in the Benedictional of St Ethelwold, c. 963–84 (Fig. 86). These are drawn letters moving with exquisite sensibility from a generous width of stroke to a very fine line, curving slightly at the termination of the stem to give a slight movement to the outline, finished off with a thin line drawn at right angles across the ends. Unroman are the A with a line across the apex, R with a straight leg tapering to a sharp point, and S with a stronger, more pronounced curve. The contrast between thick and thin is greater, but then, unlike the Carolingian letter, this is essentially a drawn letter.

Unlike their Insular predecessors, letters were not the primary vehicle of expression for the artists of the Winchester school: their pictorial paintings and drawings are more important. Nevertheless, their lettering is varied, original and remarkable. They drew characteristic initials, in two different styles.[3] Some are composed of foliage and creatures, sometimes quite loosely, as in the Junius and Bosworth Psalters (Fig. 88). One can see that the ideas relate to late Insular letters, but these are freer, less dynamic, more relaxed. Some in the

larger, grander books are stiffened with structural panels, and may be framed in one of the leafy borders typical of the Winchester school. These and the rare examples where the limbs of letters are actually made of human figures[4] are early examples of a great series of Romanesque initials, which are interesting as drawing and illustration, but not as letter-structure.

Characteristically Anglo-Saxon are the second style of initial, drawings in which fine and heavy lines are contrasted and interwoven in a complex of fronds, animal heads and interlace (Fig. 87). The multiplication and breaking-up of the line anticipates the Broken Gothic capital (p. 139). The influence of the Insular line is again apparent, but it is now an element in a different sort of pattern. With both these styles of initial we often get a new style of titling, no longer related to Roman inscriptions but much nearer to the sort of experiment which was happening in contemporary inscriptions (see Ch. 7, Fig. 102). The first line is often large; letters are compressed in proportion; square C is very noticeable, G also is sometimes square, and S angular, the apex of A is flat and the v of M short. The contrast between thick and thin is strong, but in some letters the horizontal stroke, which is thin in the Roman canon, is wide, so that the letter is almost even-line—an idea which was later developed. The Bosworth Psalter is an important example of this style (Fig. 88); its continuing influence is seen in the Arundel Psalter (c. 1080).

There was one more new beginning in the tenth century. In 936, Otto, Duke of Saxony, as crowned King of Germany, and in 962 in

OPPOSITE ABOVE **86** A page from the Benedictional of St Ethelwold. This elegant lettering is typically Anglo-Saxon. London, British Library, Add. ms 49598.

OPPOSITE LEFT **87** One type of Anglo-Saxon initial and titling. An early eleventh-century manuscript from Canterbury. Oxford, Bodleian Library, ms Auct. F. 1.15, f. 5.

OPPOSITE RIGHT **88** The Bosworth Psalter, showing the other type of typically Anglo-Saxon initial, coloured, with elaborate fronds and interlace. c.980. London, British Library, Add. ms 37517.

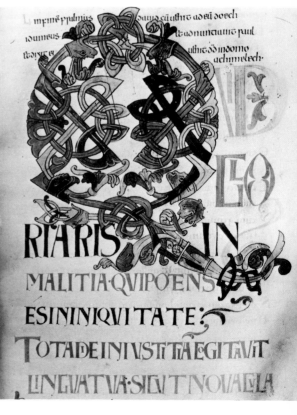

ABOVE LEFT **89** A page from the Gospels of Abbess Uta of Niedermünster, Regensburg, 1002–8. This lettering is typical of the Ottonian style. Munich, Staatsbibliothek, clm. 13601.

ABOVE RIGHT **90** The Sacramentary of the Emperor Henry II, 1002–8. Munich, Staatsbibliothek, clm. 4456.

OPPOSITE TOP LEFT **91** The opening page of a manuscript of Cassiodorus' treatise on the Psalms. An Ottonian incipit design. Tenth century. Paris, Bibliothèque Nationale, ms lat. 2196.

OPPOSITE TOP RIGHT **92** A more elaborate incipit composition from the Abbey of Senones (then within the Ottonian Empire). Paris, Bibliothèque Nationale, ms lat. 9392.

OPPOSITE CENTRE **93** A detail of the inscription on the pulpit given by the Emperor Henry II (1014–24) to Aachen Cathedral.

OPPOSITE BELOW **94** The inscription of Archbishop Willigis, 975–1011, on the bronze door of Mainz Cathedral.

95 An epitaph of 979, characteristic of the vigorous style found in North Italy, from a squeeze. Verona, Museo Civico, Castelvecchio.

Rome, as Emperor. Under his dynasty—Otto II, Otto III and Henry II—art was again revived. Louis the Pious, the son of Charlemagne, had divided his empire between his three sons; with the break-up of the Carolingian empire, this became permanent. France was divided from Germany, and between them was the Middle Kingdom, the disputed lands in European history: the Netherlands, Alsace and Lorraine, Switzerland and Italy. Otto was ruler of Germany and most of the Middle Kingdom, but France was now separate.

Ottonian art started, like the Ottonian empire, from the Carolingian example. Capitals are Roman, but with a difference: now they are rather heavy, with slightly concave stems ending in wedge-shaped serifs. Certain non-roman forms are introduced: some are uncial, such as D, E, U and M; others—A with broken cross-bar, square C, Q with an interior tail and L with a curved horizontal limb—show that the artist is again turning to earlier sources to find variations to suit changing taste (Fig. 89). These are forms found in Insular manuscripts or in inscriptions (see Charts 2 and 3). There

are still fine incipit pages: dignified and balanced, as in the Morgan ms 755 in New York, or richly embroidered, as in the Gospels made for Bishop Bernward of Hildesheim (992–1022); himself, like Archbishop Dunstan of Canterbury, a distinguished artist. But the visionary quality which is so strong in the pictorial creations of this school (for instance in the Gospels made at Reichenau, Munich, cod.lat.4453, with its paintings of heaven-seeing evangelists) is absent from these pages. Gone is the positive space and the great architectural background of the early Carolingian pages. Instead, we get richly-coloured forms, often single forms which fill the page (Fig. 91), frequently against a background embroidered with pattern (Fig. 92). Or the letters may be woven into the texture of the page pattern, as in the Sacramentary of Henry II (cod.4456), now in Munich (Fig. 90), thus continuing the tradition of later Carolingian manuscripts such as the Bible of San Callisto (see Ch. 5, Fig. 74) and the *Codex Aureus* of St. Emmeran. We see again the tendency that, as artists become more able, or more interested, to express themselves

through representational painting, so lettering becomes less and less important as a medium through which imagination can be expressed. Instead of the words of the Gospel, it is now illustration of their content which evokes the highest inspiration.

Insular work in precious metal was looted by the Vikings, and the arts for which Anglo-Saxon England was famous, goldsmiths' work and embroidery, were dispersed or destroyed by the Normans,[5] fortunately some Ottonian work survives. Figure 93 shows the lettering on the pulpit given by the Emperor Henry II to Aachen Cathedral. Almost baroque in contrast is that embroidered round the hem of the mantle made for the same emperor, now in Bamberg Cathedral Treasury.

During the Ottonian period the standard of craftsmanship in the execution of inscribed lettering improved. The inscription commemorating Archbishop Willigis (975–1011) incised in bronze on the door of the Cathedral at Mainz is sensitive and classic in feeling, though it now includes ligatures and square C (Fig. 94). The painted lettering below the frescoes at Oberzell in Reichenau on Lake Constance, the monastery where the emperors kept their chancery, is also classic and accomplished. This revival in art and lettering, like the Carolingian revival, was inspired and patronized by the Imperial Court and high ecclesiastics, and monasteries were the great centres where the work was done.

Otto III (983–1002), whose mother was a Byzantine princess, was only three when he succeeded, and died at the age of twenty one. He was more at home in Rome than in Germany, and took over the idea of *renovatio*, of the revival of the idea of the City of Rome as capital of the Christian empire. In this he was taking over, transforming and enlarging the idea of the local Roman aristocracy, expressed in their inscriptions, and other ways. The Roman inscriptions of the tenth century are spacious and remarkably classical in the forms used. They are very different from contemporary work from north Italy, which is strong, with a liking for square letter-forms, and rather crude (Fig. 95); different again from the more modest style which replaced the short-lived Carolingian revival (see Ch. 5, Fig. 70). In Italy, and particularly in Rome, the idea of classical revival in the historic Roman sense is endemic. In south Italy the style is different again and more compressed (see Ch. 5, Fig. 78). Italy was part of the Ottonian empire, but the long-standing cleavage between the north, where the cities were now fast developing into lively independent units, and the south, which had been divided between duchies ruled by the Lombard invaders, with Byzantine rule surviving in the toe and heel, subsisted. The cleavage was about to be accentuated by the Norman take-over.

Notes

1. Illustrated in Van Moé, *Illuminated Initials in Medieval Manuscripts*, 1950, the letter A.

2. R. Southern, *The Making of the Middle Ages*, p. 119, 1953.

3. See F. Wormald for a discussion of these letters in 'Decorated Initials in English Manuscripts 900 to 1100', *Archeologica* XCI, 1945.

4. See Ch. 5, note 3.

5. C. R. Dodwell, *Anglo-Saxon Art: the Literary Perspective*, 1982.

A Time of Experiment:
The Romanesque

When did the Romanesque period begin and when did it end? To a large extent the name and the dates are arbitrary, the invention of the art historian trying to make sense and order out of his material. Undoubtedly we eventually arrive at a new style with Gothic. In lettering, though one can recognize the products of the late eleventh and twelfth centuries, it is not really relevant to write about a style, because the characteristic of the period is that it was a time of experiment. It was a time of testing and trying out alternatives in all the elements which contribute to the make-up of a letter: proportion of width to height; stress, that is the degree of contrast in line-width, and the angle, and the consistency of its incidence; terminations, that is sanserif, bracketed serif, hairline serif, long or short, curly or straight. Finally the infinite possibilities in formal variation, in the shape and construction of the letter. The alternatives here were particularly important in view of the wide range available to the Romanesque artist from the mixing of script and inscriptional styles, and the refining of such ideas provided by the lettering practitioners of previous centuries. And beyond all this there is the question of ways in which letters can be combined. The experimenting was not so drastic or so wide-ranging as that of the Insular artists, but it was more constructive; it resulted in a new type of letter: the Gothic.

In the mid-eleventh century people were starting to remake European civilization. The Roman empire was long disappeared; the Byzantine empire was separate and different and an outside influence. The barbarian peoples had had four centuries or so in which to mature. The inroads of the ninth- and tenth-century invaders had been stemmed or contained. Life was reasonably secure, trade was expanding, towns growing, and people were starting to travel, on pilgrimages, or further afield with the Crusades—the first Crusade was in 1096. Vernacular languages were evolving out of late Latin and the various Germanic tongues. The first *chansons de geste* like the *Song of Roland* were taking shape. Everywhere churches and cathedrals were being built or planned. Central government was becoming more effective, involving legal and administrative reforms. As these were developed in both secular and ecclesiastical organization,

OPPOSITE TOP LEFT **96** Inscription of 1069 from Elne (Pyrenées orientales) commemorating the consecration of the high altar of the Cathedral. The letter-forms, particularly R, are nearer to Spanish than to French examples.

OPPOSITE TOP RIGHT **97** Detail from an inscription on the façade of San Martino in Lucca of the time of Bishop Rangieri, 1111.

OPPOSITE CENTRE **98** A detail of the dedication inscription at Moissac, dated 1063.

OPPOSITE BELOW **99** The inscription on the marble pulpit in the Cathedral, Ravello, South Italy, showing the use of 'waisted' letter-forms. *c.*1130.

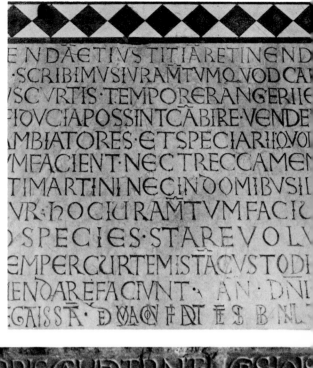

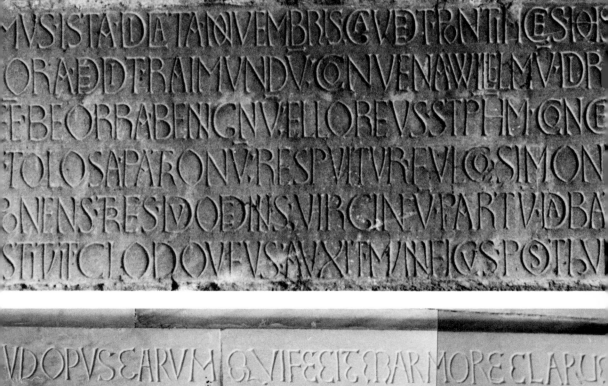

Church and State came into collision, leading to the Investiture controversy and the conflict between Henry II of England and Thomas à Becket. The collisions brought strife but they also stimulated thought and controversy. Art, culture, and new ideas were becoming accessible to a wider public, no longer centred on the royal court.

Monasteries were still the focal places for creative art and for lettering, but now there were increasing numbers. The great revival of monastic life stemmed from the Burgundian Abbey of Cluny, founded in 910, finally destroyed and demolished after the French Revolution. From Cluny monks went out all over Europe to reform old foundations or to start new houses. The monastic vocation was not now seen as a flight from the world but as 'the expression of the corporate religious needs of a whole community'. The Cluniac life offered not only the daily round of religious duties but 'the constant companionship of noble buildings, the solemnities of elaborate rite, the company of distinguished men, and that elevation and excitement of feeling which comes from the sense of being at once pioneers in the art of living and yet firmly established in the esteem and respect of the world.'[1] Monks were an integral and normal element in society.

It was membership of the Church which was now the common bond between the peoples of Europe. When the Carolingian empire disintegrated, Europe broke up into many more or less independent entities which eventually coalesced into the states of today. In the eleventh century France was the country where life was developing most rapidly, and it is in France that we find the most interesting and experimental lettering. But France was not a unity. There were differences between north and south, between the land where the word for 'yes' was 'oui' and the land where it was 'oc' (still today called Languedoc); Normandy was part of the Norman kingdom of England. In 1154 Henry, Count of Anjou, became King of England and, by his marriage, also Duke of Aquitaine, so incorporating a large part of France into his English kingdom. Culture was not so much national as local and international. The great Romanesque churches were built along the routes where pilgrims from many countries journeyed across Europe to Compostela, Rome and Jerusalem.

The Abbey Church of Cluny was rebuilt between 1088 and 1110. In these years and the succeeding decades were built the churches at Moissac, S. Sernin in Toulouse, Vézelay, Conques, Autun, St. Gilles du Gard and many other places in France. They were decorated with sculpture, and in many cases inscriptions were an integral part of this sculpture, most conspicuously on the façade at Conques. It was not only in France that great churches were built; they were also built in Germany, Spain and England, and in Italy at Modena, Cremona, S. Zeno in Verona, SS. Giovanni e Paolo in Rome, Bari, Ravello and elsewhere. Lettering was also added to these buildings: to doors, cloisters, pulpits, frescos and mosaics. Such inscriptions are an important part of the whole conception, telling the story, but also part of the pattern, as in the scenes of the Bayeux tapestry.

All this lettering is far more homogeneous and far more skilled than that of the previous century. There can be wide differences between inscriptions done about the same date, but these are differences within the same way of thinking: one craftsman, one feels, is more experimental than his fellow, rather than craftsmen working in two different partially evolved traditions, as one finds earlier. The starting point is the classical tradition in the modified form in which it appears in inscriptions such as that of Willigis (see Ch. 6, Fig. 94): that is, the lines are spaced with regularity and letter-forms are carved with precision, but there is no hint of a revival of classical letter-forms; on the contrary, the movement is away from the Roman norm. On the one hand we find essays in making unique combinations of letters, as we have found in earlier incipit pages, and in some early Christian inscriptions. On the other hand one can distinguish an impetus towards finding some new principle upon which a coherent alphabet can be constructed. It is to this latter end that one feels various forms are tried out, manipulated, often rejected. It is useful to look first at carved inscriptions such as those on the new buildings: they show us the sort of forms current in the eleventh and early twelfth centuries.

OPPOSITE **100** A stained-glass window at Augsburg, showing the prophets Daniel and Hosea. *c.*1100.

Italian examples are mostly simpler than contemporary French work, using fewer non-classical forms, fewer alternatives for the same letter, and fewer ligatures. In both cases the proportions of the letters are rather narrow, but the Italian spacing is wide, making a more open pattern. Good examples are the inscription on the Cathedral at Modena, a long verse piece dated 1063 on the outside of the Cathedral at Pisa, and one on the façade of San Martino at Lucca of 1111 (Fig. 97). Most of the non-classical letters are taken from the uncial alphabet.[2] The range at Modena is the simplest, including uncial Q, round G, R with a curved leg which joins the bowl but not the stem of the letter, and slightly pointed O. At Pisa uncial

ꝗ G R E ꝏ Ụ

forms of M, U and E are used, and also square C and square G with a final horizontal to its

Ⴀ Ꮐ

spur. At Lucca, E, H and U are uncial, and also D which, like the O, is pointed. This slightly

ꜧ Ꭷ

pointed O is the letter which all three inscriptions have in common. But as well as this pointed O it is noticeable that square forms— varieties of A with a bar on the apex and/or a broken cross-bar, and M with a short v and vertical sides— are current, none of them

Ā Ⴀ M

uncial letters. In the south, at Ravello (Fig. 99), there are 'waisted' forms of C, E, T, Q and O. These forms seem, apart from E, to be peculiar to this period and most common in Spain,

Ɛ Ƭ ꝺ

though found also in a Moissac manuscript (Bib.Nat.ms lat.252, Fig. 115). The waisted O is used also on a mosaic of 1150 in San Marco,

Venice: so although fairly rare, it is widely distributed.[3]

In France the forms are more or less within the same range. The dedication of 1063 at Moissac is a good example (Fig. 98): square C and G, pointed O, R with a curved leg and M with short-ranging v are used. Only Q and H are uncial. The cloister capitals here are interesting because the work of several different letter-carvers can be distinguished. On one we find another odd letter, M with a very short v with the vertex prolonged in a straight line.

ꟿ

This is found at Moissac, in Spain, and also in Greek mosaics, so perhaps it is Greek in origin.[4] Another capital has an inscription with many ligatures and inserted letters, and here we come to one of the areas of Romanesque inventive achievement. But first I should like to conclude this survey of the formal vocabulary current in the early Romanesque period. In stained glass and mosaic the taste for innovation does not seem to have been so strong. The lettering in Fig. 100 of c. 1100 from Augsburg is very close to the Willigis inscription of the previous century. The Venetian mosaic of c. 1200 (Fig. 101) includes pointed O, apex-serifed A and uncial E, but is remarkable for its wedge terminations which are more pronounced than in inscriptions. The inscriptions on the mosaic of S. Clemente are typically Roman in being more classical. In general the lettering artist seems to have had a fairly fluid formal vocabulary adaptable to the purposes which he chose.

One of these purposes was the making of complex unique combinations. This is seen in the dedication inscription of Abbot Ansquitil at Moissac of 1100, where the accumulation of ligatures in the first five lines contrasts with the spaced-out letters of the last five. Or again in the epitaph of Abbot Isarn in Marseilles of

OPPOSITE ABOVE **101** A detail of the mosaic inscription in the cupola of the atrium, San Marco, Venice. Mosaic designers seem to have been conservative in letter-design. c.1200.

OPPOSITE BELOW **102** The tomb of Abbott Isarn. 1048. Marseilles, Musée Borély.

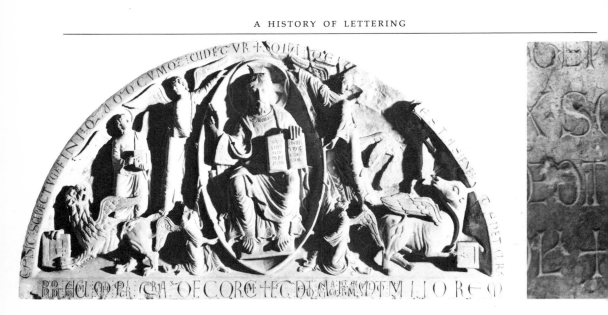

ABOVE **105** A detail from the opening page of the Book of Joshua. Eleventh century. London, British Library, Harley ms 4772.

LEFT **106** A modest dedicatory inscription particularly felicitous in the use of the variable letter-forms available in the twelfth century; now in the cloisters of the Cathedral at Amalfi.

FAR LEFT **103** The inscription on the tympanum from St-Bénigne, Dijon. A mature example of a typical Romanesque idea, the combination of letters into an intricately interwoven pattern. *c.*1120.

LEFT **104** A detail from a twelfth-century inscription from the Church of St-Théodore, Vienne, showing experiments in letter terminations and letter-forms.

BELOW **107** Letters woven into a pattern. The incipit page of the Gospel of St John. Aix-en-Provence, Municipal Library, ms 7.

1048 (Fig. 102), where the spaced-out lines come in the centre, between three lines above and below of compressed and ligatured letters (squared S is used here as well as square C). More complex and more subtle is the design of the inscription below the tympanum of St-Benigne, now in the Museum at Dijon (Fig. 103). At Beaucaire there is another brilliant example of *c.* 1180. This lettering is surely the counterpart of the wonderful elongated figures and intertwined creatures of Romanesque sculpture, as at Souillac, Vézelay and Beaulieu. It is an idea which is elaborated also in manuscripts. The Dijon inscription also shows changes in the construction of letters, particularly in terminations; some letters now end in curls instead of serifs: Fig. 104 shows a clear example; also Fig. 106. The incidence is irregular, some terminations being serifed, some pointed. Now, in the twelfth century, experiment has been carried a step further. The idea of the letter has become even more fluid, but not disordered; it is still, however, a long way from the Gothic norm.

The idea of forming letters into unique combinations and the urge to create a new type of alphabet, both of which dominate the development of Romanesque sculpture, are seen in greater detail in manuscripts. Here there was a long tradition of creating unique page compositions out of letters. This tradition is gradually transformed, finally producing letter-patterns which are more complex, more abstract, and no longer whole-page; eventually becoming very similar to the carved letter designs. The process is different in different places. In Italy very large Bibles were made with the opening words and initial decorating the first page, or the first column of a double-column layout; so very often with the initial F of St. Jerome's letter. The letters are often very elegant, but for the really interesting ideas we have to go to France—not forgetting the close connections with England.

The basis is still the Carolingian and Ottonian tradition. To begin with there are incipit pages. The Lectionary of the Abbey of Montmajour in Provence of about 1100 (Fig. 108) has fascinating great initials, almost even-line, terminating in very open, animal-headed interlace, extraordinarily different from the swelling Insular versions. The smaller letters, partly colour-filled, include unclassical forms,

non-uncial this time. Square C, angular S, and B and R with a gap between the upper and

lower members, complete a dancing abstract pattern. Figure 110 shows a more elaborate idea, a Mozarabic version, very linear. In contrast the page from the Arnstein Bible of the Moselle school is three-dimensional and representational, one of the last of the great letter-compositions. Instead we now find pages with five or six lines of capitals. The artist does not, however, use simple Roman capitals as in the Carolingian manuscripts, but plays with his forms, varying the width of letters in one line or between lines, introducing different forms of certain letters to suit his pattern: in Fig. 117 there are three forms of A; both Roman and uncial V; and uncial M and T. He is no longer absorbed in giving an adequate expression to words of import; he seems instead to be interested in the letters themselves, how they can change and interact. We have come back to the idea of incorporating letters together to form abstract patterns, an idea that we have already found in carved examples, perhaps the most typical of Romanesque ideas. Maybe it came from Cluny.[5] There is an early eleventh-century Cluniac manuscript with an elaborate essay in what one might call letter-weaving, covering whole pages. There are many later examples. Figure 106 shows one which is early and simple: it is static and peaceful; others are more complex and restless. One of the most beautiful is the Bible of Bury St. Edmunds; the most complex are again French. The Mazarin Bible (Fig. 109) has lines combining wide, strong letters, while in a rather later Bible (Bib.Nat.lat.10) the proportions are very compressed. Figure 105 shows a line from a Bible made up of such combinations; here a letter has even been turned on its side to augment the texture of the design. There are fascinating combinations too in Cartularies.

OPPOSITE **108** The Lectionary of Montmajeur, Provence. A new version of the incipit page. *c.*1100. Paris, Bibliothèque Nationale, ms lat. 889, f. 6v.

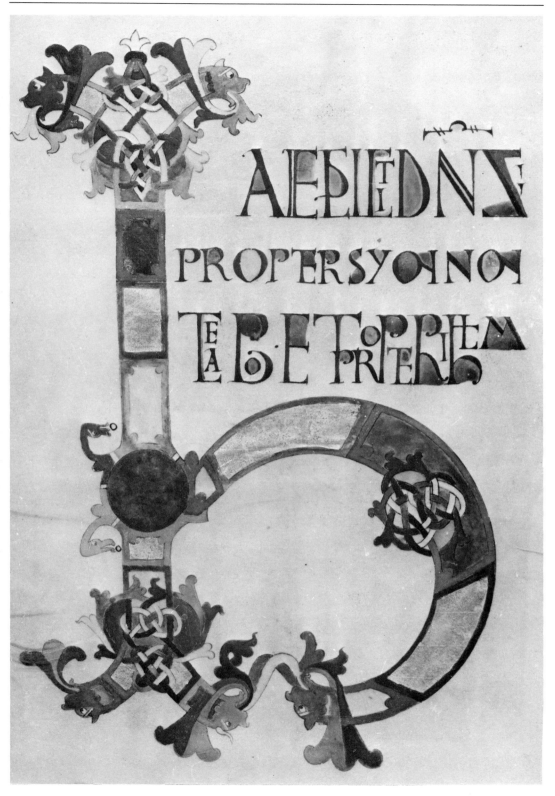

RIGHT **109** The opening
page of the Mazarin
Bible: an elaborately
constructed complex of
letters. The triangular
serifs are unusual.
Twelfth century. Paris,
Bibliothèque Nationale,
ms lat. 7, f. 1.

RA✦SPE·FI·DEI·FORTIS·SPRE

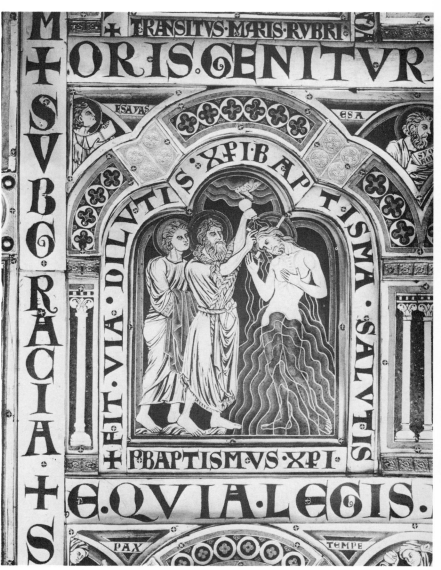

OPPOSITE FAR LEFT **110** Mozarabic Old Testament. Many Romanesque capitals have decorative additions: here they are particularly profuse. Oporto, Municipal Library, ms 32.

OPPOSITE LEFT **111** A column of capitals. The long spiky serifs presage Gothic developments. Valenciennes, Municipal Library, ms 197, f. 7r.

OPPOSITE BELOW **112** A detail of the inscription on the outside of the Church of SS Giovanni e Paolo, Rome. 1154.

ABOVE **113** A detail of the lettering on the shrine of SS Mauritius and Innocentius, Siegburg, near Cologne. 1180–90.

RIGHT **114** A detail from the ambo designed by Nicholas of Verdun. Klosterneuburg, Austria. 1181.

The practice continues into the thirteenth century. There is an inscription of this sort in Lucca as late as 1233.

We come now to the other strand in Romanesque lettering: experiments in the ways in which the elements in letter-design can be varied. Variations in proportion in comparing two Bibles in the Bibliothèque Nationale (Bib. Nat.lat.7 and lat.10) have already been noted. Very thin letters are found (Fig 110), combined with experimental forms which are a long way from uncial in feeling, even if the forms are largely borrowed thence. We also find very round letters, in which O, C, E and T are based on a circle (Fig. 118). There are also ornamentations of the letter-line, dots top and bottom (an earlier idea), little patterns or wispy lines (Fig. 110), or the stems themselves may be striped or patterned, or emphasized with internal bulges, suggesting a link with waisted letters. This ornamentation is commoner in manuscripts than in inscriptions, but the lettering outside SS Giovanni e Paolo in Rome, with mixed plain and flourished letters, is a rare and remarkable example (Fig. 112).

The experiments in stress alteration are more drastic, the impact heightened by the fact that the contrast between thick and thin in stroke-width is apt now to be stronger. Instead of the logical thick vertical/thin horizontal—originally modified by the right-handed pen-movement tilting the thickness on the curves slightly upwards on the right, downwards on the left—we now get thick horizontals tried out on E and F and on the cross-bar of A, also on the cross-stroke of T, whether roman or round

T E

in form. M and N become forms of questionable construction. Should the diagonals be thick or thin? Or should one vertical be thick and the other thin? Or, returning to logic, should both verticals be thick? In fact, all diagonals are questioned; X may have one straight,

X

one curved cross-stroke, and many forms of A are tried. These experiments are tried particularly on enamels (Figs. 113, 114). They are also

found on wall-paintings: for instance at St. Angelo in Formis near Capua, and Minuto near Amalfi. They are seen most magnificently on the great altar of Nicholas of Verdun at Klosterneuburg, near Vienna (Fig. 114). Here the lettering, which is wonderfully strong and confident for all its experimental forms, is a dominant part of the whole design.

In a few manuscripts one finds the stress eliminated and experiments with an even-line letter, usually sanserif. Fine examples are the Life of St. Martial, written at his monastery at Limoges (Bib.Nat.lat.5296a) of c. 1100. The Bible written at this monastery (Bib.Nat.lat.8) also has strong, even-line capitals and initials[6].

In serif formation the experiment is not so interesting, although the Mazarin Bible (Bib. Nat.lat.7) (Fig. 109) anticipates nineteenth-century type design in trying out triangular serifs. Most often the letter-line is terminated by a line drawn across at right angles. Sometimes, however, it ends in a curl, or bifurcation. In rows of small capitals, serifs may be long and restless, anticipating the Gothic (Fig. 111).

So we come to the most fundamental factor in this analysis of experiment, the form of the letters themselves. How far has this element been developed since the situation considered at the beginning of this chapter? How much more experimental were manuscript-painters than letter-carvers? We now find that alternative forms have multiplied: for instance 'uncial' forms of E, D, H, A, M, U and Q; but they were not used exclusively: almost always the roman form is retained as an alternative. Moreover, they were considerably altered; it is illuminating to compare them with true uncials (Figs. 37, 36). We also find other non-roman forms

OPPOSITE ABOVE 115 The opening words of the Gospel of St Matthew showing Romanesque invention. A twelfth-century New Testament from Moissac. Paris, Bibliothèque Nationale, ms lat. 252, f. 8.

OPPOSITE BELOW 116 The plays of Terence. Rustics were used in the twelfth century for headings; they differ, however, from the Roman prototype in their lively rhythm. St Albans, mid-twelfth century. Oxford, Bodleian Library, ms Auct. f. 2.13 f. 96v.

LIBER GNE
RATIONS
IHESV XPI
filii dauid. filii a

ARGVMENTVM. IN ADELPH.
Dvos cvm haberet demea adulescentulos.
Dat micioni fratri ad optandum aeschinū.
Set ctesiphonem retinet. hunc citharistriae ~
lepore captvm svb dvro ac tristi patre
frater celabat aeschinvs. famamq;
amoris in se transferebat. deniq;
fidicinam lenoni eripvit. viciaverat
idem aeschinvs civem atticam pavpcolam
fidemq; dederat hanc sibi vxorem fore.
demea ivrgare · & graviter ferre. mox tamen
vt veritas parefacta est dvcit aeschinvs
a se viciatam civem. atticam virgine m -
vxorem potitvr ctesipho citharistria
exorato svo patre — dvro demea ---
~prologos~

101

117 The Dialogues of St Gregory. A page in which the proportions and the forms of letters are varied in order to create a unique composition. Twelfth century. Paris, Bibliothèque Nationale, ms lat. 2267.

118 Opening page of the Letters of St Augustine. 1152. (The cursive script is a later addition). London, British Library, Harley ms 3107.

INCIPIT : SECVN
DA PARS : EPIS
TOLARVM : AV
RELII AVGVS
TINI YPONI
ENSIS EPISCOPI :

Rᵈᵘˢ in christo p̄r d̄n̄s Nicolaus & comitib; scī Donini sius &d̄ p̄is lucēis
dono dicauit hūc sodicē Biblioth̄c̄ c̄uentus scī Petri cœlicolę octis &obh̄
frium Carmelitarz z̄ ᴍ ᴄᴄᴄᴄ̄ʟxxxxi

INCIPIT EPIS
TO LA PRIMA

ABOVE LEFT **119**
St Jerome's commentary
on Isaiah, initial letter.
Normandy, the end of
the eleventh century.
Oxford, Bodleian Library,
ms 717, f. 2.

OPPOSITE LEFT **120** Initial and titling fm the Winchester Bible now in the Bodleian Library, Oxford (ms Auct.E.inf.1, f. 51).

ABOVE LEFT **121** The Winchester Bible, f. 363. Lettering by the 'Master of the Leaping Figures' in a style which must have been old-fashioned at the time when he was working, probably in the 1160s. Winchester, Winchester Cathedral.

ABOVE RIGHT **122** The Winchester Bible, heading for III Kings (the last line is in the next column) by the 'Uncial Master', after 1170. An early example of a new style, no longer experimental. The lines are painted in alternate red and blue. Winchester, Winchester Cathedral.

123 Charter of King
Stephen (1135–54).
London, British Library,
Add. charter 19582.

124 Romanesque book-
hand. A page from a
twelfth-century
Winchester manuscript
showing the very fine
book script evolved
from the Carolingian
minuscule. Oxford,
Bodleian Library, ms
Auct. E inf. 1.

such as round G, and D with an open bowl

curving outwards at the top. Where did these forms originate? Eleventh-century scribes wrote rustics more often than uncials, using them for the first words or lines of a chapter between capitals and the text-hand. Figure 116 shows a rare example of a page of rustics. The pen is not held (or cut) to give so steep a diagonal bias as in the Roman prototype, and certain new forms have been introduced such as round M; the conspicuously curved horizontal

strokes are prominent along the top, not as with the Roman rustic along the base-line. The whole is immensely lively and restless—much more so in English and French than in German versions. Here is a source for the Romanesque G and D. The taste for wavy horizontals is

found also on Cluniac capitals A and G, and also on F, L and T. Clearly ideas were taken from rustic, as well as uncial, vocabulary. Where were the other forms found? Typically non-roman and non-uncial are square C and G and pointed A with a broken cross-bar, all part of the normal repertory of pre-Romanesque inscriptions, all phased out by the end of the Romanesque period. Round G and T are not

uncial forms; round G is endemic, found in some Roman inscriptions and in some rustic and earlier inscriptions. It does not however come into its own as a typical letter till the Romanesque. Round T is a half-uncial letter, found in some minuscule hands, again developed by Romanesque and Gothic designers. Curious forms, not generally used, are waisted O and C; M with the point of the v prolonged (see Appendix 1); and H and N with a nick in the cross-stroke. B and R with separated bowls

are old forms (see Appendix 1), again to be phased out.[6] As with pre-Carolingian designers, Romanesque artists used the forms which appealed to them from any current source.

Romanesque lettering artists did the work of research and experiment which led to the creation of a new version of the Latin alphabet: the Gothic. They also created wonderful pieces of lettering design. Both these achievements are exemplified outstandingly in the two magnificent Bibles made at Winchester in the twelfth century, the Winchester Bible and the Bodleian manuscript Auct.E inf.1-2, two of the great series of Bibles made in England in the twelfth century. These books have large, elaborately decorated, often historiated, initials at the beginning of each book, and comparatively small, simple initials, several to a page, throughout. Here I want to consider only the lines of capitals beside and around the large initials. These are by several hands. Walter Oakeshott identifies the artist who did the 'square' capital lettering in Volume II of the Winchester Bible (Fig. 121) as possibly the one he calls the 'Master of the Leaping Figures'.[7] Characteristic are the square C and G and angular S, A with the longer right-hand member, and M with short central diagonals. The proportions of the letters are condensed, with long I and L in the first line. The rhythm is staccato. This style is clearly related to Anglo-Saxon books such as Bodleian ms Auct.F.I.15 and the Bosworth Psalter (Fig. 88) and the group of manuscripts which include initial letters made out of pen-drawn interlace, books mostly written at Canterbury in the late tenth or early eleventh century. So the Winchester rubricator must have been choosing an old-fashioned style; perhaps he was Anglo-Saxon and chose it for that reason? The other most remarkable letterer of the book, called the 'Uncial Master', on the other hand presages future development. Figure 122 shows his lettering at its most mature. It is very regular, all the letters except the first being the same height; there are two forms of A and M, but these seem to be introduced to create balance rather than movement; the curve of the rounded contours is consistent throughout. It is an

extraordinarily beautiful and serene piece of lettering, the most mature of many examples of this type, in which the love of round, curved forms is predominant. Here we are on the verge of the Gothic style; it is indeed impossible to draw any exact line, but one can highlight examples which are characteristically Romanesque.

In Fig. 119 the motive theme is a changing rhythm of movement. The lettering is combined with the initial to make an integral composition. The strange architectural structure of this initial, which burgeons into interlace and animal vitality and supports thrones and figures, creates a dramatic tempo which, combined with the surrounding letters, is a brilliant expression of the experimental ideas of letter combinations which we have already noted both in sculpture and in manuscripts. Figure 118 is simpler but stronger, again a carefully composed, unique design. These qualities are, to my mind, the characteristic contribution of Romanesque design to the art of lettering.

Finally, one needs to remember more modest types of Romanesque lettering. The charter-hand (Fig. 123) is based on the Carolingian tradition, but characteristically, like the Romanesque rustic, it has a new vitality with strongly contrasting movements—very different from the stately book hand when it is at its most formal (Fig. 124).

Many manuscripts have coloured initials in the margin throughout the text; these are sometimes plain, sometimes ornamented with simple arabesques. They are very beautiful, sensitive letters. The Bodleian Library has collected and copied many of these.

Finally, one should note the introduction of a style of small round capitals embellished with conspicuous, restless serifs which are clearly a prelude to the Gothic use of long serifs (see Fig. 111). These small capitals, of which there are often three or four rows drawn below larger letters and above main text, seem to constitute a definite if undistinguished style; they are common in German manuscripts.

Who were the scribes or painters who normally drew the lettering we have been studying? Was it a separate person, a rubricator? Or was it the same person who drew the initials? Or was it the person who transcribed the text? In most cases we do not know.[8] Sometimes there is evidence that the initial and the lettering are by the same hand; sometimes the same man also wrote the text. By the twelfth century we know that some of the artists were laymen, and that manuscript-making was no longer exclusively in the hands of monks.

And it had enormously proliferated; many more manuscripts were written, a much wider range of texts, encyclopaedias, natural histories, commentaries as well as theological and biblical books were copied. There are hundreds of inscriptions, wall-paintings, enamels and reliquaries.

Notes

1. R. Southern, *The Making of the Middle Ages*, p. 163, 1953.

2. Round Gothic capitals are often described as 'uncial', but though forms borrowed from uncial are an important element, these are often substantially changed and other, different, sources are involved.

3. See Appendix, p. 225.

4. See Appendix, p. 222.

5. The inscriptions on the capitals surviving from the Abbey of Cluny also show experimental forms of A with a curved cross-bar extending to the left, and G with a spur curving to the right, a form derived from cursive, found occasionally in early Christian inscriptions.

6. See Appendix on these letters.

7. The lettering in the two Winchester Bibles is discussed and illustrated by Walter Oakeshott in *The Two Winchester Bibles*, 1982. He calls attention to the resemblance between the style of the 'uncial forms' rubricator and that of the painters of the frescos at Sigena, Spain, pp. 24–5. See also Oakeshott's book on *Sigena*, 1972.

8. See J. J. G. Alexander, 'Scribes as Artists: the Initial in 12th-Century English Manuscripts' in *Essays presented to N. Ker* edited by M. B. Parkes and A. G. Watson.

A New Alphabet:
The Gothic Capital

There was no break between the Romanesque and the Gothic world, as there was, for instance, before and after the Carolingian Renaissance—although Europe was a very different place by the end of the Gothic period. In the thirteenth century the development of the twelfth century continued: trade and commerce were still expanding, and cities were growing. Craftsmen had multiplied and were now organized into guilds. Bishops and princes were no longer artists as in the time of Dunstan, nor were monks any longer the chief makers of manuscripts. The tendency, already apparent in the twelfth century, for professionals to be employed had accelerated, and the work was now often divided among various specialists: rubricators, colourists, gilders, etc. This was due in part at least to an enormously increased demand for books, due again to wider education and new universities. New orders were founded, such as the Franciscans and the Dominicans; and many of these friars taught in the universities, where men studied law and medicine, and above all logic and theology. By the thirteenth century we have moved from the world of Abelard (1079–1142) to that of Aquinas (c. 1225–74); from question and analysis to the writing of the *Summa contra Gentiles* and the *Summa Theologica*. These writings of Aquinas, in which he surveys all philosophy and theology, seem the intellectual counterparts of Dante's vision of Heaven and Hell (written in the early fourteenth century) and of the great Gothic Cathedrals such as Chartres and Bourges, which unite superb stained glass and sculpture in buildings which

are a triumph of engineering technology. It is appropriate that the capital letter of this period is also both logical and, at its best, beautiful.

First of all we have to distinguish between the two meanings of the term 'Gothic capital'. There is the round letter sometimes called 'Lombardic',[1] with which we are now concerned, evolved in the mid-twelfth century. There is also the broken Gothic letter which was not developed till the late fifteenth century (see Chapter 10). In considering the round Gothic letter one has to think of a point of arrival rather than an exact date. One can say in lettering that at certain points new styles were crystallized which satisfied, which therefore for an appreciable period were adopted, and which have thus become part of our idea of the Latin letter: styles such as rustic, uncial, italic, etc. It is remarkable that the Gothic style of capital was so different from previous styles and that, as far as one can see, it did not arise from any practical necessity or from the use of any new tool. It seems to have been the product of taste and theory. One can see the Gothic text-hand, Textura (Fig. 125), developing in a gradual progression over four centuries out of the Carolingian minuscule (Fig. 68) and the Romanesque script (Fig. 124), also the Gothic cursive changing with the introduction of a new sort of pen (see Fig. 142). The capital seems on the other hand to have been evolved out of the Romanesque letter by a series of conscious choices. Some experiments were adopted, others were rejected. The experiments in stress were abandoned, and also the idea of pattern-making by playing with different sizes

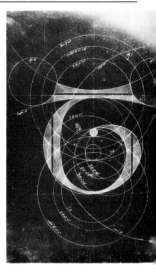

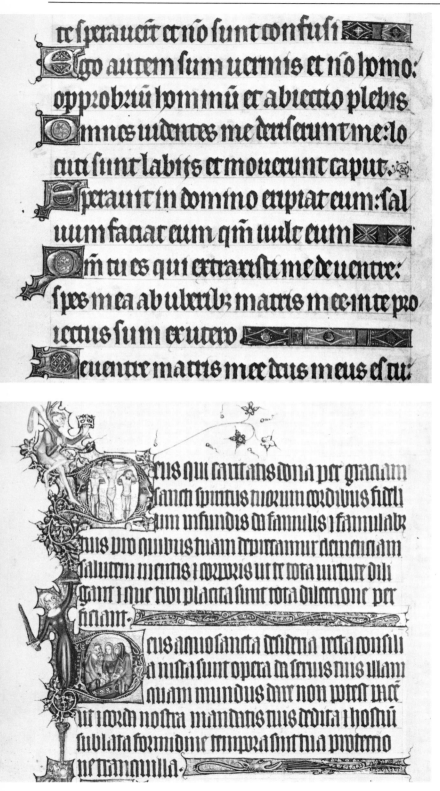

and shapes. Three ideas were adopted: the idea of using the counter, the inside shape of the letter, as a unit of construction; the idea of elongating the serif (thereby creating new counters); and the idea of making letters out of curves, instead of out of straight lines combined with curves. The alphabet which re-sulted was new.

There are a number of manuscript books which show the construction of these letters (Fig. 126), but they are late (fifteenth century); even later are the alphabets in some of the writing-masters' books.[2] An interesting check is provided by a twelfth-century Italian alpha-bet book (now in the Fitzwilliam Museum in Cambridge; ms 83)[3] where the construction is still Romanesque. These Italian letters have been called 'geometric',[4] but it is the slightly later, fully Gothic ones which have a clear geo-metric basis. In the fifteenth century Italians such as Feliciano tried to *impose* a geometric basis on the Roman alphabet in constructing it with a compass and within squares (Fig. 180). The Gothic letter seems on the contrary to be *built up* on its basis, not constructed within a square, but around an oval counter. This coun-ter supplies the module which regulates the width of the letters. The idea was worked out gradually in different places by different people, but one can see all the time the grow-ing interest in order, balance, uniformity and logic.

In manuscripts in the thirteenth century the fashion was for initials, probably historiated, accompanied by a few lines of smaller capitals, the whole contained in a frame on a coloured background (Figs. 127, 128). Lettering has become less important in manuscript design,

although we get great ornament-filled Bs, filling the whole page in Grand Psalters (Fig. 130). The smaller capitals are clearly related to those in earlier books (Fig. 111), but now the interest in serifs is more marked: they are prolonged to close the counters of A, V, E, F and T, and in doing so they add new and important curves to the design, enhanced by curled terminations. It is noticeable that there is no straight line in these compositions—in contrast to the text script—all the letter-stems are slightly curved. We have seen this curve in a gentler form in Anglo-Saxon and Ottonian letters, but now it has a double effect: it not only eliminates straight lines, but also means that the stem makes a curve congruous with the curve on the other side of the counter, as with D, T and N. It is not accidental that the square forms of C, G and S have been aban-doned, and the new alternative forms of M, N, U and E are all curved forms replacing straight lines. In other letters such as R, curves are exaggerated, and the leg is now never straight. Diagonals are clearly disliked—they do not fit into the new rhythms—so M, N and V all have alternative forms. Pointed A with its two converging diagonals has disappeared, and various alternatives are tried. The idea of the counter as a module is more difficult to trace. I wonder whether it is not due to the way in which the letter was actually drawn. If the in-side rather than the outside outline was drawn first, the idea of making the counters equal in all letters would follow, and from that the idea of closing them with the new elongated serif. It would also fit in with the new wish to have letters of equal width. One can see the ideas coming together to coalesce in the formation of an almost completely logical alphabet. One finds deviations and modifications, but by and large this becomes a standard capital alphabet used from the end of the twelfth century till the beginning of the fifteenth, and in many places later still. It had a sort of apotheosis in its final phase in the great representational initials in the magnificent liturgical manuscripts made in Italy in the fifteenth century (Fig. 129); also in the woodcut initials of early printed books.

It is useful to try to define the letters of the round Gothic alphabet. I have done this in Ap-pendix 2. Alternatives were sometimes kept, and not all letter-designers followed a consis-tent pattern; but it seems that the tendency was

OPPOSITE LEFT **125a,b** Textura: the script evolved for the copying of grand books, still used in the fifteenth century for many of the first printed books. The illustrations show two types of letter termination: (a) from the Queen Mary Psalter, British Library Royal ms 2B VII, and (b) from the Bohun Psalter, British Library Egerton ms 3277.

126a,b Letters from a fifteenth-century alphabet-book showing the construction of the round Gothic capital. A rationalization of a letter invented two centuries earlier. Paris, Bibliothèque Nationale, ms lat. 8686.

for the alphabet to become more and more consistent, until at the end of the fourteenth century it began to be discarded, either for new experiments, or for more extensive use of Textura.

Apart from the process by which this alphabet was evolved, which entailed the gradual elimination or acceptance of alternative forms, these letters could be varied in very much the same ways that display letters were varied in the early nineteenth century (see Chapter 12). The proportions could be altered both in the relation of height to width and in the contrast between thick and thin in line-width; and the line itself, or the serifs, could be given decorative features. Figure 128 from the Salvin *Book of Hours*, thought to have been made in Oxford about 1280, shows a compressed version. Others even thinner exist—one is reminded of the very thin Roman rustics (see Fig. 9). In contrast very round versions were also made.

The very close spacing and the colour of the background now create a new sort of pattern: the letters are not positive characters against a neutral background, but part of a positive/negative design. Figure 131 shows a simple example in bronze. Ligatures, used in Romanesque work to create a sudden nexus contrasting with more open movement, are now replaced by abbreviations or letters one above the other (Fig. 132). The most remarkable examples which I know of closely-woven Gothic lettering pattern are in the Siennese record tablets (Fig. 133) and the Evesham Psalter (Fig. 127) of about 1275–80. A whole page of lettering such as this latter is now rare.

Again, the letters may be outlines creating a linear pattern, as in the Oscott Psalter of *c.* 1270 (British Library, Add. ms 50000) (Fig. 134). There were earlier outline letters, for instance in the Melissenda Psalter, but these are dull and undistinguished; the more sophisticated Gothic letter is clearly a better medium for this technique.

Ornamenting the silhouette of the letter with curls and scrolls was an idea used in the Romanesque period, often with delightful if erratic results (see Figs. 110, 112). Now we get serifs used to give movement to the line silhouette, sometimes also emphasized by interlinear divisions, and by rolling up some terminations into curls or by doubling some of the cross-strokes (Fig. 135). Lettering is again made into

a pattern, but one based on the formation of the letter and on regularity, not on the irregular juxtapositions of the Romanesque designers. This is illustrated most clearly in inscriptions where the third dimension provided by a deep v cut, or occasionally by letters in relief, provides an extra element. There is a delightful collection in the Musée des Augustins in Toulouse where one can see the transition: in Fig. 135 the O is still pointed and D is rustic, but the whole is a pattern of light and shade, whereas Fig. 136 is linear. In Fig. 137 from Assisi, dated 1305, the lettering forms an all-over pattern of light and shade, and we find this concept continuing in Italy into the fifteenth century. It is remarkable that the sculptures of the Pisani, which are so strongly influenced by Roman sarcophagi, are decorated with Gothic lettering (Fig. 139). Gothic architectural forms seem to have been foreign to the Italians, but not Gothic letters. There are examples also of relief lettering in Spain, where one can see the influence of the calligraphy which was so important in Islamic architecture and decoration:[5] for instance on the stucco work at Las Huelgas, Burgos and in the Fuensalida Palace in Toledo. In France, on the other hand, lettering ceases to be treated as an integral part of Gothic sculpture, and in French and English manuscripts the titling beside the initial is replaced by long strips of ornament extending vestiges of the letter down the margin or even all round the text.[6]

In surprising contrast, in Italian painting inscriptions are often incorporated. It may be on the halo of a saint or on a scroll indicating spoken words, or the artist's name on the frame (Fig. 138). This writing is sometimes in Textura or Rotunda, but most often it is in round

OPPOSITE ABOVE 127 An initial showing Jonah and the whale from the Evesham Psalter. This illustration shows the new style of layout for chapter headings in manuscripts, also a style of textura with horizontal letter-terminations. English *c.*1275–80. London, British Library, Add. ms 44874, f. 93.

OPPOSITE BELOW 128 The martyrdom of St Edmund from the Salvin Book of Hours. English, mid-thirteenth century. London, British Library, Add. ms 48985, f. 95v.

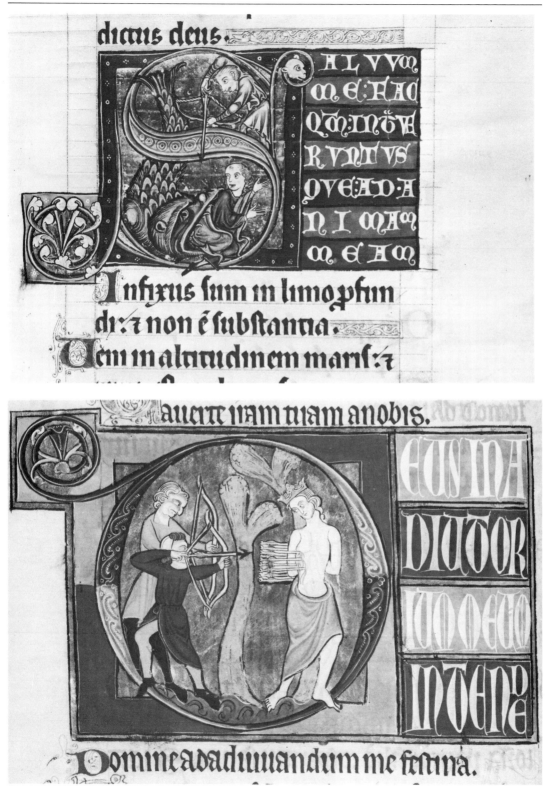

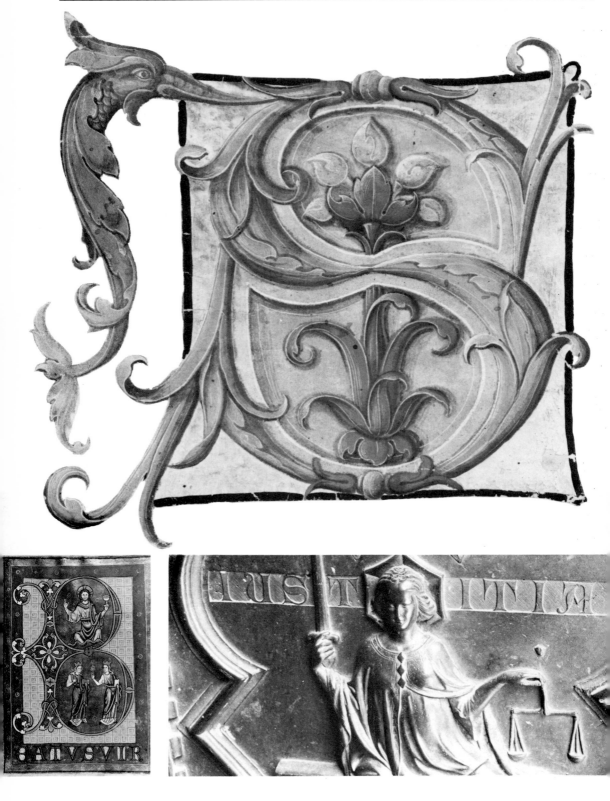

LEFT **129** An initial from a fifteenth-century Italian manuscript. The last phase of the use of the round Gothic initial.

OPPOSITE BELOW LEFT **130** The initial B from a Psalter: the first letter of Beatus, the first word of Psalm 1, showing geometrical structure. 1260–70. Cambridge, Fitzwilliam Museum, ms 2, f. 12v.

OPPOSITE BELOW RIGHT **131** A panel from one of the bronze doors of the Baptistery in Florence, by Andrea Pisano (c.1290–1348). A letter clearly designed as a two-dimensional, not a linear structure.

RIGHT **132** A page from the Evesham Psalter. Gold letters with red counters on a blue background; not a linear pattern but one created in areas. Whole pages of lettering such as this are rare at this date. c.1275–80? London, British Library, Add. ms 44874, f. 8.

BELOW **133** An example of one of the record tablets of the Republic of Sienna, dated 1320.

ABOVE **134** Outlined letters: initial and heading from the Oscott Psalter. Late thirteenth century. London, British Library, Add. ms 50000, f. 101r.

LEFT **135** The epitaph of Peter Bernard, still showing a rustic form of D and pointed O. 1173. Toulouse, Musée des Augustins.

OPPOSITE TOP **136** The epitaph of Canon Gaubertus. Toulouse, Musée des Augustins.

OPPOSITE LEFT **137** Inscription commemorating the building of a tower in 1305, clearly conceived as a three-dimensional pattern. Assisi.

OPPOSITE RIGHT **138** Detail from a painting by Nardo da Cione (active c.1343, died c.1365). London, National Gallery.

OPPOSITE BELOW **139** Detail of the inscription on the pulpit of Pisa Cathedral. The pulpit was finished in 1310. By Giovanni Pisano.

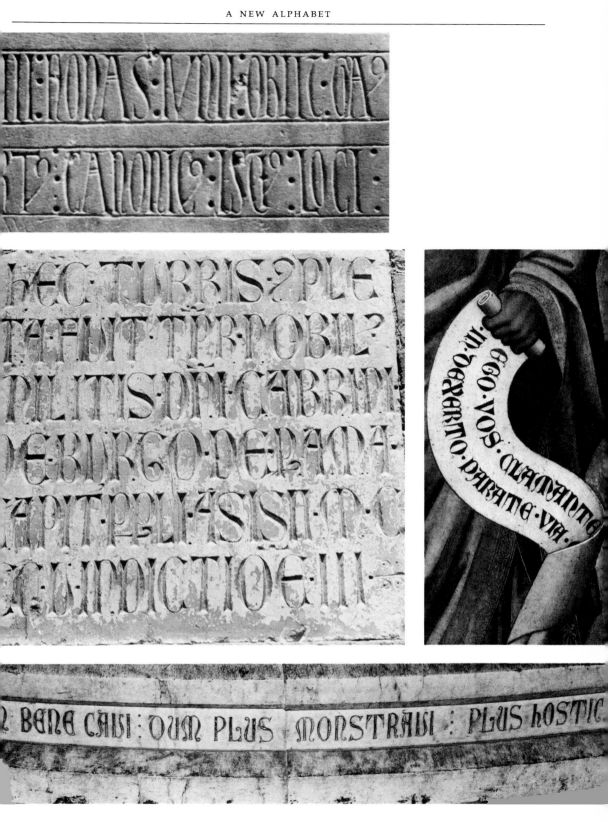

Gothic. Figure 140 shows a typical example from a frame; particularly dramatic are the words given to the figures invoking death in Orcagna's *Triumph of Death* in Florence.

In mosaic lettering there is great variety.[7] In San Marco in Venice, it was clearly designed in different styles by contemporary artists—unlike the twelfth-century work at Monreale which is homogeneous. The inscriptions in the cupolas are dignified, though surely rather old-fashioned in the mid-thirteenth century. It is not till we come to the fourteenth-century work in the baptistry that we find lettering which is really Gothic, its design tied together by the long movement of serifs. The strange form of the letter M in this mosaic seems to be Greek in origin, but also occurs in Spain (see p. 225).

In Rome there is a considerable quantity of lettering in the mosaics of both Torriti in Sta Maria Maggiore and of Cavallini in Sta Maria in Trastevere, but in both cases it is unimpressive—too small perhaps? Or spaced too wide? Or ineffective because the letter-forms are inconsistent? The inscription round the cloister at San Paolo fuori le Mura is even less successful: there is no pattern of thick and thin, and the spacing is too wide. The round Gothic letter is not an easy letter to use. Unlike the roman, its beauty does not consist in the perfection of the drawing of each letter so much as in the interplay of form and movement in a complex of letters—once again a Romanesque idea has been taken over and transformed. In the most successful designs it is the close spacing of several rows which creates unity in a pattern which is composed vertically as well as horizontally. Single lines are seldom

OPPOSITE TOP **140** Lettering on the frame of a painting by Lorenzo Monaco. 1413. Florence, Uffizi.

OPPOSITE CENTRE **141** Textura lettering on tapestry. Fifteenth century, Flemish. London, Victoria and Albert Museum.

OPPOSITE BELOW **142** The new cursive script with loops. Other contemporary scripts also show changes in line-width derived from pressure on a flexible nib. Assessment for repairs to Caterham Church, 1334. London, British Library, Harley ms 3739, f. 100.

impressive. One sees this on tomb ledgers in many countries, for instance on the tomb of the mason Richard of Gainsborough in Lincoln Cathedral: the letters are too far apart for design interplay. It is not surprising that at the end of the fourteenth century Gothic tended to be abandoned in favour of Textura. Apart from design problems, there is the difficulty inherent in a logical geometric alphabet constructed on a modular basis: the forms tend to be similar, whereas for legibility letters need to be different. All consistently geometric alphabets run into this problem; one is very much aware of it today—the roman alphabet is flexible and legible because it is *not* geometric. The round Gothic alphabet came to be seen as limited: it was only flexible up to a certain point, then lettering designers had to start again. In the thirteenth century it had seemed possible to envisage the rational order of the universe: for a moment in the pontificate of Innocent III the conception of a united Christendom seemed a possibility, a realizable goal. Saint Francis dreamed of men living a literally Christ-like life. By the mid-fourteenth century people were more disillusioned and more sophisticated. The papacy had been driven from Rome to Avignon. England and France became involved in the Hundred Years War, scholasticism became more professional, the sophisticated literature of courtly love blossomed; Decorated and Perpendicular succeeded earlier Gothic styles of architecture. The Gothic world had grown inward-looking.

The round Gothic letter was not, however, the only Gothic letter. It was designed in part at least as a display letter to go with the formal Gothic book-hand, Textura. As such, its great curves were in superb contrast to the serried ranks of Textura verticals, and as such it was used with great effect both in grand manuscripts and in early printed books.

Textura (Fig. 125) was evolved in the thirteenth century and used throughout the fifteenth, and even later. It was used on brasses, tombstones and tapestries, and has been revived in this century both by calligraphers and for commercial purposes. Its characteristic is the breaking of the curves of the earlier book-hand into angular forms—in fact the opposite process to that by which the round capital was created. The degree of compression varies; strokes may be both taller and closer together.

Terminations also vary: they can be diamond-shaped (Fig. 125), or turn at an angle (Fig. 127) or end horizontally, so creating a contrast with the broken line above. At its best a page of Textura is certainly a work of art, a marvellous formula for juxtaposing angles and verticals, punctuated with the occasional horizontal movements in T and G, contrasting with the movement along the upper and the base line. Figure 141 shows its possibilities as a basis for decorative embellishment in tapestry.

It is a script for luxury books; other books of all sorts were now being produced in great numbers, literacy was growing, universities multiplying, commerce and bureaucracy expanding; books and documents were in demand, speed and economy important factors. All this is outside the subject of this book, but it should be noted that a new sort of cursive

(Fig. 142) was also developed, due largely to the use of a new nib, pointed and flexible instead of flat and broad, so creating thick and thin strokes by pressure instead of by changing the direction of the stroke or the angle between pen and paper. Loops were also introduced, presumably to promote speed. Many different styles of varying degrees of informality were created in many different centres. The new rhythms and the new variety of movement provided particularly by loops, and by more important descenders and ascenders, created new potentialities for free design in cursive handwriting.

By 1400 the round capital was reaching the term of its currency, but Gothic lettering in other forms still had a long future before it (see Chapter 10).

Notes

1. The term 'Lombardic' is also used for the pre-Carolingian North Italian script. Applied to round Gothic it is misleading because it is only used for wide forms of this letter.

2. Four alphabet manuscripts are mentioned by Mardersteig in 'Leon Battista Alberti e la Rinascita del Carattere Lapidario romano nel Quattrocento', *Italia Medioevale e Umanistica* 11, 1959: Newberry Library, Chicago, ms fsw 141/46; Paris, Bib. Nat. lat. 8686; Mantua, cod.f B.v.6; and a Venice manuscript of 1493. Among the writing-masters, Yciar's book of 1550 shows the modular method of construction based on the counter very clearly.

3. See D. Jackson, *A Working Alphabet of Initial Letters from Tuscany*, 1978.

4. By E. B. Garrison, *Studies in the History of Medieval Italian Painting*, 1953–62. See D.

Jackson, *A Working Alphabet of Initial Letters from Tuscany*, 1978.

5. Calligraphy executed in stone, brick, stucco and ceramic tile is the chief type of decoration on most Islamic buildings; the lettering is sometimes painted or carved on top of an underlying decorative design. The stucco inscriptions which are very important in the Alhambra are similar to these in decorative purpose and in being in relief.

6. For instance in the fourteenth-century manuscripts of East Anglia.

7. Since this book was written the magisterial book on the mosaics of S. Marco by Otto Demus has appeared. This book includes new and very numerous photographs of the mosaic inscriptions, also a chapter on their palaeography by Rudolf M. Kloos.

OPPOSITE **143** Christ as a pilgrim. Stained-glass showing Gothic lettering, Niederhaslach.

The Fifteenth Century and the

Italian Revolution

The Gothic world was a unity and Gothic art was a coherent language which could be used in diverse ways—and was indeed taken over and re-used in the nineteenth century. In the fifteenth century this world began to split up, and a new period of experiment and revival started.

In Italy the Roman tradition was revived. The history of lettering can be seen as the repeated revival of the Roman letter. One may see this as a repeated return to right understanding, that is to the idea that the only right understanding of lettering is acceptance of the Roman letter; or one can see it as the constant inspiration of classical antiquity; or as the natural human alternation between stability and experiment, which can also be seen as the alternation between classical and romantic. Whichever way you see it, the effect has been to preserve the continuity of our tradition and the identity of each letter through all its transformations and vicissitudes.

Italy was different from other European countries in that it was not in the fifteenth century a nation state, but was divided into a number of city states and principalities, including the Papal states. More than other peoples, Italians were aware of the classical inheritance, particularly in Rome, where the mosaic lettering in San Clemente and Sta Maria Maggiore was in the twelfth century more spacious and classical than contemporary work elsewhere. The normal Italian book-hand, Rotunda, had remained round, in contrast to the angular script (such as Textura) that was developed in the north. In the later thirteenth

century, however, the classicizing sculpture of Nicola and Giovanni Pisano in Pisa and Siena is decorated with round Gothic lettering, and we have seen that some of the most successful Gothic inscriptions are Italian: there was a dichotomy in the Italian approach. In the late fourteenth century, however, the endemic identification with the classical Roman tradition finally began to triumph, with the revival of classical learning. An early result of this revival was the formulation of a new script and the revival of the Roman classical capital.

The early humanists, men like Coluccio Salutati (1330–1406), Niccolò Niccoli (1363–1437) and Poggio Bracciolini (1380–1459), wanted a lucid script, dissociated from the Gothic. The Humanist hand, evolved above all by Poggio, is based on the Carolingian and more particularly the Romanesque book-hands of the manuscripts from which classical texts were being copied. It is the hand used in very many beautiful Renaissance manuscripts and is the model upon which French and Italian lower-case roman type design is based. The cursive, italic style which was developed at about the same time was used as a book-hand, but also as a quicker, less formal cursive (Fig. 170); as such it became the model for contemporary handwriting, and for the revival of cursive calligraphy in the twentieth century.

With the new Humanist book-hands, new capital letters were introduced. The early capitals used, for instance, by Poggio, are essentially pen-made; they are not like Carolingian capitals, nor are they related to carved Roman letters. In fact, as one would expect, they are

NCOMINCIA · VNO · TRACTATO · DICON
ESSIONE · COMPOSTO · PER · R̊do · HVOMO · M̊
ANTONIO · DI · SER · NICCOLO · DAFIRENZE ·
ELLORDINE · DEFRATI · PREDICATORI · ET
ER DIVINA · CLEMENTIA · ARCHIEPISCOPO

144 Early Humanist capital letters, pen-made, showing the influence of rustics in ductus. Italian, dated 1431. London, British Library, Add. ms 54245, f. 6.

145 A page from an Italian manuscript of Josephus' *De Bello Iudaico*. Third quarter of the fifteenth century. Florence, Biblioteca Laurenziana, Plut. ms 66. f. 8.

nearer to the Romanesque rustics found in the manuscripts which they copied. This is particularly clear in the formation of N, M and D. The restlessness of the Romanesque letter is, however, replaced by a new feeling for balance. This letter (Fig. 144) is the most common early Humanist capital, but other ideas were tried out. Figure 146 shows a page from a manuscript of Plutarch written in North Italy. The capitals which appear beside the initials at the opening of each section in this manuscript are by at least two different hands. Those prefacing the life of Mark Antony are full of Romanesque features: pointed O and D, R with a curved leg, M with the central v ending in a vertical and H with a nick in the cross-bar. The spacing is, however, very ordered and open, measured in units of background patterning.[1] The other hand is more Roman: it revives the spurred G—which had not been used for centuries—but both M and N have thin diagonals, contrary to the Roman norm. Rather similar are the pages of lettering in the manuscripts of Josephus and of Pliny made for Piero de' Medici, clearly both by the same hand (Fig. 145). The artist has again had trouble with his M; his Gs and some Es are still round; R no longer has a curved leg, but is still not quite Roman. Clearly these artists were seeking to revive the Roman inscriptional letter, but had not yet arrived at the 'Trajan' norm. It is difficult for us to imagine what it must have been like to find Gothic writing familiar and easy to read, and romans foreign, yet the roman letter had been obsolete for two centuries and there is evidence that people found them difficult to read.[2] Details of letter-construction would surely not have been so noticeable then as they may be to us.

In fifteenth-century Italy, lettering and the sudden change in style were important. Many

famous painters and sculptors were interested. In painting, the tradition from the Gothic practice is continuous; but we see the lettering on frames, haloes, etc. change to a new style related to that of the manuscripts in works by Masaccio, Benozzo Gozzoli, Fra Angelico, Piero della Francesca, Gentile da Fabriano and Vivarini among others (Figs. 147, 148). It is in fact an identifiable style. Characteristic is the letter-stroke with a slight wedge-serif, sometimes almost sanserif, but with a definite movement from thick to thin; diagonals are sometimes elegantly splayed towards the termination. Clearly no canon of letter-forms was established, and yet the style is unmistakeable: it has a delicacy and clarity and that sense of the primitive and unexplored which comes so often with something new. It is familiar today in the Optima type design by Hermann Zapf.

It seems likely that this style was first used in carved lettering. The inlaid marble tombstones on the floor of Sta Croce in Florence provide a dated series which goes back to the beginning of the fifteenth century. The lettering on the tomb of the anti-Pope John XXIII by Donatello and Michelozzo in the Baptistry in Florence was made about 1425;[3] that on Donatello's tombstone for Bishop Pecci in Sienna Cathedral is dated 1426 (Fig. 149). These are definitely in the new style. Another beautiful example is the lettering on the Cantoria of Luca della Robbia (1431–7) (Fig. 150). The same style appears also on early Italian medals (Fig. 161). Particularly beautiful is the inscription on the Tomb of the Beata Villana by Rossellini (1451) (Fig. 151); and here one notices that not only is the letter-stroke very thin, almost without modulation, but the width of the letters varies: O is almost circular, while E and L are very thin, so making an irregular but effective pattern. Rather similar lettering on the frame of a painting by the Master of the Nativity of Castello in the Louvre is worked into a complex of letters ligatured or inserted into one another, as in a Romanesque design (Fig. 152). There is, I think, no doubt that this style of lettering was strongly influenced by Romanesque lettering; one has only to compare the record of the Council of Florence of 1438 (Fig. 153) with a Romanesque inscription of similar size and shape (Fig. 98). We have already noted the peculiar Romanesque letters in the Plutarch manuscript; another example which could be

OPPOSITE TOP **146** Detail from a manuscript of Plutarch of *c*.1450. London, British Library, Add. ms 22318, f. 100.

OPPOSITE CENTRE **147** Lettering on the frame of a painting by Gentile da Fabriano. 1423. Florence, Uffizi.

OPPOSITE BELOW **148** Lettering on the frame of a painting by Vivarini (*c*.1420–76). Paris, Louvre.

OPPOSITE TOP 149
Inscription on the bronze
tombstone of Bishop
Pecci by Donatello. 1426.
Sienna Cathedral.

OPPOSITE CENTRE 150
Inlaid marble inscription
on the Cantoria Frieze
by Luca della Robbia.
1431–7. Florence, Museo
dell'Opera del Duomo.

OPPOSITE BELOW 151
Inscription from the tomb
of Beata Villana, by
Bernardo Rossellino. 1451.
Florence, Sta Maria
Novella.

TOP RIGHT 152 Detail of
the lettering on the frame
of a painting by the
Master of the Nativity of
Castello. Paris, Louvre.

CENTRE RIGHT 153 The
inscription recording the
Council of Florence of
1438. Florence, Duomo.

BOTTOM RIGHT 154 An
inscription commissioned
by the German Emperor
Frederick III in imitation
of a Roman inscription.
It is not dissimilar to
Alberti's inscriptions on
the façade of the Tempio
Malatestiano at Rimini.
1470. Trieste, Museo
Archeologico.

155 Inlaid inscription designed by Alberti. 1467. Florence, Cappella Rucellai, San Pancrazio.

TOP LEFT 156 Inscription on the façade of Sta Maria Novella, Florence, designed by Alberti. 1470.

TOP RIGHT 157 Inscription on a painting by Mantegna. London, National Gallery.

ABOVE 158 The inscription on the sarcophagus of an Archbishop. Dated 1478 (the date is given according to the era of Spain). Lisbon Cathedral.

LEFT **159** Title-page from a manuscript of the *Cosmography* of Ptolemy. 1470. Paris, Bibliothèque Nationale, ms lat. 4802, f. 1v.

ABOVE **160** The new Gothic book-hand, 'bastarda'. *c.*1500. Oxford, Bodleian Library, Ashmole ms 764.

RIGHT **161** Medal by Nicolaus, from an example in British Museum. Before 1441.

cited is square C—a letter-form which had been dropped from the Gothic repertory.

Whether these artists thought that Romanesque inscriptions were Roman, or whether they saw examples of these letters which were obviously not Gothic and so took them over, is hard to gauge. It is, however, clear that after about 1470, when the serious study of antique inscriptions had progressed, this delightful style was abandoned in favour of a more orthodox Roman. Before that, however, we have the lettering designs of Leon Battista Alberti. Alberti certainly looked at Roman work. His lettering on the Tempio Malatestiano at Rimini (which is rather crude) looks quite like Republican inscriptions, particularly S and M.[4] It is indeed the only Renaissance lettering that I know which appears to be based on Republican prototypes—apart from the inscription of the Emperor Frederick III in Trieste which is a direct imitation of Augustan (i.e. pre-'Trajan') lettering (Fig. 154). Alberti's most beautiful designs, however, for the Cappella Rucellai in S. Pancrazio, Florence (Fig. 155) and on the façade of Sta Maria Novella (Fig. 156) are neither purely Roman (witness the R and S on the latter), nor related to the earlier style just described, but individual. An example which is comparable, though more mannered, is the inscription on the sarcophagus of the Archbishop of Lisbon in Lisbon Cathedral, dated AD 1478 (1439 by the 'era', reckoning from the conquest of Spain by Augustus—see Fig. 40): the wide D is in Portuguese taste (Fig. 158).

In the later fifteenth century the influence of archaeological studies becomes more important: we know that inscriptions were carefully studied, and one expedition of Mantegna and his friend Feliciano is recorded in 1464. Mantegna introduced inscriptions into his paintings of Roman scenes (Fig. 157),[5] and Feliciano produced an alphabet of Roman letters—to be followed by many others—drawn to show their 'just proportions' in relation to the circle and the square (see Fig. 180). Thereafter we find many beautiful initials drawn as if they were carved in stone, and representations of incised inscriptions in paintings.

The first examples of these new 'correct' Romans are singularly beautiful: they seem to have once more preserved a primitive feeling that disappears in later inscriptions which become mechanical. Figure 159 shows an example from a manuscript of about 1470. The wide, very careful spacing and sensitive execution give it a serenity and distinction that makes one feel some Roman inscriptions worldly. The architectural lettering has the same quality in the inscriptions in the Sistine Chapel that one so easily misses between the ceiling above and the paintings below, or that in the Cloister of Sta Maria della Pace designed by Bramante in 1504. More eccentric is that in the Courtyard of the Palazzo Ducale at Urbino,[6] probably designed by Francesco di Giorgio about 1475; and that by the same artist in the Church of San Bernardino, also in Urbino: very splendid, but with some odd letters.

The Italian achievement in this century is indeed impressive. The early style is primarily a Florentine creation and the best and the earliest examples are there; but it is found also elsewhere: in Sienna, on the tombstones in the Campo Santo in Pisa, and on ceramic plaques. Later it influenced lettering elsewhere, where more diverse experiments were being made (see Chapter 10). It is also to the Italians that we owe the eventual revival of the classical inscribed Roman letter, the revival which changed the whole course of the history of lettering—but not in the fifteenth century. There was still a lot more experiment to come before it was established.

Politically and in the history of art, the fifteenth century is remarkable for the importance of the independent Duchy of Burgundy, which at this time included the Netherlands, Lorraine, claims on Switzerland and Savoy, and the rich cities of Bruges and Ghent as well as Dijon—in fact the still debatable lands of the Carolingian Middle Kingdom. Burgundian scribes, no longer monks but professionals, now wrote their grand non-liturgical books in

OPPOSITE ABOVE **162** Detail from the *Adoration of the Holy Lamb* by Hubert and Jan van Eyck. 1432. Ghent, St Bavo.

OPPOSITE CENTRE **163** Lettering on the frame of the portrait of Charles VIII of France by Jean Fouquet. *c.*1445. Paris, Louvre.

OPPOSITE BELOW **164** Detail from the *Hours of Etienne Chevalier* by Jean Fouquet. Mid-fifteenth century. London, British Library, Add. ms 37421.

a new style, Bastarda (Fig. 160); this was less serious and austere than Textura and made a new sort of pattern with its strong, pointed diagonals. Flemish, Burgundian and French painters were interested in lettering and often introduced it in their paintings: they too were clearly tired of Gothic and were looking for alternatives. The lettering on the great *Adoration of the Lamb* by Van Eyck in Ghent (Fig. 162)[7] is an important element. Many Gothic forms are retained (M, P, G, D, E and L), but not the Gothic interest in curves: square C is revived, and both stems of A are straight and almost vertical. Alternatives to the Gothic forms are also used.

Elsewhere, the changes are more experimental. The French painter Jean Fouquet tried several styles. That on his portrait of Charles VIII of France, painted about 1445, with its broken-back E and recoiling S (Fig. 163), did not apparently appeal to his contemporaries, who preferred to use versions of the letter-forms more in the style used in his *Hours of Etienne Chevalier* in the British Library (Fig. 164): stilted, illusionist, Gothic in feeling, not Gothic in form. These seem very expressive of this moment, when chivalry and scholasticism were mixed with exploration and individualism, and when late Gothic and early Renaissance were contemporary and often intertwined.

In this time of transition certain features emerge. In the north the Gothic tradition is the starting-point, and there is little sign of classical influence; but at the same time Gothic preferences and Gothic norms are being rejected. As with Van Eyck, the interest is in vertical rather than curved forms; proportions are compressed, and thick and thin strongly differentiated. The long serif is ceasing to be important; instead, letters are wedge-terminated or even sanserif, as in the French *Book of Hours* (Harley ms 2877) in the British Library (Fig. 167). For new forms, designers everywhere seem to be looking to the Romanesque for inspiration: for instance in forms of D, M, N as well as C. The wedge-shaped stroke is reminiscent of the letters of about 1200 in S. Marco, Venice. In these tendencies one can see the beginning of one of the lines of experiment of the next century.

In Spain, the picture is even more confused. On Burgos Cathedral there is a parapet of monumental lettering: it is in Textura, but presages the architectural examples of the future. In the two great rooms of the Palace of Al Jaferia at Saragossa there are magnificent friezes dated 1472 in a very compressed script which is minuscule except for A and R (Fig. 166). In the Cappella Palatina in Palermo there are inscriptions commissioned by Ferdinand and Isabella of Spain which run above the twelfth-century mosaics (Fig. 165). It is extraordinary how even in the setting of the superb mosaics these still tell through the uninhibited vigour of their design. Some letters are made of leafage and some end in foliage; sizes also vary, but most noticeable is the interweaving of letters with one another. The lettering in the aisles is somewhat later (1482), but similar, done also to the order of Ferdinand.

The fifteenth century was a century of exploration; it was of course also the century of the invention which revolutionized the course of the history of lettering: printing (Fig. 168). The great succession of manuscripts in which, by and large, the finest and most inventive work had been done hitherto, is now coming to an end. Henceforth the material will be found elsewhere, made for different purposes.

OPPOSITE ABOVE **165** Detail of the inscription above the mosaics in the Cappella Palatina, Palermo, commissioned by Ferdinand and Isabella of Spain. 1482.

OPPOSITE LEFT **166** Part of the inscription round the great room in the Palace of Al Jaferia, Saragossa, commissioned by Ferdinand and Isabella of Spain. 1472.

OPPOSITE RIGHT **167** Detail from a French manuscript by Jean Bourdichon. *c.*1500. The letters are almost sanserif. London, British Library, Harley ms 2877.

168 Type-design. Aldus Manutius,
Hypnerotomachia. 1490.

Notes

1. This page is reproduced in Charles Mitchell,
A Fifteenth-Century Italian Plutarch, pl. 1, 1959.
For this form of M see Appendix, p. 225.

2. Roberto Weiss, *The Renaissance Discovery of
Classical Antiquity*, p. 19, 1969, cites two examples
of early fourteenth-century travellers who found
Roman inscriptions hard to read.

3. The John XXIII inscription is reproduced by
Dario Covi, 'Lettering in Fifteenth-Century
Florentine Painting', *Art Bulletin*, 1963, together
with other examples of painted and carved
lettering in this style. See also N. Gray, 'Sans
serif and Other Experimental Inscribed Lettering
of the Early Renaissance', *Motif* 5, 1960, and G.
Mardersteig, 'Leon Battista Alberti e la Rinascita

del carattere lapidario nel Quattrocento', *Italia
medioevale e umanistica* 11, 1959.

4. See N. Gray, op.cit., *Motif* 5, pls. 16, 17. The
lettering on the Tempio Malatestiano is also
reproduced in A. Bartram, *Lettering in
Architecture*, 1975. Stanley Morison, *Politics &
Script*, p. 269, suggests that the new Italian letters
are 'strongly reminiscent of the Rome of say 150
BC', and that the pioneers such as Poggio,
Donatello and Alberti were deliberately reviving
Republican sanserif letters because this was the
Roman period which they admired. This
example in Rimini seems to me the only
one—apart from Fig. 151—which is at all close to
the Republican inscriptions in style.

5. On Mantegna's lettering see M. Meiss,
'Towards a More Comprehensive Renaissance
Palaeography', *Art Bulletin* XLII, 1960.

6. Reproduced in A. Bartram, op.cit., pls. 19, 22.
See also R. Papini, *Francesco di Giorgio Architeto*,
1967.

7. For reproductions of other lettering on the
painting see Ludwig Baldass, *Van Eyck*, 1952.

A Time of Division

1500–1650

In the mid-sixteenth century Europe was split by the Reformation. Almost everywhere the minority, whether Catholic or Protestant, was persecuted by the governing majority. Religious strife, complicated by political issues, distracted Europe for a century. The Religious Wars in France lasted from 1562 to 1593. The Revolt of the Protestant Netherlands against Spanish rule began in 1572 and did not finish until 1609. In England there was civil war between 1642 and 1651. In Germany the Habsburgs, the French and the Swedes fought one another for thirty years until the Peace of Westphalia in 1648.

In lettering the picture is now also one of division. The classical letter, revived in the previous century, was supreme only in Italy. Elsewhere its dominance was patchy. In Germany, in contrast, the new century begins with the invention of a new Gothic letter, Fraktur, and with the remarkable creation of the new broken Gothic capital. Most characteristic of the time were the spasmodic attempts made in France and England to find a new style, neither Roman nor Gothic, turning for inspiration to Romanesque prototypes.

The scene had, of course, been to a large extent transformed by the invention of printing in the mid-fifteenth century. The requirements and techniques involved in letter design had been expanded and a new profession created, that of type designer (Fig. 169). Type design involved new problems: the working out of two alphabets, upper- and lower-case, in which standard letters should harmonize in infinitely variable juxtapositions to make a page of legible, balanced design. These were problems similar to those involved in the creation of the medieval text-hands which had been developed by scribes, and the design of early types was based on this experience, and only gradually discarded. Type design does not, however, come within the scope of this book, except as a factor in the background, until the nineteenth century, when the demand for display faces created a new field for the design of capital letters.

By 1500, scribes were no longer needed to write books, although the traditional need for notaries in chanceries, and in legal and business offices, continued. Many scribes now combined this work with that of a new profession, that of the writing-master. Here opportunities were expanding. Gentlemen and women wrote their own letters, and good handwriting was an admired accomplishment. The writing-masters advertised their skill by publishing books showing sample pieces, usually in a number of different styles: these were often elaborate compositions, more pieces of virtuoso design than practical models for the student (Figs. 174, 175). These provide a new and important type of material for the historian of script.

The divergencies in European culture are immediately apparent from this material; so too is the extent of correspondence between lettering of this sort and art-historical styles. The earliest books are Italian, showing most prominently examples of the new italic chancery script, although including also other traditional local mercantile hands.[1] The first

TOP LEFT AND RIGHT
169a,b Type-design.
Garamond upper- and
lower-case (cast from
original matrices in the
Plantin-Moretus Museum,
Antwerp).

CENTRE **170** Italic
handwriting, dated 1517.
The examples given in the
writing-masters' books
are set-pieces reproduced
by woodcuts, losing
spontaneity.

RIGHT **171** An example of
secretary-hand, the
English version of a
Gothic cursive which also
continued in use. Dated
1534. It is a script with
great vitality, which
contributed to the beauty
of seventeenth-century
hands. London, British
Library, Cotton ms
Cleo.E.6.

138

was that of Sigismondo Fanti produced in 1514. In 1524, Ludovico Vicentino degli Arrighi produced his book, in competition with that of another master, Giovannantonio Tagliente, both of which appeared just before the disastrous sack of Rome in 1527. This sack was a momentous event which contributed to the change in feeling between the optimism, balance and grandeur of High Renaissance art and the disillusion of Mannerism. The new master is Giovan Cresci, who published the first of his three books in 1560; he stressed the importance of speed and offered a model which was more sloped, less angular. With the chancery hand went new capitals, flourished versions of the Humanist pen-letter but with its rustic origins now discarded (Fig. 173). More typically Mannerist are the books of the French master Pierre Hamon (published 1561), and that of Francesco Baildon and J. Beauchesne, published in England in 1571. In these we find compositions based not on the uniform italic slope, but on a rhythm of contradictory movements.[2] A generation later, in the Netherlands, the mood is essentially Baroque. Here the great master is Jan van der Velde, who published his book *Spieghel der Schrijfkonste* in 1605, about the time when Rubens was painting his first Baroque pictures (Fig. 174). This book shows a number of wonderful linear compositions: some based on accenting and prolonging the curves of capitals and letters such as v, h, m and g, and others contrasting this movement with the verticals of f and s or, most brilliantly, with diagonals made by d, y and x. These compositions, which seem far more concerned with abstract pattern than with legibility, are surrounded by great spiral swirls and begin with an elaborate initial. The technique of line-engraving by which van der Velde's books were reproduced certainly lent itself to such swirls, more than the woodcuts used in the earlier Italian books.

Such compositions are undoubtedly works of art, but the cursive styles evolved at this time, like medieval book-hands and the contemporary text types, are only background material in the context of the present study. Consideration of the many diverse and often fascinating styles presented in these writing-masters' books has therefore been omitted.

I have noted the flourished initials of the masters of the chancery script; far more cre-

ative and original are those invented in Germany. The new writing style, Fraktur (broken), was evolved in the Imperial Chancery. It became the most used of all Gothic type designs and was still used in Germany in the twentieth century. The pen-written version is shown in the writing-book produced by Johann Neudörffer in 1538, but here it is subordinated to the great initials, often reduced to a small, very regular zigzag. These initials are the second version of the Gothic majuscule, the broken letter (Figs. 172, 175).

The search for the origin of this letter takes us back to the twelfth century. Then one can see that the notaries writing charters used a rustic construction in forming their capital letters, building them up with separate strokes: so C is started at the top downwards, a horizontal is then added above; R starts with a down-stroke, ending in a movement to the right, the rustic serif, and the bowl and leg are added. In order to give emphasis to these capitals, one of the strokes is often doubled. In Italian manuscripts of the thirteenth century written in Rotunda there are pen-drawn capitals of similar construction in the text, but rounder, and the doubling stroke may be a zigzag; and the round letters C, E, O and Q may also have a vertical line down the middle. Later Gothic scripts and early type designs multiply complications, and curves begin to be broken into separate strokes meeting at an angle. By the beginning of the sixteenth century a style has been evolved, but one which is extremely difficult to define.[3] Verticals may be doubled or ornamented, or emphasized by a row of diamond shapes; curves may be broken into two converging lines; and the vestigial rustic serif may be emphasized on letters such as A, H, K and R. But none of these practices are rules which are consistently applied. The starting point is apparently the round Gothic alphabet with rustic survivals in A and D, but the underlying form seems to disintegrate; for every statement one makes one finds exceptions. It is as if in reaction to the rationalism of the round majuscule a deliberately nonconforming letter was produced. Like Peer Gynt's onion, it has no heart.

Perhaps for this reason the broken Gothic capital proved a wonderful vehicle for endless diversifications; it is not surprising that it was invented by chancery scribes who had

inherited the tradition of embellishing documents with elaborate opening and closing lines. The grandest examples were designed at the end of the sixteenth century by Christoph Fabius Brechtel, Anton Neudörffer (grandson of Johann), Jost Amman and Paul Franck (Fig. 172). They appear in their manuals, but are also found in the genealogical books produced for eminent families. The letters are dissolved into great swirls of magnificent asymmetrical linear movement, here dark and foreboding, there melting into diaphanous curls. Richness is attained by contrasting line-width, variety by dramatic breaks in the surging curves, made by sudden interpolations of interlace or of cross-strokes. They have been compared to counterpoint in music; one is also reminded of the late Gothic German sculpture in wood with its piled-up drapery, as well as of the later splendours of German Baroque architecture. These great letters do indeed continue into the eighteenth century (see Fig. 196).

Broken Gothic letters are found in the books of writing-masters in other countries, though with characteristic differences. The Italian examples are decorative and elegant, but the element of fantasy is missing; those of the Frenchman Tory are strong and lucid; and the English examples are complex but rather wiry. The latter are reproduced by line-engraving, whereas the early German books are woodcut or etching, media which seem sympathetic to the unique quality of the German work, which alone conveys a sense of imaginative power, an element of sinister Nordic darkness which makes its productions outstanding examples of lettering as a creative art.

Textura also continues throughout the sixteenth century as a decorative script; particularly magnificent are the great woodcut title pages using Textura or Schwabacher (a version of Bastarda) on a monumental scale (Fig. 176),[4] as in Dürer's opening page of his *Apocalypse*. And Textura is still used on tapestries and on ceramics. There is a new rather thin and spiky version found on tombstones in both Belgium and Portugal, but ceramics illustrate another potentiality, its capacity to create dynamic pattern, to be exploited later by Rudolf Koch. Italian drug jars are often inscribed with romans, but in other countries broken Gothic initials are often combined with Textura, and the tradition continues into the eighteenth

century. Because the painted line is wide and strong, movements which contradict the verticals have a particular vitality (Fig. 177).

The most exciting ceramic lettering is, however, that on Hispano-Moresque plates and jars; the first examples date from the fifteenth, and the best from the sixteenth, century. The craftsmen may have been Moorish, used to the superb tradition of Islamic lettering, for instance on the great Alhambra vases made in Valencia[5]. They use several styles of Latin lettering, including Textura of great energy, and a round letter in which they do not seem to be so much at home; also a version of the transitional letter of this period. Calligraphy is an important element in the design of this magnificent lustre-ware, and its productions are perhaps the most remarkable examples of Latin lettering in this medium (Fig. 178).

Similar in the placing of the text is the lettering on sixteenth-century German brass dishes (Fig. 179). The style is normally Textura or the contemporary transitional Roman, though unfortunately the letters are often blurred with cleaning.

Most writing-masters' books include together with the pages of script which we have mentioned, alphabets of Roman capitals. These are in direct sequence with the alphabets produced by Feliciano, the friend of Mantegna, in 1463, and other Italians, such as Mollyus and Pacioli who made alphabet books in *c*. 1480 and 1509. Dürer also included a Roman alphabet as well as—indeed more prominently than —his Gothic version, in his book *On the Just Shaping of Letters* (1625). All these letters are drawn within a square and related to a circle (Fig. 180). They are illustrations of the Renaissance interest in the importance of proportion

OPPOSITE ABOVE LEFT **172a,b** Capital letters designed by Paul Franck. The broken Gothic capital at its grandest, from *Schatzkammer Allerhand Versalien*, 1601.

OPPOSITE ABOVE RIGHT **173** Capital letters associated with the new Italian handwriting. From G. A. Tagliente, *L'Arte di Scrivere*, 1525. The forms are still uncertain and experimental.

OPPOSITE BELOW **174** A page from Jan van der Velde, *Spieghel der Schrijfkonste*, 1605.

OPPOSITE **175** Page from Johann Neudörffer, *Ein gute Ordnung*, 1538.

OPPOSITE BELOW LEFT **176** Woodcut title-page of the index to the *Chronicle* of Hartmann Schedel. 1493.

OPPOSITE BELOW RIGHT **177** Drug jar made in Deruta. *c*.1500. London, Victoria and Albert Museum.

ABOVE RIGHT **178** Hispano-Moresque dish. Other examples show Gothic lettering. Late fifteenth century. Paris, the Louvre.

RIGHT **179** German brass dish. Sixteenth century. London, Victoria and Albert Museum.

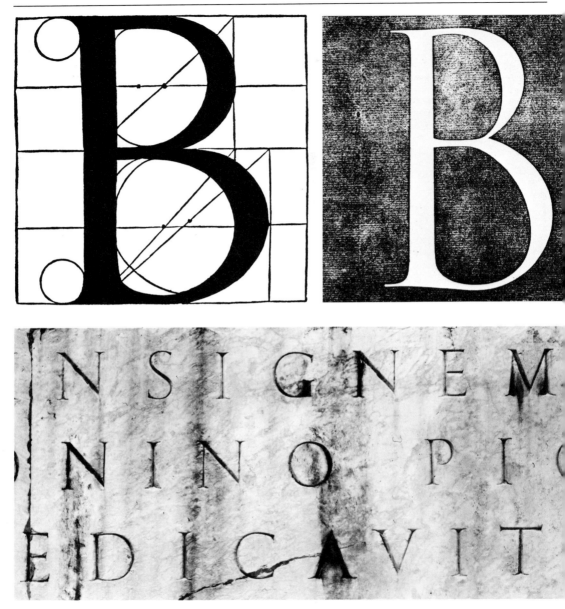

TOP LEFT **180** Letter constructed on a mathematical basis. From the alphabet of Luca Pacioli. 1509.

TOP RIGHT **181** Letter based on the 'Trajan' model. From *Il Perfetto Scrittore* by Cresci. 1570.

ABOVE **182** Inscription on the base of the obelisk in the Piazza Laterano, Rome, designed by Horfei. The letters are classical but the spacing is not. *c*.1588.

OPPOSITE ABOVE **183** The inscription on the Rotes Haus, Trier. M and R are unclassical in design. 1684.

OPPOSITE BELOW **184** Balustrade lettering. Castle Ashby, Northampton. 1624.

TOP **185** Cast-iron tombstone. 1677. Wadhurst, Sussex.

CENTRE **186** Tombstone in the Church of St Peter, Leiden. The inscription is carved in relief. Seventeenth century.

BOTTOM **187** Painted inscription on the staircase in the Fuensalida Palace, Toledo. Probably sixteenth century.

and in mathematics and in the Platonic idea of perfect form. Most of these letters are beautiful, but they demonstrate two facts. Firstly, that although there is a relationship between Roman forms and the circle and the square, this is approximate rather than basic: had it been basic, surely all these alphabets should have arrived at the same, instead of slightly different, solutions. Secondly, that mathematical principles were not the basis upon which the 'Trajan' alphabet was constructed; these alphabets all differ from that prototype. This is shown very clearly in the sixteenth century, when designers started to study Roman lettering in detail.

A pioneer in the new approach was the writing-master G. F. Cresci. We know that he studied the Trajan inscription very carefully, rejecting the claims of geometry and re-establishing the criterion of the eye as the arbiter of judgement (Fig. 181). His alphabet was largely followed by Luca Horfei who designed much of the lettering connected with the great town-planning works in Rome inaugurated by Pope Sixtus V (1585–90). On the base of the many obelisks which Sixtus erected may be seen inscriptions in the new style (Fig. 182). The form of the letters is Roman, but the spacing is very different, wider and more spacious, giving a new character to the design. The great mosaic inscription round the interior of St. Peter's shows this style of lettering at its grandest and most appropriate. It may be seen also in other churches, palaces and monuments in Rome.[6]

This Italian letter is far removed from the contemporary broken Gothic capital. Between these two poles there is a great variety of diverse lettering surviving from the sixteenth and early seventeenth century.

There are many examples of roman lettering on buildings and monuments, but outside Italy this does not mean strict conformity to the historic 'square' capital of the Romans. As in contemporary type design, there is much variation in the detail of the drawing of capitals. We have to distinguish between 'Roman', meaning the particular letter invented by the Romans for their grand inscriptions, of which the recognized example is the Trajan column inscription, and 'roman', the much less precise letter classification for forms corresponding more or less to the Roman style. In the sixteenth century it is not always easy to decide whether some examples are sufficiently orthodox to deserve even this latter description.

The inscriptions on the tombs of Lady Margaret Beaufort (1511) and Henry VII (1512) in Westminster Abbey are very pure, but they were designed by an Italian, Torrigiano. The lettering on St. Michael's Church in Munich and on the Rotes Haus in Trier (Fig. 183) is impressive, but in both cases the R is conspicuously non-roman. Another sort of R found in bronze memorials in Germany has a leg with a concave curve,[7] a form also found in Italy, for instance on ceramic plaques.[8] The Munich inscription shows another new practice, that of using larger initial letters.[9] Yet another new fashion is the use of square section letters, as on the gates of Gonville and Caius College, Cambridge. One also finds inscriptions in relief, as on the Cathedral gateway at Canterbury, at Hampton Court, or at the Casa Miranda, Burgos.

Perhaps the most remarkable innovation of the period is the use of lettering as an important architectural feature. In Spain Textura inscriptions are used outside Burgos Cathedral, as well as relief roman lettering round the inside of the dome and that of Saragossa Cathedral (in the same position as the Arabic lettering in the Sala de Dos Hermanas in the Alhambra). In France at La Ferté Bernard (1535–45) there is a balustrade of free-standing letters around the outside of the apse.[10] But it is on English country houses that the most remarkable series are found: at Hardwick Hall in Derbyshire (1597), Castle Ashby in Northamptonshire (Fig. 184), Felbrigg Hall in Norfolk, and Skipton Castle in Yorkshire. (In Scotland they are found at Dunfermline.) Examples since destroyed also existed at Northumberland House, Charing Cross and the outer court at Audley End. All these were in stone; another at Temple Newsam, Leeds, was later replaced in bronze.[11] For the first time letters are given a new dimension: the bronze letters of Roman triumphal arches must have been in relief, but these now stand silhouetted against the sky, the forerunners of modern sky-line letters. In style there are certain common characteristics: letters are more or less even-line, with minimal serifs. They are wide, with a circular O; M is straight-sided, and the spacing is open.

There is perhaps some similarity between this lettering and that on the cast-iron tomb-

slabs in Wadhurst in Sussex (Fig. 185), Sale-hurst in Kent, Burrington in Herefordshire and Bridgnorth in Shropshire—not that these are uniform, but there is a common taste for a stocky, almost even-line, short- or wedge-serifed letter, not unlike contemporary relief lettering in Holland, such as that in the Church of St. Peter in Leiden (Fig. 186). In contrast there are delicately carved memorial stones of this period, for instance in Winchester Ca-thedral. In fact, there is great diversity.

There is, however, one type of letter which reflects a tendency that is typical of the six-teenth century. It is to some extent a continu-ation of the transitional style of French let-tering of the preceding century, of an attitude which, while rejecting the Gothic tradition, does not wholly accept the classical revival; which turns to the Romanesque for inspir-ation, wishing perhaps to retain something of previous tradition. Sometimes it seems to be just a question of using one or two non-roman forms; sometimes of wayward self-expression; and sometimes a real style is achieved. Typical letters are A with a bar across the apex, or perhaps a broken cross-bar; G is round, not spurred, and so sometimes is D. The sides of M

Ƭ G D Đ

and N are straight and heavy, the diagonals thin; M has a short-ranging v, and sometimes

M N

it is drawn like an H with a vertical falling from the centre of the cross-bar. The diagonal of N

H

may be thin and curved, or short, not reaching to either base-line, and there may be a nick in this cross-bar, also in that of H. O may be pointed; E may be Greek, with a double curve.

Ɛ

Letters are normally fairly square—not com-pressed as with some earlier French tran-

sitional letters. Terminations are often wedge-shaped, sometimes with a bite out of the base; there may also be a bite or a bulge in the middle of the stem.

Examples of this tendency are widely dis-tributed. In Spain, it appears on buildings, for instance on the staircase in the Fuensalida Palace in Toledo (Fig. 187); in France, on paint-ings (Fig. 188) and on manuscripts such as the Hours of René of Lorraine (now in New York); in Germany on tombstones such as that of Johannes Ghainer in Staubing (Fig. 189), on paintings such as that of Hans Maler zu Schwarz (Fig. 190) and in woodcuts. In England they are often carved in wood (Fig. 191). They are to be seen outside houses, on choir-screens, pew-ends, etc.[12] The example carved in stone on the chancel screen in Winchester Cathedral in 1525 is typical. In England also we find some of the more wayward inscriptions, for instance on the tombs of Thomas Bennett in Salisbury Cathedral or that of Bishop Shurburne in Chichester, both slightly compressed and medieval in feeling. The very prominent inscription on the pulpit at Wells Cathedral is strong, almost wild, using the same R as in Toledo and a D of rustic derivation—quite a common form at this time. The pulpit was erected by Bishop Knight (1540–7). There is the same unrepressed vigour on the tomb erected by Archbishop Sandys (1575–88) to his father in Hawksyard Church in Cumbria.

OPPOSITE TOP **188** Painting of *Three Prophets*. School of Avignon. End of the fifteenth century. Paris, The Louvre.

OPPOSITE, SECOND FROM TOP **189** Rubbing of a detail from the tomb of Johannes Ghainer, Straubing, 1482 (from Wilhelm Weimar, *Monumental Schriften*, 1898). This type of eclectic lettering is clearly continuous with the French and Spanish experiments described in the last chapter.

OPPOSITE CENTRE **190** Painting by Hans Maler zu Schwartz. 1517. New York, Metropolitan Museum.

OPPOSITE BELOW **191a,b** Part of the incised lettering on a wooden Communion table, North Walsham Church, Norfolk. *c*.1550.

EGREDIETVR · VIRGA · DE · RADICE · IESSE · ET · FLOS
DE · RADICE · EIVS · ASCENDET · ISAIE · XI

ES ⁊ GHAINER ⁊ E

LES ⁊ VOS ERIT

DA MAN · 1517 · ZALT · SEBASTIÃ
WAS ICH · 48 · IAR ALT ANNDORFE-
ER

AND BLOVD
THE BODY OF OVR
WAS GEVEN FOR

The medieval world order was broken, an alternative was still in the making; divergent new ideas and inherited traditions co-exist. We are in the world of Shakespeare where Catholic and Protestant, pagan, Christian and faery ideas and beliefs are accommodated in rich if incoherent variety, to be rationalized and ordered in the succeeding century.

Already in the mid-seventeenth century there is once more a period of change. Cursive capitals are growing more ordered and consistent (Fig. 199). In England and Belgium there is the new vogue for lower-case and italic inscriptions. And in France the classical is at last triumphant, for instance in the grand lettering inside and outside the Church of Val de Grâce in Paris, built by Mansart and Lemercier 1645–67.

Notes

1. The chancery-hand and the books of the early Italian writing-masters are fully dealt with by A. S. Osley in *Scribes and Sources*, 1980.

2. For reproductions from the books of the writing-masters see P. Jessen, *Masterpieces of Calligraphy*, 1923, and J. Tschichold, *Schatzkammer der Schreibkunst*, 1945. Here I have only mentioned the most characteristic work of each master; most books show a great variety of script.

3. For the German masters see W. Doede, *Schön Schreiben eine Kunst*, 1957.

4. Other examples of such pages are reproduced in Degering, *Lettering*, 1965. Tombstones show similar designs; see Weimar, *Monumental Schriften*, 1898, pl. LI; bronze, Nuremberg, 1591.

5. Alhambra vases are reproduced in A. W. Frothingham, *Lustreware of Spain*, 1951, and Sourdel-Thomine and Spuler, *die Kunst des Islam*, 1973, pl. 300 (Propyläen series).

6. The letters of Cresci and Horfei and their relation to the Trajan column letters and to other contemporary Italian inscriptions are dealt with fully by James Mosley in 'Trajan Revived' *Alphabet*, 1964.

7. Reproduced in Weimar, *Monumental Schriften*, pl. XVI, Merseburg 1514, pl. XXVII Magdeburg 1513.

8. This sort of R is seen in the school of Della Robbia plaque of 1512 in the Victoria and Albert Museum. In the inscription round the drum of the dome inside Burgos Cathedral, the bowls of B and bowl and leg of R end in curls.

9. Larger letters sometimes also occur in the middle of words; they are used to indicate the date (in Roman figures).

10. Reproduced in J. Kinneir, *Words and Buildings*, 1980; see also A. Bartram, *Lettering in Architecture*, 1975.

11. A. Bartram, op.cit., illustrates a number of these houses.

12. I have noted examples of lettering in this style in wood on the screen in the Abbey Dore in Herefordshire, on houses in Chester and Shrewsbury, and in Churches at Bibury and Buckland, Oxfordshire.

The Triumph of the Classical

By the mid-seventeenth century principles of order and stability were being re-established. The Roman Church was reorganized and consolidated through the Counter-Reformation. Holland was independent and prosperous. In England the Restoration was succeeded by the Glorious Revolution of 1688, and the Hanoverian monarchy. Spain was in decline, and both Italy and Germany were divided into a number of different states; but France had recovered from the wars of religion. This is the age of Louis XIV, to be succeeded by the Enlightenment. It is in France that the new classical revival was initiated, with the plays of Corneille and Racine, the painting of Poussin, the architecture of Mansart and the foundation of Academies for the regulation of language, science, art and literature according to correct principles.

It is, however, a classical revival with a difference. The revivals of the Carolingian period and of the later Italian Renaissance had revived the classical Roman letter in its second-century 'Trajanic' form; this time, as with the makers of the Italian mathematical alphabet-books, it is a revival of the idea which is felt to be behind the Roman letter: the idea of excellence based on the perfection of each part, of order throughout, and of classical as opposed to romantic ideals. One becomes aware of the flexibility of the Roman alphabet. Without changing the form or construction of the letters, alterations can be made in stress; the line-width may move from thick to thin on a vertical or a tilted bias, gradually, or abruptly; the contrast between thick and thin can be

emphatic, or barely perceptible; serifs can be long or short, bracketed or unbracketed, blunt or pointed. 'Trajan' is in fact only one version of this roman letter, one which, as James Mosley has pointed out, was selected as a standard only in sixteenth-century Rome and twentieth-century England.[1]

The evolution of this idea of the roman letter, and the formulation of two distinct styles within this idea, the modern face and the English vernacular, is the theme of this chapter (Figs. 192, 193). There are, however, other strands in the web of lettering history, and in the seventeenth century we are still in the Baroque period. The sixteenth-century transitional letter has now become obsolete, replaced by more orthodox and restricted experiments in the roman idiom, but Gothic is still alive. It is no longer a normal letter outside Germany, but as a decorative letter the initial is still important in documents and in the writing-masters' books, and it acquires a new function in the decoration of the opening lines on memorial inscriptions (Fig. 194). In Germany, the eighteenth-century tombstone grows more ornate, with diaphanous flourishes complementary to the delightful ornament and statuary of German rococo architecture (Fig. 196). A pleasing counterpart were the painted panels in churches transcribing the Ten Commandments and the Lord's Prayer, now sadly almost all disappeared, though there are one or two still surviving in England and Holland (Fig. 195).

The Baroque letter, curvaceous, dynamic, three-dimensional, which one might expect,

MANUALE

TIPOGRAFICO

DEL CAVALIERE

GIAMBATTISTA BODONI

VOLUME PRIMO.

PARMA

PRESSO LA VEDOVA

MDCCCXVIII.

P. VIRGILII MARONIS

BUCOLICA

ECLOGA I. cui nomen *TITYRUS*.

Meliboeus, Tityrus.

Tityre, tu patulæ recubans sub tegmine fagi
Silvestrem tenui Musam meditaris avena:
Nos patriæ fines, et dulcia linquimus arva;
Nos patriam fugimus: tu, Tityre, lentus in umbra
5 Formosam resonare doces Amaryllida silvas.
 T. O Meliboee, Deus nobis hæc otia fecit:
Namque erit ille mihi semper Deus: illius aram
Sæpe tener nostris ab ovilibus imbuet agnus.
Ille meas errare boves, ut cernis, et ipsum
10 Ludere, quæ vellem, calamo permisit agresti.
 M. Non equidem invideo; miror magis: undique toti
Usque adeo turbatur agris. en ipse capellas
Protenus æger ago: hanc etiam vix, Tityre, duco:
Hic inter densas corylos modo namque gemellos,
15 Spem gregis, ah! silice in nuda connixa reliquit.
Sæpe malum hoc nobis, si mens non læva fuisset,
De cœlo tactas memini prædicere quercus:
Sæpe sinistra cava prædixit ab ilice cornix.
Sed tamen, iste Deus qui sit, da, Tityre, nobis.
20 *T.* Urbem, quam dicunt Romam, Meliboee, putav
Stultus ego huic nostræ similem, quo sæpe solemus
Pastores ovium teneros depellere fœtus.
Sic canibus catulos similes, sic matribus hœdos
 A Noram

ABOVE LEFT **192** Modern face type-design. Bodoni *Manuale Tipografico*, 1818.

ABOVE RIGHT **193** The title-page of Baskerville's edition of Virgil, 1757. Baskerville's designs are prototypes of the style which has been called 'English Vernacular'.

OPPOSITE **194** An English tombstone of 1776. The inclusion of a Gothic heading is typical of the more elaborate designs of the eighteenth century.

TOP **195** Painted panel inscribed with the Ten Commandments, Hooglandsekerk, Leiden. Such panels were common also in England, but have mostly now been removed.

ABOVE LEFT **196** Memorial tablet outside the Peterskirche, Munich. 1702.

ABOVE **197** Bronze lettering on the memorial to Doge Giovanni Pesaro in the Church of the Frari, Venice. 1659.

198 Initial letter designed by Mauro Poggi from his *Alphabeto di Lettere Iniziali.*

199 Capital letters from *A Tutor to Penmanship* of J. Ayres, 1698. It is illuminating to compare these with those of Tagliente (Fig. 173); although flourished and ornate, the letters are now consistent and more ordered. Those of Bickham are even more so.

seems to be very rare on buildings or monuments. The finest I know is a bronze three-dimensional letter enriched with scroll-work in Venice dated 1659 (Fig. 197). It occurs in books of ornamental letters (Fig. 198) but elsewhere in Italy the late-Renaissance Roman continues as a standard letter. It is above all in the books of the northern writing-masters that the Baroque letter is to be found. We have seen that it is already triumphant in the Netherlands at the beginning of the seventeenth century (see Ch. 10, Fig. 174). In France, masters such as Barbedor, Materot and Senault exploited the rich possibilities of contrast between thin and swelling line and soft curves, made particularly appropriate by the use of line-engraving as a medium of reproduction. In England, Ayres, Daniel and Cocker produced as well as ordered designs (Fig. 199) others incorporating exuberant interlace, or proliferating into flourishes which may turn into creatures, fabulous birds or fantastic figures—until they cease to be letters. These seem typical of the Restoration period: sophisticated, elegant, ornate and withal serious; they are contemporary with Dryden (1631–1703), Sir Thomas Browne's *Urn Burial* (1659), theologians such as Traherne (1637–74) and the music of Purcell (1558?–1695).

Among memorial inscriptions there are also examples which might be called Baroque. These are quite different from the later English tombstones decorated with broken Gothic letters, mentioned at the beginning of this chapter, which are eighteenth century. Before this the memorials in our churches and cathedrals show a variety of styles, continuing the earlier tradition of diversity but showing a new taste for lower case and italic, and for movement, indeed restlessness, in design. Figure 204 shows an example from Ripon in Yorkshire with spiky serifs which project beyond the base-lines; another in Worcestershire has odd claw-like terminations. Figure 203 shows another with flourished capitals and strongly curved ascenders and descenders. These very *mouvementé* designs seem to be peculiarly English—though other, simpler memorials also exist. In Norwich, for instance, there is a series carved in relief with strong heavy capitals, and others which are delicate and serene (Fig. 205). It is clear that there were local traditions and workshops where master-masons had their own style which they taught

to their apprentices. There is also the variety in local stones which again affected style.

Elsewhere also there were local styles. There is a Dutch example with a beautiful delicate italic (Fig. 201) used also on Dutch glass (Fig. 202). Different is an inscription in Toulouse (Fig. 200); the close spacing and the characteristic forms of E with a short central arm, straight-sided M and the tipped-up S give this a definite stylistic character. In architectural lettering one can also in some cases distinguish local styles. The relief or square section inscriptions on the river front of Greenwich Hospital (CAROLUS II REX), on the London Monument (1677), on All Saints, Northampton, and on the Sheldonian Theatre, Oxford (1668) (Fig. 207) are identifiably similar, again with a very short central bar to E and G with a very low spur. Different and less idiosyncratic is the great inscription round the Painted Hall at Greenwich. In Munich the gilt letters on the Bürgersaal Church are sensitive if slightly insecure (the C is very beautiful, but the M is not quite right) (Fig. 208). In all this the idea of a classical orthodoxy seems to be gaining momentum, but does not seem to have found an expression which is fully satisfactory.

In France, however, the problems had been examined in detail. In 1675 Colbert, minister of Louis XIV, ordered the Académie des Sciences to undertake the study of craft techniques with a view to their improvement. One result was the study of letter-design. The Renaissance alphabets based on mathematical proportions were studied; so were existing typefaces and the work of the calligraphers. The research was done by Père Sebastien Truchet, Jacques

OPPOSITE TOP LEFT **200** Memorial inscription incised in black marble, 1722. Toulouse, Toulouse Cathedral.

OPPOSITE TOP RIGHT **201** Inscription in roman and italic. St Peter's Church, Leiden.

OPPOSITE LEFT **202** Diamond-engraved italic on glass. Dutch seventeenth century. Rotterdam, Boymans-van Beuningen Museum.

OPPOSITE RIGHT **203** Memorial to Catherine (d. 1708/9) and Richard Gosnell (d. 1726). The flourished letters create restlessness in a different way. Winchester Cathedral.

ANN, RICHARD, a
vive; She was the only
GE PICKERSGILL o
IZABETH his Wife I
HRISTOPHER WAL

204 Detail of an inscription in Ripon Cathedral, Yorkshire. The angle of the serifs creates a restless impression.

205 Gravestone of 1699. Norwich, Norwich Cathedral.

Reliquiæ
GULIELMI NEWBURY
et Notarij Publici, qui C
29° die menlis Julij A
Domini 1699
Ætatis Suæ 62°

ABOVE **206** Brush-drawn lettering on ceramic. Eighteenth or early nineteenth century. The unbracketed serif is also found earlier on ceramics and engraved letterings.

TOP RIGHT **207** Relief metal letters. Note wide E with its short central arm. 1668. Oxford, Sheldonian Theatre.

CENTRE **208** Gilt letters on the Bürgersaal Church, Munich. 1710.

RIGHT **209** Modern face inscription. Namur. 1779.

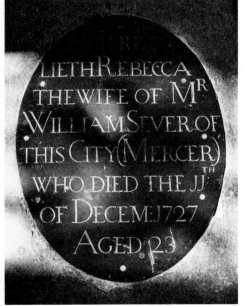

TOP **210** Modern face inscription on the memorial to Dean Swift by Patrick Cunningham, 1766. St Patrick's Cathedral, Dublin.

ABOVE LEFT **211** Tablet dated 1727 in St Cuthbert's Church, Wells. Incised brass, filled in white. An early example of a slab-serif letter.

ABOVE **212** Gravestone at Steeple Aston, Oxfordshire. 1756.

OPPOSITE **213** A page from Bickham's *Universal Penman*. 1743.

To the Right Honourable the

Lord-Mayor, and Court of Aldermen,

Of the City of London.

A B C D E F G H I.

To the Hon^ble the Sub-Governor,

Deputy-Governor, and Directors of

the South-Sea Company.

J K L M N O P Q R

To the Honourable the

Governor, Deputy-Governor, and Directors

Of the Bank of England.

S T V U W X Y Z &

Invented, & Written by Joseph Champion

Master of the Boarding-School, in

King's-Head-Court, S^t Paul's Church-Yard.

Jaugeon, and G. F. des Billettes. They produced designs of upper- and lower-case letters, roman and italic. These were engraved between 1695 and 1716, though they were not published until 1965 when they were reproduced in the *Printing Historical Review*.[2] It is interesting to note that the italic is a sloped roman, not the traditional design derived from calligraphy, so relevant to the problems of modern designers; with computer-aided designs a roman typeface can be sloped automatically. The seventeenth-century alphabets are shown drawn on a grid (Fig. 214), but they were not constructed on a grid; the final arbiter of the design was the eye, not mathematics. From this point of view, they are irrelevant to digital type design. This research was the background to the new typeface, the Romain du Roi, designed by Grandjean for the Imprimerie Royale. The type was actually produced in 1702 while the research work was still in progress.

The *Romain du Roi* was the forerunner of the new roman letter called, because of its typographic origin, Modern Face. This is a roman with unbracketed serifs and vertical stress, accentuated by an abrupt transition from thick to thin in line width (Fig. 192). This was not just an experiment: it is a logical development, finally freeing type design from characteristics irrelevant to its technique, such as the tilted stress derived from the angle between pen and paper, and the bracketed serif native to the chisel. The first true Modern Face fount was designed by Didot in 1784. It seems a complete expression of the age of reason.

Hitherto developments in type design do not seem to have been influential in the design of lettering in other media. Now there is cross-fertilization, though without slavish copying—until the present day, when the specification of a type design has all but destroyed the traditional forms of the sign-writer. The slab-serif letter can be found incised in stone before it appears as a type design (Fig. 211). In the same way the unbracketed hair-line serif, which is natural to the technique of brush-drawn lettering on ceramic, and also to engraved lettering on brass, may be found earlier in these techniques than in type design (Fig. 206). At the end of the eighteenth century, the Modern Face letter becomes normal, adopted for architectural lettering as well as for type design (Figs. 209, 210). Lucid and elegant, it is the form of

roman which was inherited by nineteenth-century commercial designers on the Continent (Fig. 227).

In England, the form was different: more robust, wider, and with bracketed serifs. In the mid-eighteenth century there is a marked change in the design of tombstones and memorials. They become more uniform, but the lettering is finer. Both upper and lower case are used, normally in combination, and the capitals are those to which the name 'English Vernacular' has been given.[3] The influence of Baskerville (Fig. 193), who was a letter-cutter and writing-master before he became a type-designer and printer, must have been of great importance, although no specimen book of his is known and no carving has been identified. His type designs, and versions cut by other founders such as Fry's Baskerville (cut before 1770), introduced the new letter. It was made easily available to letter-carvers and sign-writers through alphabets in manuals such as that of Bickham (*c.* 1760) and Bowles (1775). It became the normal English letter in the early nineteenth century, and the basis upon which the first experiments in diversified letter-design were made (Egyptian, Tuscan, etc.). It is a magnificent architectural letter, a creative design (Fig. 215).

Bickham's book, published in parts between 1733 and 1741, also shows another model, the English 'round hand' (better known as 'copperplate' or Anglaise), the cursive style which became standard in the nineteenth century. Its derivation is clear. The rounded curves introduced into the chancery italic by Cresci have grown more emphatic with time. The ink-filled loops and occasional quirks and extravagant capitals of the seventeenth-century masters are now reduced and ironed out, and the hand is now perfectly regular, flowing in smooth, uninterrupted line, varied only by the regular pressure on the down-stroke (Fig. 213). It is a cursive which can be very beautiful when expertly written by a careful clerk, when sign-written elegantly, when engraved (Fig. 229), and even when carved (Fig. 228). Many nineteenth-century examples survive testifying to this. As a model for ordinary handwriting, it was not successful; few Victorian hands are at all distinguished, in marked contrast to eighteenth- and more particularly seventeenth-century handwriting.

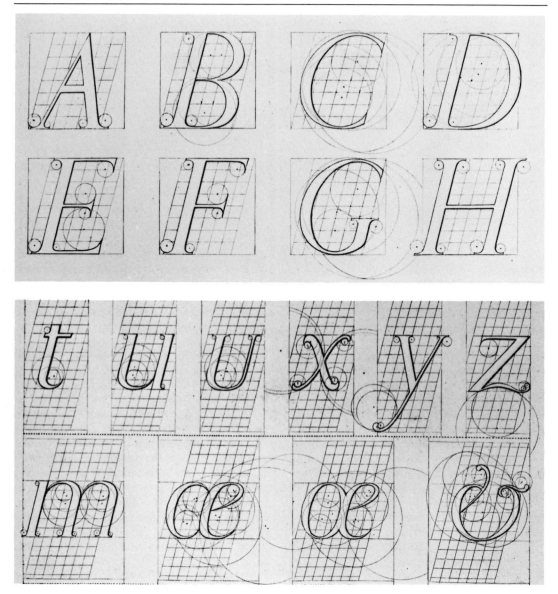

214a,b Italic alphabet designed for the
Académie des Sciences in France. 1702.

Notes

1. See James Mosley, 'Trajan Revived' *Alphabet*,
p. 17, 1964.

2. See André Jammes, 'Académisme et
Typographie', *Journal of Printing, Historical
Society* 1, 1965.

3. See James Mosley, 'English Vernacular',
Motif 11, 1963–4.

The Advent of

Commercial Letter-Design

In the history of lettering the nineteenth century divides into two halves. In the first half, the letters evolved in the later eighteenth century, Modern Face and the English Vernacular, are dominant. But now they are used in a new setting. The Industrial Revolution and all the social change which it occasioned has revolutionized Europe and above all England. Advertising is no longer confined to the manuals of writing-masters, but is on the streets: shops and pubs have names instead of signs, bills are pressed into the hands of every passer-by, walls are painted with announcements, streets have name-plates, and railway stations and engines are identified. Both the reading public and the market for goods has expanded. In the first half of the century, the demand for innovation and variety is met by endless diversification on the basis of the eighteenth-century letters. By about 1870 taste and invention have, however, become more sophisticated. The United States begin to play a more important role. Letters now become flexible and pliant; no longer is it only proportions and terminations which can be varied, but the form itself is mutable—partly due to the influence of the Gothic revival. In all this the way was paved for the experiments of the Art Nouveau designers.

In this chapter I want to deal only with the first phase. Here, as so often when one is dealing with an art produced in most cases by craftsmen—men probably trained in the style of the preceding generation as apprentices—there is liable to be a time-lag. The date of the first production of a display type-face can be fixed fairly accurately from the type specimen book in which it first appears—these were issued by the founders fairly frequently, though not always dated.[1] Tombstones are usually dated, but the masons were not so concerned with adapting to fashion. Shopkeepers commissioning a new fascia for their premises would not necessarily know, and maybe might not want, the latest style in lettering; and it is seldom that present-day occupants can tell one the date of a sign which looks early nineteenth-century. The illustrations to this chapter may therefore easily actually belong to the period covered by the next. They do, however, represent the styles initiated in the years before 1870.

The easiest area in which to study the new letters is the new display types. It is now no longer a question of founts designed solely for books, or of larger sizes intended for title-pages. The new letters are almost all capitals designed for advertising, for bills and posters, all in large sizes and meant to attract attention. So they are stronger, more brash and exaggerated than earlier letters. We get 'fat faces' where the thick line is extra heavy, and the thin extra-fine, Tuscans with curled terminations, not serious and magnificent like the letters of Filocalus (see Figs. 26, 27) but jolly, with curls to every limb, and sometimes in mid-stem as well. There are shaded letters too, imitating three-dimensional forms, and heavy letters with slab-serifs.

Here the connection with architectural lettering is manifest, though it is not possible to be sure for which purpose particular styles were first invented. Most of the lettering still to be

TOP 215 An example of the 'English Vernacular' used as an architectural letter, from Brecon. Early nineteenth century.

ABOVE 216 A 'perspective' architectural letter, that is, a letter with a slanted return. Probably *c*.1860. Lincoln.

RIGHT 217 Slab-serif as an architectural letter, seen in Devizes, Wiltshire, but since destroyed.

RIGHT **218** Ceramic
Tuscan letter. Appleby,
Cumbria.

RIGHT **219** Tuscan used
on a ceramic street name-
plate. Early nineteenth
century. Córdoba, Spain.

BELOW **220** 'Saracen'
metal letter used as a sky-
line display on a building
of *c*.1868. Norwich.

TURNIP
SEEDS
Of various Sorts
To be Sold.
☞ *APPLY TO*
Mr. MERRYWEATHER, Millwood.

Soulby & Thornley, Printers, Market-place Ulverston.

TOP LEFT **221** Sample
letter, etched and gilded
on glass with multiple
shadows. (The gilt has
flaked off in places.)
Probably mid nineteenth-
century, but no doubt in
use for several decades.

222 Typical early
nineteenth-century
layout. A bill printed by
Soulby, Ulverston.

ABOVE LEFT **223** Gilt
letters on glass. Later
nineteenth century.
Lisbon.

LEFT **224** Trade card of
c.1840.

H. W. WHITE,
BOOKSELLER,
BOOKBINDER, PRINTER,
AND
STATIONER,
HIGH-STREET, MERTHYR-TYDFIL.
—o—
ACCOUNT BOOKS RULED AND MADE TO ANY
SIZE AND PATTERN.

seen seems to be made of wood—though it is not always possible to be sure of the material of a letter *in situ* when it has been covered with many layers of paint. It is still possible to find examples of fine English Vernacular lettering dating presumably from the first decades of the century (Fig. 215). In the type specimen books this sort of display letter appears at the end of the eighteenth century. It is followed at the beginning of the nineteenth century by more exaggerated fat-face letters, some with triangular serifs, such as those which survive on the arch of Chester Terrace, Regents Park (built in 1825). The tradition of the earlier, more classical design, however, certainly continues later than this, particularly in the United States, though in Britain it grows debased, particularly in the design of R. The street names carved into the stone in Bath give an interesting conspectus of this style, but unfortunately few can be definitely dated.[2] Some applied letters are given a perspective return, that is, the return is sloped at an obtuse instead of at a right angle, a practice used also with slab-serif letters, presumably to be more effective when seen from below (Figs. 216, 230). Roman 'perspective' letters are rare; slab- serifs must have been commoner, and they are certainly easier to find today.

The first slab-serifs—or Egyptians, as they are more frequently named—appear in the type specimen books in 1815. The even-line structure—in contrast to fat-face letters—corresponds easily with architectural detail, and they are often used very effectively (Fig. 217). The flat relief face of this letter recalls earlier examples such as the Roman metalled letter— seen on the Pantheon in Rome, where the letters have been replaced—and those of Donato Bramante in the Vatican.[3] It is clearly more architecturally congruous than the triangular-section incised letter. The more substantial English version, wider than the French, is a particularly successful creation.

The new Tuscan letter (with curled serifs) was in the early nineteenth century usually made in ceramic, white with blue veining to imitate marble. They must have been produced in quantity by firms making ceramics (Figs. 218, 219). There is also a metal letter with an ornamented face, given the trade name 'Saracen', which seems to have been popular judging from the numbers of surviving examples.

Figure 220 shows an effective use, a new version of balustrade lettering. The richest Tuscans are however those made in glass (Fig. 221), gilt and shadowed, often in several colours. It is a jovial letter and a painted version was much used in fairgrounds—indeed, it is still so used, though in a sadly emasculated version. These are all very different from the Filocalian precursor and from the elegant type design of Fournier in 1764. The intention and the usage are obviously different. Formally, the nineteenth-century version differs from that of the fourth century in having every termination automatically curled. The basic form, however, is still roman, though in the mid-century more compressed letters appear (Fig. 223).

These new display letters were used in every current medium. Many must have been sign-written on walls as well as on shop fascias. In type design there was an immense variety, and as the century progressed such faces were designed with many different expressive intentions, for different purposes and occasions, lugubrious as well as jolly: for trade cards, invitations, auction sales, programmes, etc. (Figs. 222, 224). We have letters which are compressed or expanded, sloping backwards, or away from the paper surface, broken-backed or ornamented with various scrolls or trailing wisps; an unparalleled array of inventive letters differing from medieval invention in

OPPOSITE TOP LEFT **225** A letter from a French alphabet-book. Chicago, Newberry Library.

OPPOSITE TOP CENTRE **226** A French three-dimensional architectural letter. Nineteenth century. Orange.

OPPOSITE TOP RIGHT **227** French street-lettering. Nineteenth century. Toulouse.

OPPOSITE CENTRE **228** Gilt-wood cursive shop-sign. Late nineteenth century. Penrith, Cumbria.

OPPOSITE BOTTOM LEFT **229** Copper-plate cursive incised in marble, from a butcher's shop, Wallingford, Oxfordshire (since removed). Nineteenth century.

230 Sanserif letters on a shop. Edinburgh. Probably mid-nineteenth century.

ABOVE LEFT **231** Tombstone, Tavistock, Devon. 1827.

LEFT **232** Slate tombstone, Wadebridge Church, Devon. 1852.

OPPOSITE ABOVE **233** The letter 'a' from 'Rebus Charivariques'. Paris, c.1840.

OPPOSITE **234** The title page of Richard Doyle, *The Foreign Tour of Messrs. Brown, Jones and Robinson*, 1854. Designed by Richard Doyle.

235 Binding of *Speaking Likenesses* by Christina Rossetti, 1874, designed by Arthur Hughes.

236 Drawing by Victor Hugo of the letters V H (Victor Hugo) and J D (Juliette Drouet). 1855.

that it concentrates on letter surface and proportion rather than on actual form—though in both cases the substance of the letter may be transformed into pictorial terms—so moving beyond the compass of this book (Fig. 225). In the first decades of the nineteenth century the new letters were used very effectively in fairly simple pieces of layout, as in Fig. 222. Later, the excess of material seems to have been too much for the printer. He gave up the attempt to organize his copy and just used a different, not always appropriate, typeface for every line. More creative design is found in the work of artists designing for wood-engraving and lithography (see Figs. 234, 262).

In France the basic letter is the narrower Modern Face (Figs. 226, 227) instead of the Vernacular, though the variations applied to it are similar if rather more restrained; many of the typefaces in the British specimen books were certainly designed in France. In almost every western country one can, or could, see examples of traditional lettering, stock designs, made according to standard patterns which differ in different countries; but nowhere, apparently, is there such variety as in Britain and France.

There are two more styles much used at this period: cursive and sanserif. The 'copperplate' Anglaise of the writing-masters is now used on a different scale. It may be carved in wood and set up as a free-standing legend on the face, or even on top, of a building (Fig. 228); it may be painted (a free-flowing italic was part of the sign-writer's repertory); or it may be carved and inlaid, particularly, it seems, on butchers' shops, where it is often beautifully executed (Fig. 229). I find the carved and painted versions particularly attractive. The latter seems to be a continuous tradition, lasting even into the present century.

In a different category are sanserif letters. All through this book we have come across isolated examples of these letters, but the idea does not seem to have been pursued until the end of the eighteenth century, when it was taken up as part of the revival of Greek architecture—classical fifth-century Greek letters are even-line and sanserif, and small (Fig. 1). In the next century it was used in a very different context and as a different conception, as the alternative names given to it, 'Grotesque' and 'Gothic', imply. First introduced as a type design in England in 1816, it proliferated. Thereafter a number of crude founts of capital letters were produced, first in England and then elsewhere, for use on bills and posters; a heavy black letter, a substitute for Gothic as a letter to give emphasis; more suitable to the new industrial age than the latter with its antiquarian, ecclesiastical flavour. A delightful cheery fat-face black, however, was produced in 1821, an early result of another contemporary movement—the Gothic revival.

Unlike the other variants of the roman, if it can be so categorized, sanserif has been valued and used in different ways and with contradictory intentions. It is in fact more appropriate to treat it as a separate style. It can be considered as a letter with historic implications, Greek in origin, usually drawn small and neat, often in outline, often used on lithographed title-pages. Or it is a letter for emphasis, large and crude, as in newspaper headings. Or it can be thought of as a skeleton letter, the basic form upon which all letters are built (Fig. 277). Or it can be thought of as it is today, as a norm. In Victorian England it was used as an architectural letter: sometimes on a building in classical style, as in Brecon in 1842[4]; sometimes, one feels, simply because it was less complicated to design than an Egyptian, for instance on pubs or shops (Fig. 230). On the big title-pages of some of the large topographical books illustrated by lithography produced in the forties and fifties, the use is more sophisticated. Here the flat surface plane is used to emphasize the contrast between the plane of the paper on which it lies and the pictorial recession behind.

These different ways of thinking of sanserif are very important in considering the nature of letters, but from a formal point of view sanserif is very much a utility letter. The introduction of some modification of line-width is almost always required to give it any subtlety of design. We have seen that some experiments were made in the fifteenth century (Fig. 164) and there is another example at Walcot Chapel, Bath, of 1815;[5] but the idea does not seem to have been pursued until this century, when it has been used in type designs such as Optima (Fig. 280).

These nineteenth-century letters were designed by craftsmen to meet the popular demand for novelty from a wider section of the population. We do not know their names.

Although this is a period when architectural lettering became more widespread and important than ever before, we do not know of architects particularly interested in letter design.[6] One sort of lettering is, however, sometimes signed. Tombstones, particularly those carved in slate, which are the most elaborate, often carry the name of the carver. A list of known carvers is given by William Burgess in his book *English Churchyard Memorials*. In this field the eighteenth-century tradition of fine lettering continued (Fig. 231); now enhanced, or sometimes coarsened, by the inclusion of some of the new letter-forms, sometimes even carved with a shadow, in mock relief (Fig. 232). By the mid-century, however, this art was in decline. Tombstones are duller, using sanserif more often, with less diversificaton.

Throughout this period there are two divergent strands of taste, one reflecting the new industrial age, the other a corresponding need for fantasy. Both strands are reflected in display type design, but the second is catered for more fully in book and magazine illustration, and above all in children's books. It has a part also in the Gothic revival, which was gaining momentum as the century progressed. The taste for fantasy was further encouraged by the development of printing processes for the illustration of books, games etc. Lithography, wood-engraving (as a means of reproducing drawings), etching, steel-engraving were all used. There are delightful initials in many books, often incorporating figures and landscapes, though the picture is often more interesting than the letter. There are title-pages, chapter-headings, magazine covers and bookbindings, children's games and comic alphabets. A great selection has been collected by Massin, and is shown in his book *Letter and Image* (Fig. 233). Very typical are the 'rustic' letters made out of twigs, found earlier in fifteenth-century manuscripts and the books of early writing-masters such as Amphiareo (1565); they reach an apotheosis in the wood-engravings of Dickie Doyle (Fig. 234). The expressionist potentialities of lettering are now developed more than ever before by illustrators such as Granville, Cruikshank, Caldecott, Noel Humphries, Maclisle, and above all Dickie Doyle, whose letters carry us on the breath of the south-west wind and into Fairyland.[7] Letters are made into vehicles of imaginative expression: the strange characters on the binding of Christina Rossetti's *Speaking Likenesses* drawn by Arthur Hughes suggest the singular guests at the children's party within (Fig. 235). Victor Hugo introduces a more brooding, sinister note in the floating intertwined initials of himself and his mistress (1855) (Fig. 236).

Notes

1. For the dating of English display types see my book *Nineteenth-Century Ornamented Type Designs*, 1976; also my article on the slab-serif 1816–50 in the *Printing Historical Journal*, 1980–1.

2. A number of examples of the lettering in Bath are reproduced in A. Bartram, *Street Name Lettering in the British Isles*, 1978.

3. This lettering, designed by Bramante, is reproduced by James Mosley in 'Trajan Revived' *Alphabet*, pl. 8, 1964.

4. The Brecon example is reproduced by A. Bartram in *Lettering in Architecture*, 1975.

5. Walcot Chapel is reproduced by N. Gray, *Lettering on Buildings*, pl. 66, London, 1960.

6. James Mosley notes in 'The Nymph and the Grot', *Typographica* 12, that George Dance the Younger and John Soane had some interest in lettering. Presumably, considering its prominence, Nash approved of the very large letters on the arch at Chester Terrace, Regent's Park, London.

7. Most of the work of these illustrators is wood-engraved. Chromolithographed Victorian lettering is considered in Chapter 13 in connection with the revival of the arts of calligraphy and illumination.

Experiment Unlimited:

1870–1910

Change sets in during the seventies and eighties. It appears first in commercial type design —at least, it is here that the first dated intimations appear, not only in specimen books but also in magazine title-pages and in all sorts of ephemeral printing and design. We find that the innovation is no longer in English and French work; but the Germans and, more particularly, the Americans are in the forefront. It seems as if the demand for novelty is insatiable, and new sources of inspiration were now becoming available in alphabet-books such as that of Silvestre (1850), followed by more popular ones such as that of Delamotte (1859) and Stacoll and no doubt many others.[1] These show drawings of many sorts of letter including ones outside the roman tradition, such as Insular and Gothic. No longer is the letter varied only by compression or expansion, excrescences and different terminations; now the structure itself begins to be altered, as in the early Christian and Romanesque periods, and the roman mould is no longer the only valid basis. The revolution was not only in letter design but in layout. The new style was known as 'artistic printing', and it affected all commercial display lettering, signs and architectural cartouches as well as printing (Figs. 241–4). Today we are very apt to characterize all such design as Art Nouveau, whereas 'artistic printing' was undoubtedly earlier and belonged to a completely different milieu. There were indeed many strands in the complex world of art and design at the turn of the century: different movements and organizations, such as the Arts and Crafts movement, the

Aesthetic movement, the Private Press and the international Symbolist movements, etc. Letters were designed by many different sorts of people, many of whom would have disowned any connection with one another, though today we are most aware of the common factors in their work.

Something still survives of the signs, shop fascias and architectural decoration, though often there is little evidence of date. The taste may seem early, but when the date is known it often proves later than expected; the style seems more or less continuous up to the 1914 War. Nor is it easy to find out anything about the designers. Some of the best work is on glass, particularly in France. I always find the *Boulangerie* and *Patisserie* in the Boulevard St. Germain in Paris one of the best, with its delightful 'melting' letters (Fig. 239). I show also some 'melting' letters from Lisbon (Fig. 240). The French shop has a panel as well as a fascia, and this is a period feature found also in Holland, Spain and Portugal (Figs. 241, 242, 243). Here one can see the new principles of design: asymmetry, and words set diagonally or on a curve, letters planned as letter-combinations as well as fluid letter construction. Similar designs can be seen in pattern books for painted signs, on lettering panels (often combined with ornament), in terracotta (Fig. 244) and stone, and occasionally surviving on sign-painted advertisements, usually on corner walls. By far the most sophisticated examples are, however, those which were printed or lithographed, normally in colour (Fig. 238). For these we also have much better sources, in collections made

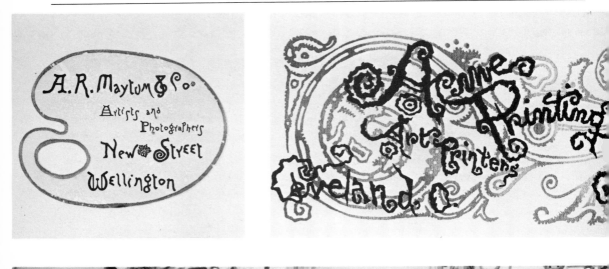

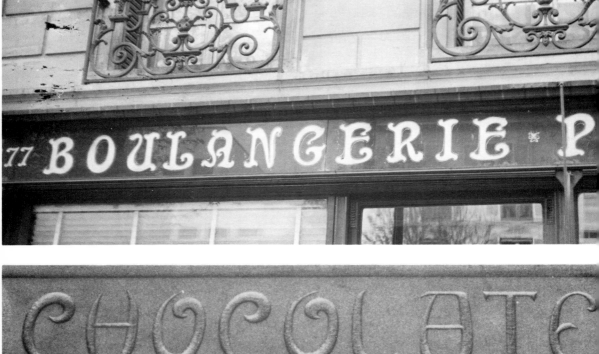

TOP LEFT **237** An example
of the use of an American
display type-design. 1890.

TOP RIGHT **238** 'Artistic
printing', a design from a
collection of examples of
typography. Probably
American. *c.*1887. St
Bride's Typographical
Library.

CENTRE **239** Gilt letters
behind glass. Boulevard
St-Germain, Paris. Late
nineteenth century.

BELOW **240** Shop fascia,
Lisbon.

by contemporaries. There is one such in many volumes at St. Bride's made about 1888—there are also the volumes of the International Specimen Exchange, to which many printers, provincial as well as metropolitan, contributed between 1880 and 1898. The fact that these collections were made is an indication that people found the work new and important. Looking through them, one notes the choice of letter from the immense variety now available (though not in every printer's works) and the discrimination used to give the impression proper to the job, be it a menu or a funeral card. There is craftsmanship too in the elaborate setting and the use of rule to build up panels, and invention in their combination.[2]

How does one judge this work? How can it be compared, for instance, with an example of Romanesque design such as Fig. 119 in Chapter 7? The design problem seems not dissimilar; both are concerned with the meaning of the words set. The printer is, however, committed to the work as a job, whereas the Romanesque artist is giving form to words that he believes important, in a book intended to be used by his community for years; there is a difference in the seriousness of the work, as well as in its make-up. The monk was creating his own letters and giving to each its beauty and an individual relationship with its fellows. The printer was using the selection available to him, which had been designed to meet period taste. These types are seldom the product of real thought or personal feeling. Some are clever and witty; they are often ingenious, but seldom serious. The achievement of the pioneers of artistic printing was not so much that they produced individual designs of importance (one has to admit that most of their work is banal) but that they broke the unimaginative mould of display layout and that they promoted the use of letter-forms which disrupted the established categories of letter design.

Whence did these new forms derive and why were they invented? A major source was the lettering of the Middle Ages, above all the Gothic. Fraktur and Textura had already been revived in the forties. In the seventies one begins to see the influence of the round Gothic capital and the idea of experimental forms: round M, N, H and T; A with a broken crossbar or a flat top; and R and B with bowls, or bowl and leg meeting in a curl.[3] Concave

Gothic stems are taken and exaggerated. Sanserif is also treated as a flexible base to which irregular serifs, often pointing in different directions, can be added. Curls and flourishes are attached to some, but not to all, letters. Lower-case letters become popular because characteristics can be borrowed from informal cursive script, sometimes from brush-written script, and here one comes across another influence, one particularly destructive of the idea of letter-structure, the Japanese. In England the first pseudo-Japanese fount appears in 1868, the second about 1885.

The serious intent and study of Japanese art was pioneered in Paris, and by artists like Whistler and Rossetti. The influence on commercial type design was, however, at a different level, just as the interest in Gothic was different from the serious study of Gothic architecture and manuscripts. It was more related to the vogue for contemporary Japanese and Chinese products such as those shown in the Paris exhibition of 1867, now for the first time becoming available in Europe.

All this time the book-illustrators such as Dicky Doyle were also demolishing the idea of the roman letter by using letters to create atmosphere and, above all, by giving them a corporal body and incorporating them into pictorial designs, as in the later Middle Ages. Many Gothic revival architects also introduced lettering into their buildings, but though any fairly orthodox Textura always looks well, I have not seen any examples where the use is creative. On the other hand the extraordinary lettering used for the signing system at the London Law Courts (it must be one of the first examples of a signing system) with its shamelessly mixed-origin letters is surprisingly successful.

In all this experiment one does not, however, see any sign of a purpose. Unlike the Romanesque period, there is no search for an alphabet; it is this which differentiates 'artistic printing' and parallel developments in other techniques from Art Nouveau experiments. It is indeed true that here too no new alphabet was evolved. The difference is that instead of random search for novelty, what the Art Nouveau artists did was to examine with ruthless logic the possible bases upon which letters could be constructed.

We are now involved in a tradition,different

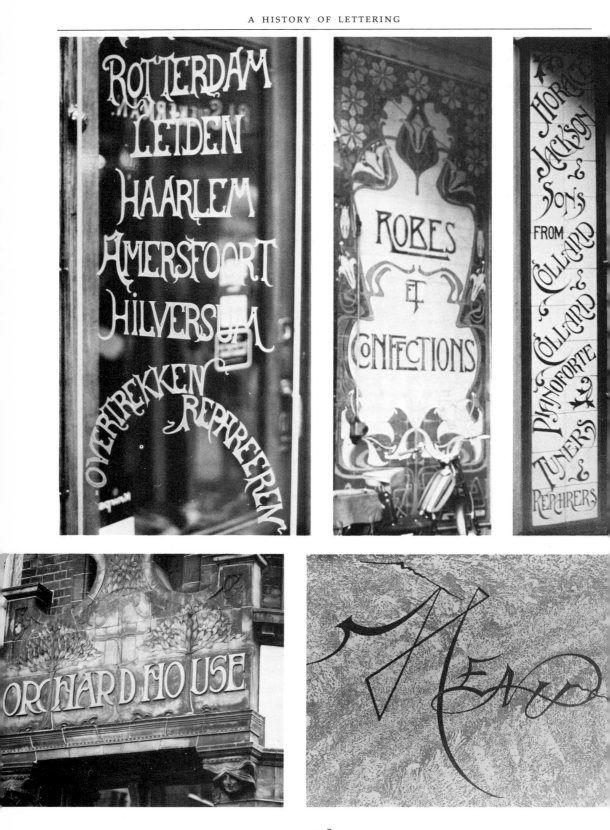

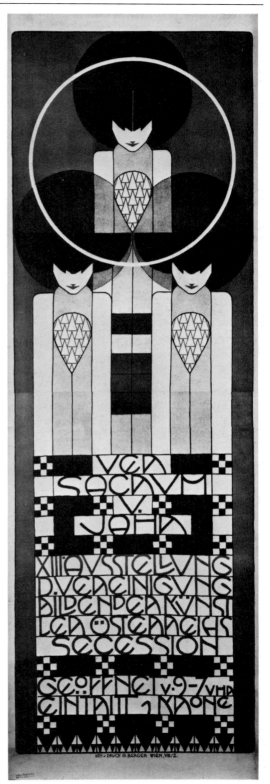

OPPOSITE TOP LEFT **241** Glass panel outside an umbrella shop in The Hague.

OPPOSITE TOP CENTRE **242** Ceramic panel outside a shop in Leiden.

OPPOSITE TOP RIGHT **243** Ceramic panel in Lewes, Sussex.

OPPOSITE LEFT **244** Terracotta cartouche. London, Victoria Street.

OPPOSITE RIGHT **245** Designs for menu heading. Probably American. *c.*1890.

ABOVE **246** Poster by A. Roller for the magazine *Ver Sacrum*, Vienna. 1903.

RIGHT **247** Poster by Kolo Moser. An alphabet dominated by curves and diagonals. 1902.

248 Design by Cissarz, Darmstadt, from *Beispiele Künstlerischer Schrift*. The curves are eliminated. 1906.

249 Design by Max Klinger from *Beispiele Künstlerischer Schrift*. 1902.

LA·FONTAINE·
COROT·MANET·
MOLIÈRE·HUGO
·BEETHOVEN·
REMBRANDT·

VOM ✦ TIEFEN ✦ LEBEN

✿NOTIZEN ÜBER
MEXICO ✿ von Harry
Graf KESSLER,

TOP **250** Design by
Moreau Nelaton from
*Beispiele Künstlerischer
Schrift.* 1902.

CENTRE **251** Letters
designed by Melchior
Lechter. The B is a
favourite period form.
1898.

BOTTOM **252** Title-page
designed by Georges
Lemmen for a book
prospectus. 1898.

253 Design for the journal *Cocorico* by Alphonse Mucha. 1898.

254 Design for a title-page. H. van de Velde.

from that of commercial display design. Professional artists had become interested in new fields; the distinction between fine and decorative art was being broken down and art was part of the whole background of life— furniture, clothes, wallpaper, books, were all part of the artist's province. There were many centres, particularly in Belgium, France and Austria, and many magazines and societies. Lettering was a field in which many artists experimented. A useful conspectus is provided by the examples collected by Rudolf von Larisch and published in his *Beispiele Künstlerischer Schrift* in 1900, 1902 and 1906. These include specimens by artists of many different countries. Larisch invited contributions from those he thought interested and encouraged the idea that these might include all the letters of the alphabet (consequently in some cases the text is nonsense). Here we can see definite, purposeful experiment. In the contributions and other work of Alfred Roller and Krenek the background is treated as positive, with letters as rectangles from which lines, sometimes ending in a dot, are excised in order to differentiate and characterize each (Fig. 246). A three-dimensional application of this idea is seen in the relief plaques in the Garden of the Hochzeitsturm in Darmstadt, one of the centres of Art Nouveau activity. Letters might alternatively be thought of as bounded by a horseshoe-shaped circumference forming a series of similar, almost closed, forms (K. A. Fischel); or they were conceived as linear characters, curves being eliminated. J. V. Cissartz achieves this by introducing two descenders, h and y (Fig. 248). H. P. Berlage introduces four circular letters, O, G, Q and C. The opposite principle is tried out by Kolo Moser, whose alphabet is dominated by curves and diagonals (Fig. 247). Max Klinger is more empirical (Fig. 249): he succeeds in creating a balance by the irregular incidence of stress, combined with forms stressing the diagonal. This combination of curves with diagonals as a dominant motif is a favourite theme.

More complex patterns are derived from the idea of thinking of letters as outlines. The space inside the form is then separated from that outside by a moving line which can be used to equalize the relative areas and to adapt each form according to its neighbour (Roller). R. Riemerschmid bases his outlines on two repeated curves ending in blob terminations. Moreau Nelaton eliminates straight lines, using concave stems ending in wedge-terminations (Fig. 250).

The French and Belgian artists started with more organic concepts, and their lettering often looks freer, less bound to fixed principles. I note, however, that the letter-forms of Georges Lemmen (Fig. 252) which look so free and flowing are actually worked out as an alphabet. The designs shown in the Larisch folders were in fact in many cases used by the artists in other work: posters, magazine covers and titles, and occasionally on buildings. A. Mucha makes a good deal of play with lettering on his posters: a favourite device is to treat them as fluid shapes dripping down to a point. His best design is his heading for the journal *Cocorico* (Fig. 253). T. R. Steinlen's lettering is always interesting; so is that of Henry Van de Velde (Fig. 254). The line at the bottom of the latter's design for the title-page of Nietzsche's *Ecce Homo* is a beautiful example of letter-combination, like the Romanesque, but based on a more consistent alphabet. The movement in his design is masterly in its use of carefully-chosen form and combinations. His designs for bindings are both original and skilful. The master in the more fluid idiom is, however, Hector Guimar. His entrances to the Paris Métro are well-known (and much better than the lettering on the Viennese Stadtbahn designed by Otto Wagner), but the design of that on the Castel Henriette at Sèvres (destroyed in 1969) and that on the Maison Coilliot at Lille are also brilliant.

It is typical of the movement that these letters were often part of some other design, and also that most of the artists worked mainly in other fields: they were painters, architects, theatre-designers, interior-decorators who turned their hand to letter-design. It produced no great lettering artist, but it pioneered experiments in different ways of thinking about the formation and nature of letter-forms, ways which provide useful ground-work for graphic designers today.

There were, however, also professional designers, people like Otto Eckmann, E. R. Weiss, F. H. Ehmcke and Otto Hupp, whose work was not so experimental, who were seriously concerned with traditional values, with type-design and the teaching of lettering, areas

greeted him, but in some-
what surly wise. Then he
said to him: Well, King

255 William Morris. Troy
type. 1892.

Ubi est dialectica? ubi astronomia? ubi sa-
pientiæ consultissima via? Quis, inquam, venit
in templum, et votum fecit, si ad eloquentiam
pervenisset? quis, si philosophiæ fontem at-

256 Charles Ricketts.
King's type. 1903.

257 Eckmannschrift,
type-design by Otto
Eckmann. 1900.

ECKMANN

Geschnitten nach den Entwürfen des Herrn Professor O. Eckmann

DER heutige Tag, an dem Sie auf eine
25jährige Tätigkeit als Chef der Firma
Feld zurückblicken, darf Sie mit froher
Genugtuung erfüllen. Wohl waren diese
25 Jahre eine Zeit der Mühe und Arbeit,
aber auch des Erfolges. Und wenn heute Ihre Firma
zu den vornehmsten und besten Buchdruckereien

Vom Schlechten kann man nie zu wenig und das Gute
nie zu oft lesen: schlechte Bücher sind intellektuelles
Gift, sie verderben den Geist. Um das Gute zu lesen,

258a-c Behrensschrift,
type-design by Peter
Behrens. 1902. (b) Joseph
Sattler, Nibelungen-
Schrift. 1900. (c) Otto
Hupp, Unziale. 1910.

Vom Schlechten kann man nie zu wenig und das Gute
nie zu oft lesen: schlechte Bücher sind intellektuelles Gift,
sie verderben den Geist. Um das Gute zu lesen, ist eine

OPPOSITE 259 Lettering
on the cover of The Dial
magazine by Charles
Ricketts. 1897.

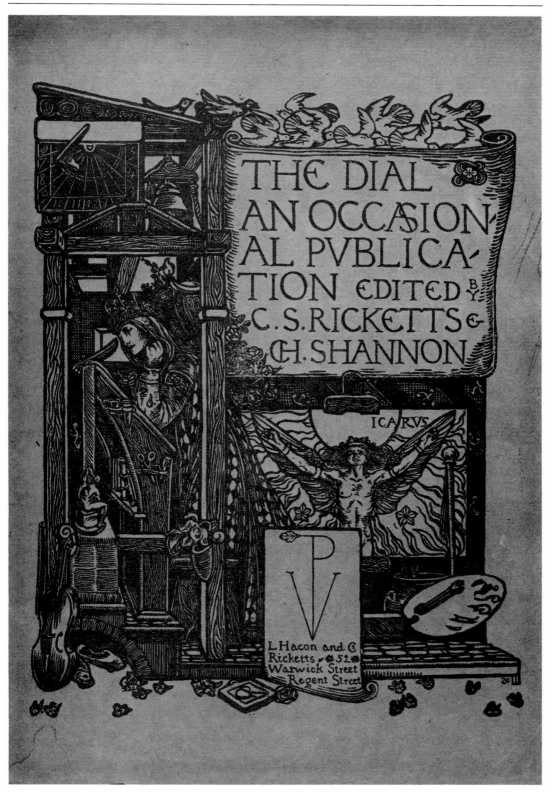

where very important developments were taking place.

In type design it is the time of the private press movement. Primarily this was a movement in reaction against the productions of commercial printing, a revival of standards in all the crafts connected with the book; but it was also an initiative to make a new sort of book using new type designs. Here I am only concerned with the latter, and only insofar as these were new and experimental, a contribution to the extension of the concept of lettering. The examples reproduced illustrate this approach: they are interesting as experiments rather than as book-type. Charles Ricketts' King's type is uneasy to read with its unexpected forms of e, r, t and g, but the open texture which these produce is visually satisfying (Fig. 256); his title-page of *Nymphidia and the Muses Elizium*, 1896, and to *The Dial* magazine, Fig. 259, are successful compositions. Only on analysis is one aware of the odd proportion and serif incidence upon which the success is based. Selwyn Image's design for *The Shilling Garland* (1895–7)is even more experimental (Fig. 260). Eckmannschrift I find rather restless (Fig. 257) and Behrensschrift constricted (Fig. 258), but both are important examples of the search for new principles of letter formation— the first using the round Gothic principle of surface area rather than linear movements as the basic element.

Many of these artists taught in the schools of arts and crafts which were being founded in Vienna, Munich, Berlin and elsewhere, and it is at this time that lettering was first introduced as a course. The new discipline was pioneered by two teachers, Rudolf von Larisch in Vienna and Edward Johnston in London. Their methods, their aims and their influence were contrary. Both wrote books which went into many editions, explaining their teaching; but whereas those of Larisch were in harmony with Art Nouveau experiment, those of Johnston started a new tradition, and it was this which came to dominate lettering in the United States and even Germany and Britain in the next century.

Larisch's book *Unterricht in Ornamentaler Schrift* was first published in 1905. He did not believe in teaching a style, or an alphabet, or by geometrical principles. His students started with a very soft pencil or a disc-ended pen,

making an unmodulated line, and the letter was thought of as existing in relation to the letters beside it and the spaces between them. The ordering of these elements into a creative rhythm was, in his view, the aim of the artist; he condemned unnecessary and meaningless alterations. He believed that the study of lettering was important not only in itself, but as a means of educating taste, a preparation for practice in other fields of art, and a complement to book-learning. He liked his students to try out different tools and to work in various materials. As one might expect from such an open and undogmatic approach, the pupils who succeeded him in Vienna, and other teachers in other schools in Germany, followed some of his ideas but also initiated various new approaches.

Edward Johnston started his first class in 1898 at the Central School of Arts and Crafts in London at the invitation of the principal, W. R. Lethaby; that is in the same year that Larisch started his class in Vienna. Johnston's background was the study of medieval manuscripts in the British Museum, and the basis of his teaching was the craft of pen lettering, the mastery of a 'foundational hand' based on a tenth-century Anglo-Saxon model, and the understanding of writing with a quill on vellum (Fig. 261). Because his teaching was so thorough and specific and his personality so strong, the effect was the creation of a new art of calligraphy; the same factors also inhibited its development and any cross-fertilization with the other arts, which in the next century were to be vivified by so many dynamic movements. Calligraphy flourished; it was introduced to Germany by Anna Simons, and also to America, but in splendid isolation.

Edward Johnston's book is itself however by no means so confined, nor was his own work; but we shall return to this in the next chapter. Here we need to consider other people and movements concerned with lettering from different points of view. Johnston revived the craft of pen-lettering, but calligraphy was already revived at a more popular level. Books about medieval illumination go back to the early chromolithographed books of Henry Shaw, J.O. Westwood and Noel Humphries in the mid-nineteenth century and before.[4] In 1860 Tymms and Wyatt produced *The Art of Illumination: What it was, what it should be, and*

that went to the battle were Eliab the first-born, and next unto him Abinadab, and the third Shammah. And David was the youngest: and the three eldest followed Saul. Now David went to and fro from Saul to feed his father's sheep at Beth-lehem. And the Philistine drew near morning and evening, and presented himself forty days.

AND JESSE SAID UNTO DAVID HIS SON, Take now for thy brethren an ephah of this parched corn, and these ten loaves, and carry them quickly to the camp to thy brethren; and bring these ten cheeses unto the captain of their thousand, and look how thy brethren fare, and take their

A Fifteenth Century Carol (from A. E. Carols, ed. by E. Rickert, 1910).

A dam lay ybounden,
Bounden in a bond;
Four thousand winter
Thought he not too long.
And all was for an apple,
An apple that he took,
As clerkës finden written
In their book.
Nor had the apple taken been,
The apple taken been,
Then had never our Lady
A-been heaven's queen.
Blessed be the time
That apple taken was!
Therefore we may singen
Deo gracias!

ABOVE **260** Cover-design for Elkin Matthews's *Shilling Garland*, designed by Selwyn Image. 1897.

RIGHT ABOVE AND BELOW **261a,b** Examples of calligraphy by Edward Johnston.

187

DETAILS

AND

ORNAMENTS

FROM THE

ALHAMBRA

BY

OWEN JONES

ARCHITECT.

ABCD EFGHIJ

KLMN OPQR

STUV WXYZ

OPPOSITE **262** A page from Owen Jones's *Plans, Elevations, Sections and Details of the Alhambra*. 1842–5.

ABOVE **263** Alphabet designed by Lewis Day, from his book *Alphabets Old and New*. 1902.

RIGHT **264** Relief lettering in Copenhagen. This strong, heavy style seems typical.

265 Detail from a memorial to Frank Albert Smallpiece. An example of the sort of relief-metal lettering associated with the Arts and Crafts Movement. 1904. Bridgenorth St Leonards.

266 Lettering on the Belgrave Children's Hospital, the Oval, London, designed by Charles Holden. 1906.

how it may be practised. The result of this and similar works was not only the promotion of the scholarly study of manuscripts but also the production of elaborate title-pages, particularly to gift-books, framed texts and no doubt innumerable amateur efforts, long since disappeared. The finest example of colour-printed lettering is perhaps that in Owen Jones' *Victoria Psalter* produced in 1862 (Fig. 262). This is all part of an earlier cultural strain: one connected with the Prince Consort, Sir Henry Cole, and the foundation of the Victoria and Albert Museum for the provision of models for the improvement of manufacturing design; a strain nearer to the commercial printing with which this chapter started than to Art Nouveau. But it is one which persisted, and between the two other work was being done, by people like Walter Crane, the Socialist who drew the text for many of his children's books, and Lewis Day, who was an Inspector of Art Schools (Fig. 263). Both were founder members of the Art Workers Guild and belonged to the Arts and Crafts movement. Day produced an interesting book of alphabets, a selection 'for the use of craftsmen', including historic examples and others by contemporary artists including his own work. His book *Lettering in Ornament*, 1902, is full of interesting examples and deserves reprinting. The English Arts and Crafts movement indeed produced lettering in various materials, for instance in stained glass, and also relief metal panels such as that shown in Fig. 265. Selwyn Image (Fig. 260) was connected with the Art Workers Guild.

In architectural lettering there are again different strains. In Copenhagen one sees characteristic relief or square-section lettering, very wide and strong (Fig. 264). In England there are examples in terracotta and in mosaic.[5] Most interesting and remarkable is the relief inscription on the Belgrave Hospital for Children at the Oval, London, designed by Charles Holden in 1906: it is an integrated and important part of the façade (Fig. 266).

All this time the type-founders, particularly in America, were continuing to produce letters designed to appeal to changing popular taste. Lines clearly related to the succeeding versions which are now designated as Art Deco. And all the time the gulf between this industrial art and the artistic and scholarly revival of the crafts of book production and calligraphy was again growing wider. The history of early twentieth-century art is a history of fragmentation.

Notes

1. Books such as these were produced as copybooks for craftsmen and amateurs. There is usually no text or author, often no date, but sometimes a note of the number or size of the edition, often very large. They are successors to the manuscript alphabet-books produced for the same purpose.

2. I have described this type of layout and its invention in the United States in more detail in my book *Nineteenth-Century Ornamented Type Design*, 1976.

3. See note 2. This also reproduces examples of these typefaces.

4. These books and the sort of ornamented lettering which they promoted are described, and many examples reproduced, in Ruari McLean, *Victorian Book Design and Colour Printing*, 1972.

5. Mosaic lettering is often on the pavement. The Stock Exchange Restaurant in London has a rather wild example; very period is that on the Boulting building of 1903 in Mortimer Street, London; more restrained, that on Brown's Hotel, Dover Street, London.

Yesterday and Today

Nineteenth-century industrial development, wealth and prosperity were followed by the catastrophe of the 1914 War. The cultured experiments of the Arts and Crafts movement, Art Nouveau and the brash novelties of 'artistic printing' were followed by the destructive violence of Dada and the Constructivist rejection of tradition. That is on the Continent; in England, the revival of medieval calligraphy continued, accompanied by a dogmatic canonization of the 'Trajan' capital letters, its supporters tranquilly blind to what was happening elsewhere.

If the history of lettering is seen as successive revivals of the Roman letter followed by periods of experiment, by now this assertion needs expansion. In the thirteenth century experiment led to the formation of a new style, the round Gothic letter; later came the broken Gothic letter (Fig. 172) and the writing-masters' swash capitals (Fig. 173). Pre-Carolingian experiment, on the other hand, does not seem to have evolved norms; instead, a type of inscriptional lettering was created with many alternative forms, some radically differing from others. This was not a style which could be taken over into common use, but one which gave individual artists a medium in which they could work with freedom. We are confronted with the ambiguous nature of the art of lettering; like architecture, it is an activity in which the elements of utility and art can be combined in variable proportions. A norm, worked out by generations of craftsmen, provides a means whereby lettering can be made suitable to the job and the tool; beautiful, but above all legible. The roman letter is the pre-eminent

norm, but many others have been evolved: rustic and uncial, Carolingian minuscule and Textura, 'copper-plate' and sanserif, etc. Some designers have used such norms with so much skill and sensibility that their work can rightly be called art; others seem to need greater freedom. They are happier in times of experiment.

In this century we have both sorts of lettering art. We have been particularly rich in artists of stature who have been letterers: Eric Gill, El Lissitzky, Rudolf Koch, David Jones, Hans Schmidt, Ben Shahn, to name a few. For most of these the freedom established by the experiment of the later nineteenth century was very important: they inherited a flexible medium. This has been important too for the others, those designers of shop fascias, advertisements and neon signs, who create our environment. Freedom is, of course, freedom to produce the bad as well as the good; in my opinion it is worth the price.

Dada began in 1917 in Zurich, a movement of poets and artists against the horror and pretence of the war, a nihilist movement of protest; letters, the normal means of expression of the conventional society which they abhorred, became an instrument of attack. The chaos of typefaces used in the magazine *Dada* aptly illustrated their message. Letters were already a significant element in the visual vocabulary of the whole avant-garde movement.[1] Single letters or fragments of newspapers appear in cubist paintings and collage. The motion of writing was taken over in the 'secret writing' pictures by Paul Klee and Max Ernst, carried a step further away from legibility in the trailed

verlicht olland

met ollandsche

Kabels

NKF DELFT

267 Advertisement for N K F designed by Piet Zwart. 1926.

OPPOSITE TOP LEFT **268**
Design for the magazine
Broom. El Lissitsky. 1922.

OPPOSITE TOP RIGHT **269**
Booklet for N K F
designed by Piet Zwart.
1924.

270 Page from the
children's book *Die vier
Grundrechnungsarten*. El
Lissitsky. 1928.

ABOVE **271** Title for the
magazine *Wendingen*,
apparently constructed
from a printer's rule.
Designed by M. de Klerk.
1921.

195

abcdefghi
jklmnopqr
stuvwxyz
a d d

VON SCHREIBKUNST UND DRUCKSCHRIFT
An der Spitze der europäischen Schriften stehen
die römischen Versalien, aufgebaut aus Dreieck,
Kreis und Geviert, den denkbar einfachsten und
denkbar gegensätzlichsten Formen.

für den neuen menschen existiert
nur das gleichgewicht zwischen
natur und geist· zu jedem zeit-
punkt der vergangenheit waren
alle variationen des alten ›neu‹·
aber es war nicht ›das‹ neue· wir
dürfen nicht vergessen′ dass wir
an einer wende der kultur stehen′
am ende alles alten· die scheidung
vollzieht sich hier absolut und

TOP **272** Herbert Bayer's
single alphabet design.
1925.

273 Experimental design
for the typeface Futura.
Renner.

274 Jan Tschichold design
for a single alphabet type.
1929.

brush-strokes, superimposed linear movements or detached characters of painters such as Mark Tobey and Hans Hartung. Such work is on the outer fringe of my subject, but Filippo Marinetti's Futurist compositions, his *Words in Freedom* (1919)[2] which jostle one another in dynamic disorder, are a vivid treatment of letters as a means of visual expression. They are an extension of the idea of using layout to emphasize meaning, an idea used by Lewis Carroll in his 'Tale of the Mouse' in *Alice in Wonderland*, by Mallarmé (in 1897), by Apollinaire (in 1914 and 1916), and later by the Lettristes and writers of concrete poetry.

By the end of the First World War the letter had been freed from all the restraints of tradition both in form and in layout. It was a medium which could be used at will, and which was so used by the artists of the Constructivist movement and of the Bauhaus. The Constructivists chose to make unique patterns out of letters, not by modifying the shapes, but by the disposition, size and weight of the components. They made abstract patterns, but these were also expressions of the contemporary world, of the new machine age which was to succeed the decadent and irrelevant culture of the past, and of the revolutionary new order in Russia. The work might be a poster, an advertisement, a letter or magazine heading, all relevant to the new industrial society; the means was almost exclusively sanserif. In sanserif they saw a letter which was functional, everyday, without historical commitment: 'The more uninteresting the letter the more useful it is to the typographer' (Piet Zwart). That is, it has no message of its own (unlike, say, a historic roman), and its crude forms can be made into abstract design. In their seriousness of purpose and their passionate belief in the rightness of their beliefs, these artists are comparable with those who created the medieval incipit pages.

The two most original designers were Piet Zwart and El Lissitzky. Two designs by Zwart are reproduced here, made for the Dutch firm NKF (Nederlandsche Kabelfabriek). Figure 267 is a play on verticals and different weights of line, as well as on the letter H. Figure 269 uses instead the open circle of the letter G to make a more substantial pattern. Zwart was trained as an architect; Lissitzky made his 'Proun' compositions,[3] and he too designed architecture

and exhibitions—the latter must have been particularly exciting. Both used photography. Figure 268 shows a design contrasting curves and semicircles, and Fig. 270 a more light-hearted example from a children's book of 1928. As in the fantasies of the American Saul Steinberg, the letters have come alive as people. These designs are called typographic, and they were indeed made for printing; but they are essentially free compositions in which the components are type-faces and printer's rule. Letters were indeed sometimes built up with rule—so without curves or diagonals—a technique used by M. de Klerk on the title-page of the magazine *Wendingen* (Fig. 271) in 1921, and by Van Doesburg for the heading of *De Stijl* in 1917.

A focal centre for much of the experiment which was happening in the twenties in Russia, Holland and Germany was the Bauhaus, where typography was an important subject, taught by Joost Schmidt and Herbert Bayer. Here, typically, a positive attempt was made to find a new norm for the alphabet. In 1925 Bayer designed a typeface which he called 'Universal'. It was conceived as a machine alphabet, logical and practical, one sound, one symbol, so dispensing with our second upper-case alphabet (Fig. 272). At about the same time Paul Renner was designing his Futura sanserif, aiming in this to eliminate all vestiges of the calligraphic origin of lower-case letters, thus completing the initiative of the first Modern Face designers. Futura was eventually produced by the Bauer Foundry, 1929–30, and has become a classic type. Renner's first designs (Fig. 273) were more radical, they are comparable to J. Tschichold's single alphabet of 1929 in which all letters are constructed from straight lines and arcs of a circle (Fig. 274). I find this the most successful of all the recurrent attempts to reduce the alphabet to geometric figures. It is based on two widths, one equal to the letter height, the other half the height; problems are solved by introducing some capital forms (N, Z, T, U and K), and retaining some descenders (f, g and j) and some ascenders (d, h, l and b); the effect is beautifully balanced, but it has never been commercially available.

These new norms reflect the mood of the avant-garde artists of the twenties. The old forms of letters had to be undressed, sloughing off meaningless historical and nationalist

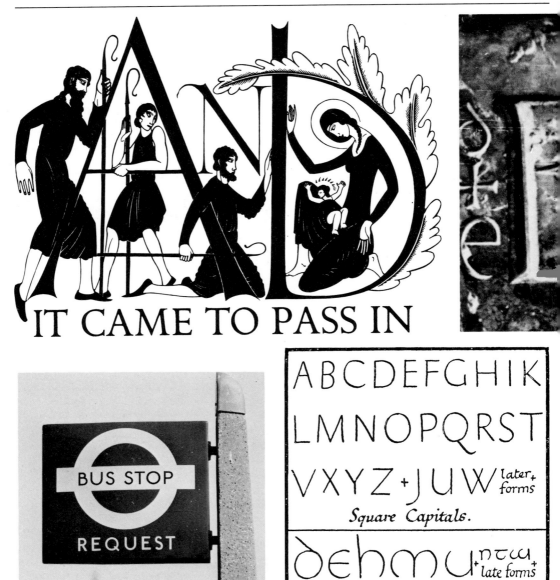

IT CAME TO PASS IN

TOP **275** Eric Gill, initial letters for *The Four Gospels*. 1931.

ABOVE **276** London Transport sign using the letters designed by Edward Johnston in 1916.

RIGHT **277** Edward Johnston's 'essential forms' from his book *Writing, Illuminating and Lettering*. 1906.

ABCDEFGHIK
LMNOPQRST
VXYZ + JUW later+ forms
Square Capitals.

ðehmu +nᴛᴡ late forms
Round Capitals.

αabcdefghiklm
nopqrstuvxyz {ᴊ w+ ᴡ 3
Small Letters.

A rough Diagram of the structural or "ESSENTIAL FORMS" of the three main types of Letters.

LASST
UNS DOCH VIELSEITIG SEYN!
MÄRKISCHE RÜBEN
SCHMECKEN GUT / AM BESTEN
GEMISCHT MIT CASTANIEN
UND DIESE BEIDEN
EDLEN FRÜCHTE WACHSEN
WEIT AUSEINANDER

TOP **278** Lettering
on a memorial. The
Frauenkirche, Munich.
1917.

ABOVE **279** Neuland,
type-design by Rudolf
Koch. 1922.

abcdefghijklmnopqrstuvwxyz

ABCDEFGHIJKLMNOPQRST
UVWXYZ

αδefGknꝺꞅt

ABCDEFGHIJKLMNOPQRSTUVWXYZ

abcdefghijklmnopqrstuvwxyz

1234567890

APRES m'avoir montré tous ses auteurs français, il m'a demandé lequel je préférais, du Télémaque, du Racine, ou du Boileau. J'ai avoué que tous me semblaient également beaux. - Ah! Monsieur, vous ne voyez pas le titre du Boileau! J'ai considéré longtemps, et enfin j'ai avoué que je ne voyais rien de plus parfait dans ce titre que dans les autres. - Ah! Monsieur, s'est écrié Bodoni, Boileau-Despréaux, dans une seule ligne majuscules! j'ai passé six mois, Monsieur,

MAIGRE

TOP **280** Optima, type-design by Hermann Zapf.

CENTRE **281** Hammer Unziale, type-design by Victor Hammer. 1923.

BELOW **282** Peignot, type-design by A. M. Cassandre. 1937.

OPPOSITE **283** Tapestry designed by Koch. 1924–6.

allusion and all decorative accretions. They had to be functional, rational and expressive of the community, not of the individual, and of the new optimism generated by the Russian revolution. With the perversion of that revolution, with Hitler, the Spanish Civil War and the Second World War, optimism faded. The innovations remained influential professionally, but their implications narrowed. Futura is still a classic type-face, but it has been succeeded by designs based on optical rather than geometrical principles, and by nineteenth-century revivals. In the fifties and sixties Constructivist ideas were, however, a powerful influence. An outstanding example was the painting on the façade of the exhibition building constructed for the UIA architects' congress on the South Bank in London. The enormous letters were very impressive, but soon, alas, destroyed. In the art schools, meanwhile, Bauhaus ideas replaced academic and craft teaching traditions. Johnston's methods were abandoned and calligraphy ceased to be taught.

We need, however, to return and to consider the other things which were happening in Europe and America in the twenties and thirties at the time these avant-garde artists were making their momentous innovations; these artists were working in comparative isolation, moving in their own circle and as yet little-known or considered elsewhere.

In England the revival in calligraphy was accompanied by a reform of letter-carving, promoted above all by Eric Gill. It was he who wrote the chapter on letter-cutting in Johnston's book. The reform was based on the lettering on Trajan's column; its characteristics were analysed in detail, taught in every art school, and used as a model for sign-writing and street-lettering as well as for memorial and foundation stones. Gill himself carved beautiful romans, not strictly in accordance with 'Trajan', particularly in his very pointed and elegant serifs. The inscriptions on the Stations of the Cross in Westminster Cathedral, carved between 1914–18, are, like the reliefs of which they are part, very beautiful. Gill was of course also a distinguished type-designer and sculptor. Of his graphic lettering, the initials made for some of his books are particularly elegant (Fig. 275). Other carvers produced lettering which is quiet and distinguished, for tombstones, street name-plates, foundation stones,

etc.; it was undoubtedly an improvement on the dreary tail-end of the Victorian tradition, but in general practice the imposition of 'Trajan' orthodoxy was inhibiting. The more vigorous English Vernacular letter was ignored and the revival became effete.

Johnston, meanwhile, had many devoted followers such as Irene Wellington and Margaret Alexander who produced superbly skilful rolls of honour and the like, but their tradition was largely divorced both from the requirements of everyday life and from individual expression. Johnston's book *Writing and Illuminating and Lettering* (1906) is not doctrinaire: it includes a list of practical uses of lettering and a theory of its nature which is in keeping with the fact that he designed in 1916 the sanserif alphabet which is still used by London Transport (Fig. 276), just as Gill designed the lettering for the shop fascias of W. H. Smith (now, unfortunately, disappearing). Gill called Johnston's sans letters 'the first notable attempt to work out the norm for plain letters'. 'Plain letters' meant letters based on 'essential forms' (Fig. 277), with their proportions derived from Roman capitals: they were plain in the sense that they lacked the differentiating details supplied by the tool, pen, chisel, sign-writing brush, etc. Johnston's sanserif, because it is based on the classical proportions of the Roman model, because it incorporated ideas of beauty and perfection, and because it implied the importance of craftsmanship, was obviously very different from the idea of the crude uncommitted letter both of the Constructivists and of nineteenth-century commercial typography. It was also radically different from the basic rational letter of Renner and Tschichold, founded on geometry. Today all these ideas seem to have fused into a pragmatic idea of sanserif as a reasonably flexible norm; we are not so interested in theory.

Johnston was himself a skilled calligrapher (Fig. 261), and he also designed initials and type for the Cranach Press of Count Kessler. Personally I find his script unsympathetic, but his handwriting is free and beautiful. His revival of lettering was paralleled by the revival of classic type-designs promoted by Stanley Morison, and by that of the italic chancery hand as a model for handwriting promoted by Alfred Fairbank. In America, Lloyd Reynolds was teaching calligraphy at Reed College,

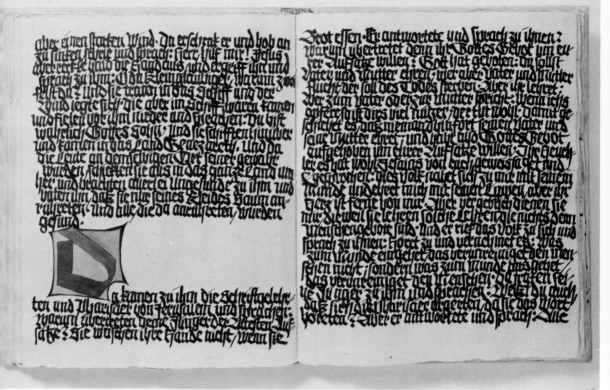

284 A page from the
Gospels written by Koch.
Textura transformed into
a dynamic pattern. 1921.

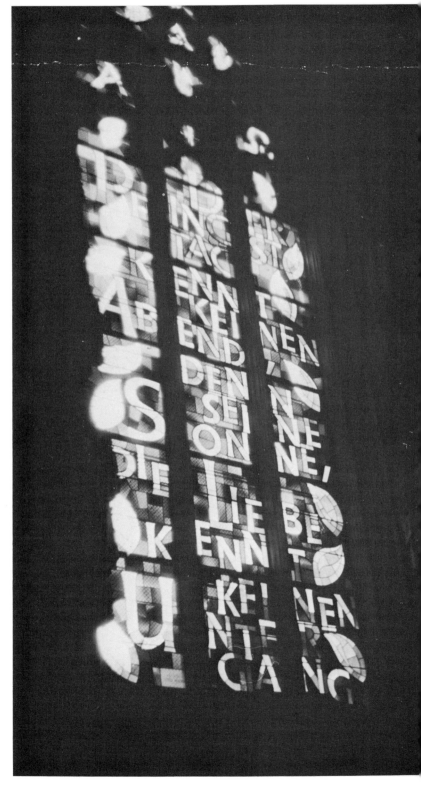

285 Stained-glass window designed by Otto Hürm in Vienna Cathedral.

Oregon, Paul Standard in New York, and J. H. Benson letter-cutting in Newport, Rhode Island. All this constituted a coherent and notable revival, one as divorced from Art Nouveau experiments as it was from Constructivist innovations.

In Germany in contrast there were a number of different schools, more continuity, more variety, and closer contacts with movements in art—although to some extent the ideas of Larisch were superseded by those of Johnston, whose pupil, Anna Simons, taught in Düsseldorf. Expressionist lettering is part of the Expressionist movement. The woodcuts of K. Schmidt-Rottluff[5] and of Kirchner's Manifesto of 1906 for *Die Brücke* are directly related to the Viennese letters based on rectangles, shown in the folders of Larisch or the posters of A. Roller. Only now the regular shapes have been hacked into raw crude forms, welded together into a jagged unity. This vein is still being explored by the Benedictine nun Meinhard Craighead. Carved lettering was more lively and freer than in England (Fig. 278).

In Berlin Ehmcke was teaching and in Stuttgart F. Ernst Scheidler made—as well as other types of lettering—his pages of freely built-up pen-drawn letter complexes. Klee was 'taking letters for a walk'—the walk is indeed more important and interesting than the rather schematic letters. By far the greatest of the German calligraphers, however, was Rudolf Koch (1876–1934), who taught at Offenbach between 1906 and 1934, with an interval of war-service from 1915 to 1917. He designed type, both roman and Gothic (Fig. 279), worked in metal, made books and designed tapestries (Fig. 283); but calligraphy, primarily Gothic calligraphy, is at the heart of his work. He studied medieval charters and manuscripts and thence created his own versions of uncial, of Carolingian-inspired colour-filled pen capitals,[6] of compressed letters, like those with which early charters begin, and of Textura. His versions of both roman and of Gothic capitals are strong and simple, but the most powerful and original of his works are in Gothic script (Fig. 284). Textura is given a new dynamism by close spacing, broken verticals and strong diagonals; his writing is a closely woven texture of vital pen-strokes. He proved that the Gothic was still a medium for creative lettering, and he has had successors in Imre Reiner and

Hermann Zapf, who have produced alphabets in rich variety.[7] Koch was a devout Christian: his lettering is often a prayer or a biblical text and, like the work of David Jones, an expression of his deepest feeling. He made his first tapestry in 1922, followed by six others, all transcriptions of biblical texts. His roman type-designs are also strong and original.

There were other very different innovations in display type-design in this period between the wars: for instance Bifur and Peignot designed by Cassandre (Fig. 282), and the uncial designed by Victor Hammer in 1923 (Fig. 281). There are also some very period examples of architectural lettering, such as the ceramic relief letters on the police station in Leiden (Fig. 286) and the stained-glass letters in the Passage in Amsterdam (Fig. 287). More impressive are the window in the Stefansdom in Vienna (Fig. 285) designed by Otto Hurm, a pupil of Larisch, and the triangular-section wooden letters designed for the Hay's Wharf building at London Bridge (Fig. 288) by the sculptor Frank Dobson (built in 1930 by the architect Goodhart Rendel). All these letters are basically sanserif—one can see the advantage of its flexibility, particularly in relation to the materials involved. They are no longer conceived as drawn, carved or printed; they have been adapted to new materials, a very important innovation in the history of lettering. More conventional, but nevertheless a definite style, are the architectural letters used on Fascist buildings in Italy, sanserif again, usually in relief.[8] It is relevant to remember that the Futurist artists were connected with the beginnings of Fascism, and that Mussolini took over Russian exhibition techiques.

Since the Second World War the polarization between the crafts movement and that of the avant-garde has very slowly begun to contract. Implicit faith in both movements has crumbled. As we have seen, the new atmosphere, which is less idealistic and more involved in utilitarian and technological considerations, has resulted in the improvement of commercial lettering. At the same time we have seen the appearance of distinguished artists who have chosen to work in the lettering field.

Imre Reiner, a pupil of Schneidler, published a number of books and made designs for publishers and magazines in England in the forties. He has added a new dimension to the

TOP **286** Ceramic lettering
on the Police Station,
Leiden. 1927.

ABOVE **287** Stained-glass
lettering in the Passage,
Amsterdam. 1928.

OPPOSITE ABOVE **288**
Triangular section
wooden letters on the
Hay's Wharf building,
London Bridge, designed
by Frank Dobson. 1930.

OPPOSITE BELOW **289**
Letter-sculpture in
plexiglass by Hans
Schmidt. 1981.

TOP **290** Lettering design by Imre Reiner. 1947.

CENTRE **291** Painted inscription by David Jones. 1958. The text is from the hymn *Dies Irae* and from Virgil's *Eclogue IV*.

BELOW **292** Hella Basu. Words from the thirteenth-century poem 'Sumer is icumen in'.

OPPOSITE **293** Anne Hechle. One of four posters about the nature of lettering.

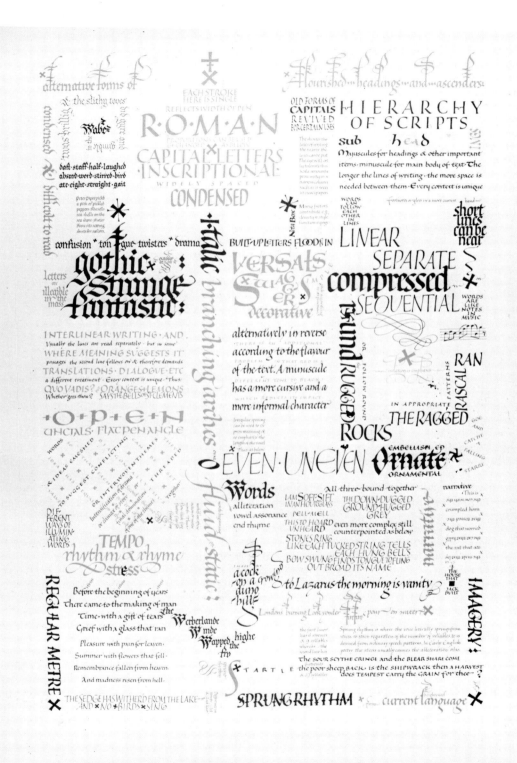

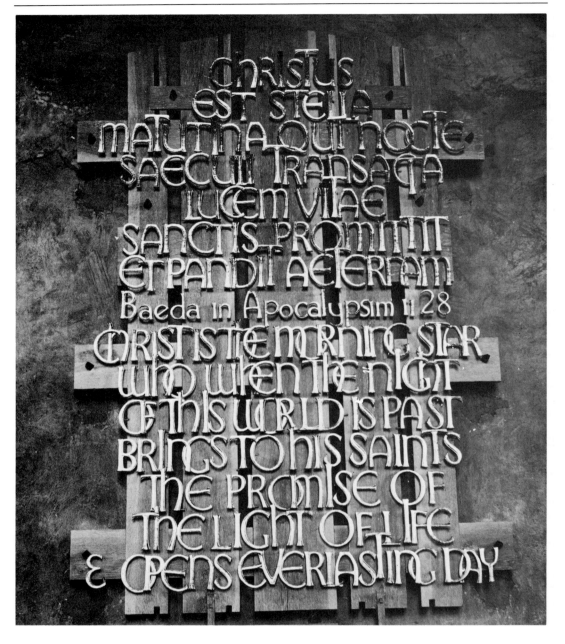

294 Three-dimensional letters in cast gilt aluminium designed and modelled by F. Roper. From the Alington memorial in Durham Cathedral designed by George Pace. 1970.

letter. Each one seems alive, each has its own personality (Fig. 290). They are made up not just of lines but of facets, dots, shadings and squiggles; the line itself divides and diverges at will, and yet the letter retains, even rejoices in, its identity. He also designed type, primarily script and display faces: Corvinus (1932–5), Matura (1938), Mercurius (1957) and Reiner script (1950). He stands apart in his originality; he is also a wood-engraver and painter.

In America, the most original artist is perhaps Ben Shahn, who reproduced much of his work in his book *Love and Joy about Letters* (1963). Nothing else touches the exuberant vitality of his Hebrew script; but the lettering which he invented to transcribe the halting speech of the prisoners Saccho and Vanzetti, a 'folk' alphabet derived from illiterate road-signs, 'cacophanous and utterly unacceptable', is an expressive creation, one which he has used in modified versions with other less tragic implications. In all his work it is the meaning of the words which is expressed with intensity through the way in which they are written or painted. In yet another sense, witty and light-hearted, the letters of Saul Steinberg are alive, walking through the door or hung up on the line to dry.

More serious is the work of poet-painter David Jones. His inscriptions are painted on a ground of Chinese white, a technique which allowed him to rework and readjust each detail. These inscriptions were made privately for himself or for friends, often as Christmas greetings; though this description does not suggest the extent of his commitment to the work, or to the words. The words reflect the complex factors in his thought, his Welsh heritage combined with his sense of the continuing Roman presence in our history, his need for poetry and sense of the fragmented condition of our language and, above all, his total involvement in Christianity. All this is given a visual form in his inscriptions. The text is not just transcribed; each letter is thought of, painted and repainted in relation to the word of which it is part and to the whole built-up complex, creating inter-relationships vertically as well as horizontally. David Jones was a painter, not a calligrapher, and his approach is different. To the purist his treatment of the Roman alphabet is a scandal; to him its letters are not absolute forms, but vehicles through which he ex-

presses his thought about Rome, Roman Britain and our diluted Roman heritage (Fig. 291).

In letter-sculpture I find the work of Hans Schmidt pre-eminent. Although he has also designed tapestries and made very interesting prints, it is his three-dimensional work which is most original. Again, the text is an important starting-point, though this time it is likely to be a quotation from Nietzsche or Sartre; but to the beholder it is the build-up of abstract forms which is impressive (Fig. 289).

In the last decade or so calligraphers in America, and more cautiously in Britain, have become less exclusively interested in the craft side of their work and more concerned with its expressive potential. I reproduce a design by Hella Basu (Fig. 292) and one by Ann Hechle. In both, the contrast between different types of letter and their abstract and expressive implications is crucial. Such compositions are now created as wall-hangings and the like, conceived, like Chinese and Japanese calligraphy, as comparable to paintings.

Ann Hechle's calligraphy reflects the sound as well as the meaning of words, in this providing a link with the ideas of the concrete poets (see Fig. 293). Much of the work of these poets is typewritten; otherwise, from the point of view of lettering, their most relevant experiments are in the letter-structure and the possibilities of making them into letter patterns. Some of the ideas in the magazine *Rhinoceros* are interesting, closely related to those of Art Nouveau artists, as shown, for instance, in the work in the magazine *Die Fläche* (1902). Indeed, Art Nouveau experimental letter design is very much a live influence in contemporary design.

In letter-cutting, the rigid 'Trajan' orthodoxy has been abandoned. Many carvers have created styles of their own: Reynolds Stone, Edward Wright, Ralph Beyer, John Skelton, Michael Harvey; David Kindersley experiments in a great variety. One outstanding achievement has been Beyer's lettering in Coventry Cathedral; not so much for the inscriptions as such as for their integration into the concept of the building.[9] They stand at an angle to the main axis so that they lead progressively towards Graham Sutherland's great tapestry above the altar; it is as if that icon spoke.

Technically more experimental is the Alington memorial in Durham Cathedral created in

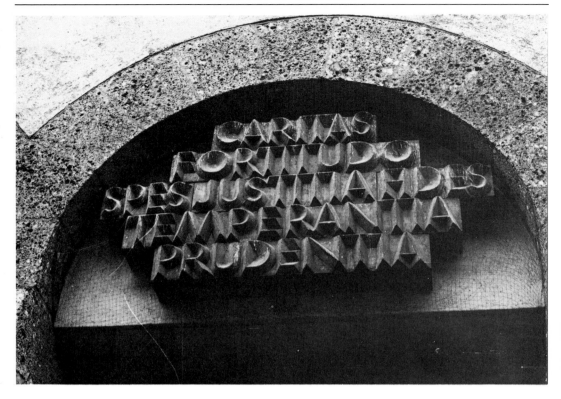

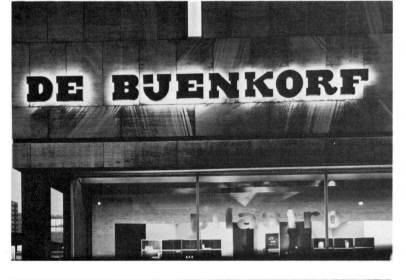

TOP **295** Triangular-faced letters above a door. Munich University. Designed by Georg Brenninger. Moulded concrete. 1963.

CENTRE **296** Back-lit lettering on the Bijenkorf building, Rotterdam. Architects Breuer and Associates. 1956.

BELOW **297** Closely-spaced letters united by the interior lighting. West Berlin.

TOP **298** Neon tube-sign. Seen in 1971. Aix-en-Provence.

ABOVE LEFT **299** Cursive lettering on a shop front. Seen in 1978. Paris.

LEFT **300** Restaurant sign, wood or plastic letters which are slightly tilted so that they present a varied instead of a flat plane. Seen in 1974. Madrid.

BELOW LEFT **301** Metal letters. Face texture and the incidence of thick and thin are exploited. Apt, France.

ABOVE **302** Logotype for a cleaner. Designed by Ken Toyne. *c*.1975.

ALPHABET DE LA BRODEUSE

Pour la broderie, employer les articles à broder en Coton, Lin et Soie, marque D·M·C

DOLLFUS-MIEG & Cⁱᵉ, Société anonyme

MULHOUSE-BELFORT-PARIS

303a,b Pages from a book
of sample alphabets
designed for embroidery.

three-dimensional letters of cast aluminium, designed in 1970 by George Pace (Fig. 294). The same artist designed the tombstone of Archbishop Morgan (d. 1957) in the graveyard of Llandaff Cathedral. The letters on the tombstone are in strong relief, a technique used much more in Germany, where one may see sample tombstones, many in relief, some interesting in design, displayed as mason's samples in cemeteries. Figure 295 shows a design cast in concrete using triangular-faced letters from above a door at Munich University.

Today the distinction between fine and applied art is again disappearing. The most interesting work in new materials and techniques is done in the commercial field, but often created by the graphic designer. The most exciting possibilities are those created by techniques in illumination signs. The city of Rotterdam, rebuilt after the Second World War, illustrates the beauty of illuminated sky-line signs. They can enhance the silhouette of a building, or crown it from every viewpoint. The idea is not new; we have seen it used in sixteenth- and seventeenth-century balustrades, and it was also used in the nineteenth century (Ch. 12, Figs. 184, 220). I recall too the Boots calligraphic logo set dramatically against the sky on a corner-site in Yorkshire. Now there is the new dimension, illumination. Light is now a factor by night as well as by day, derived from the neon tube, usually hidden inside a metal or plastic letter, its light reflected against a background. The strong, square forms of the slab-serif letters on the Bijenkorf in Rotterdam look very fine silhouetted in light against the blank wall behind (Fig. 296). Figure 297 shows a different sort of halo made by spacing letters close together. Or the neon tube itself can also be formed into a dramatic running line, dancing in the dark. Here one becomes aware of the paucity of our handwriting tradition; I have no doubt that it would have been better done in the seventeenth century. Now the best examples seem to be French or Italian (Fig. 298); British signs seem to be better in cases where modulation in line-width can be introduced. The distance between the letters and the background means that another new element, shadow, can be exploited. Here we have yet another difference between the nineteenth- and twentieth-century shop-signs: earlier ones are almost all flush against their background

(except for some cursive signs, e.g. Ch. 12, Fig. 212), and so directly related to architectural detail; today the variety is greater, but the design is often less well related to the architectural background. It may, however, be more complex. Figure 300 shows letters set at slightly different levels and angles so that the richness of formal variety is enhanced by surface variation. Figure 301 shows a very individual letter in metal from France, exploiting surface texture and alternations of the incidence of thick and thick. There are many other possibilities with other materials, particularly perspex, which can be face-lit, or built up in horizontal layers, or set into metal to form a continuous back-lit cursive inscription. Bristol Cathedral has glass-fibre letters set in concrete.[10] There seem infinite possibilities, though many have scarcely been exploited by designers.

In all this the aim is to create a one-off design intended to give a distinctive impression of the business in question. There are other fields in which the same effect is required: posters, record-sleeves, shopping bags, book-jackets, logotypes, tee-shirts, TV titles, etc. (Fig. 302). In some of these calligraphers as well as graphic designers are active. Other forms of reproduction have taken over from traditional metal type design, including instant dry transfer printing, an innovation which has made it possible to produce display alphabets cheaply in quantity and variety. The nineteenth-century idea of using letters to create some desired impression, jolly, recherché or olde-worlde, has been translated into a modern idiom. Modern scholarship has also made use of the established norms of the past. Insular majuscule, uncial, chancery italic and even the roman capital are used for their associations; Insular and uncial are used to imply Irish, or even Islamic. Italic can suggest cultured and high-class, the roman academic and established. The modern letter-designer is not only free to alter letter-forms at will, he also has all the resources of the past at his disposal.

Is it too much? Is it time once more to retrench and return to the search for first principles, or once again to the roman capital? The decision has surely been made for us by the challenge with which designers are faced: digital typography, the problem of how computer-generated letters should be formed. Such letters have at present to be formed from dots

RIGHT **304a-c** Digital letter-design for the television screen (by courtesy of the BBC).

BELOW **305** Experimental designs for use with Reuter's teleprinter. Postgraduate project, Central School of Art and Design. *c.*1980.

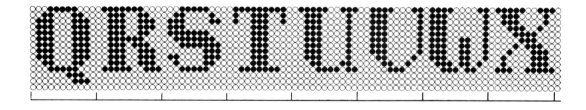

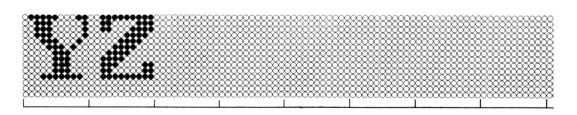

on a grid (Fig. 304). I am not concerned with the complicated technical problems of designing for book-type, but with 'low resolution' forms, such as those of the Ceefax alphabet used on television screens, where the grid is coarse and decisions have to be taken about the basic form of the letter. You can draw neither a curve nor a diagonal on a grid: both have to be made in stepped squares. The only possible prototypes are apparently embroidery alphabets (Fig. 303); mosaic is not really useful because tesserae can be set at an angle and can be cut to shape; nor is the alphabet of the Académie des Sciences relevant, since it is drawn, rather than constructed on a grid. There is lettering made from printer's rule, such as Fig. 271, and modern alphabets have been constructed from straight lines (such as that of Wim Crouwell, or the Epps-Evans typeface for electronic recognition); but none of these is readily legible to the eye. Indeed all alphabets constructed on strict geometric principles tend to be illegible because the number of forms is insufficient to differentiate twenty-six letters; the difficulty is obviously aggravated if curves are eliminated. The French alphabet book for embroidery, of which I have a copy (undated, 870,000 copies already sold at the time of printing in c. 1900), does not attempt such simple solutions; on the contrary, it has cursive, flourished italic, ronde, several versions of

Gothic, Tuscans and slab-serif, some of which look rather well (Fig. 303). I am not suggesting that these would be suitable as dot-matrix characters, but that it may be a mistake to think of letters as necessarily having linear skeletons. We have seen in this history that letters have been thought of in many ways. I note that a grid-based alphabet designed at the Central School of Art and Design (Fig. 305) which uses a variable line-width, that is treating the form as a two-dimensional surface instead of as a linear structure, is not unsuccessful. Is this the approach that we need? Certainly we need ideas which are both thought-out and flexible if we are to meet the technology of tomorrow.

I return to my proposition at the beginning of this book. A letter has no fixed shape, it does not even have a skeleton shape, it has *identity*, and this exists in the mind. To meet the challenge of stringent technical conditions, the first essential is to examine the nature of these mental concepts. 'Much more is known about our technological information transmitters such as display terminals than about our natural information receivers, the eye and brain.'[11] Much research has been done on word- but very little on character-recognition. We need research into the processes of visual mechanisms and feature-detectors by which we read and recognize *letters*[12].

Notes

1. For an account and reproductions of examples of Dada, Futurist and Constructivist typography see Herbert Spencer, *Pioneers of Modern Typography*, 1969. For letters and lettering in painting see D. Mahlow and Franz Mon, *Schrift und Bild* exhibition catalogue, Stedelijk Museum, Amsterdam, 1963.

2. Herbert Spencer, *Pioneers of Modern Typography*, 1969, pp. 24–5.

3. 'Proun' was Lissitzky's word for his abstract compositions, 'a stage in the making of a new world out of the corpse of traditional painting'.

4. The Seminars held by the Association Typographique Internationale since 1973 in Copenhagen, Basle, Reading and Mainz for the discussion of new ideas and experiments in the teaching of lettering in art schools have provided a forum.

5. There is a large collection of the wood-cuts

by Schmidt-Rottluff in the Victoria and Albert Museum, London.

6. These are found in Carolingian maunscripts. They differ from the typical monumental capitals discussed in Chapter 5.

7. I. and H. Reiner, *Alphabets*, 1947. H. Zapf, *Mit Feder und Stichel*, 1952.

8. Photographs of a number of Fascist buildings are reproduced in A. Bartram, *Lettering in Architecture*, 1975, pp. 254, 256, 261–3.

9. A. Bartram, op.cit., shows a reproduction.

10. This is reproduced in A. Bartram, op.cit.

11. C. Bigelow and D. Day, 'Digital Typography', *The Scientific American*, 1983.

12. From Seybold Report on Publishing Systems, vol. 11, 1981, 'The Principles of Digital Type' by C. A. Bigelow. A very clear account of the problems involved in this new technology.

Variant forms of A, B, C, G, M, Q

This appendix concerns variant forms of six letters. These are particularly interesting today when we are, or should be, considering the nature of the form of our letters. In the history of letter-forms in the West the tension has been continually between three types of interest: geometrical forms which satisfy the mind; forms adapted to the instrument – the pen or the chisel – or to the technique involved; or forms suited to the purposes for or by which letters are shaped. The letters here described are interesting and perhaps relevant because they are logical, geometrical forms.

The main source for the incidence of these forms is my own observation, recorded in notes and photographs, made largely from the study of originals in churches, museums large and small, and manuscripts, many of all these unpublished. Considering the vast mass of material, the observations which I offer here are only a preliminary report. In order to support this report I have included reference to reproductions in books; these are not intended to include every published example.

Books cited:

J. J. G. Alexander, *Insular Manuscripts; sixth to ninth century*, 1978

K. F. Bauer, *Mainzer Epigraphik. Zeitschrift des Deutschen Vereins für Buchwesen und Schrifttum*, 1926 Heft 2/3

Codices Latini Antiquiores, edited E. A. Lowe, 1934-1966 (cited as CLA)

R. G. Collingwood and R. P. Wright, *Roman Inscriptions of Britain*, 1965-

A. Degrassi, *Inscriptiones Latinae Liberae Rei Publicae*, 1965

P. Deschamps, *Paléographie des Inscriptions de la fin de l'Epoque mérovingienne aux dernières années du XIIᵉ siècle*, Bulletin Monumental, 1929

M. Dolley, *Anglo-Saxon Pennies*, 1970

L. Ennabli, *Les Inscriptions funéraires Chrétiennes de Carthage*, 1975, 1982

A. Ferrua, *Inscriptiones Christianae Urbis Romae septimo saeculo antiquiores*. nova series 1922–

N. Gaultier, *Recueil des Inscriptions Chrétiennes de la Gaule*, vol. 1, 1975

E. Gose, *Katalog der frühchristlichen Inschriften in Trier*, 1958

M. Guarducci, *Epigrafia Greca*, vol. IV

E. le Blant, *Inscriptions Chrétiennes de la Gaule antérieures à la fin du VIIIᵉ siècle*, 1856

Nash Williams, *Early Christian Monuments of Wales*, 1950

E. Okasha, 'Handlist of Anglo-Saxon non-Runic Inscriptions', *Transactions of the Cambridge Bibliographical Society*, vol. IV, pt V

A. Silvagni, *Monumenta Epigraphica Christiana*, 1943

A with a bar across the apex

Visually the bar across the top of the letter A can perform an important function. When A follows L, or M with splayed legs, or (to a lesser degree) letters which may have forward projections on the base line, such as E or R; or when A is followed by letters which curve away from it such as C, O, G, the inward sloping diagonals of A may leave an awkward space at the top. One solution is to make the diagonals more upright (see Gothic Alphabet), compensating this with a flat top. This was the Gothic and Art Nouveau solution. The other was to add a horizontal bar to the pointed apex.

This second form is often associated with a broken cross-bar, a feature common in Greek inscriptions after the Hellenistic period and in the West in the early middle ages; indeed between the Carolingian classical revival and that of the Renaissance the normal Roman form of A is rare. A great many variations were tried, cross-bars crooked or projecting, apex serifed or with a projection to one side, or flat, one or both legs curved. Here I want to comment on the form with a symmetrical apex bar.

This form is found, but as a ligature of T and A in Republican inscriptions (Degrassi, n.234). A wavy bar across the apex is characteristic of North African inscriptions. The straight bar is first found in a number of Pre-Carolingian inscriptions (Gose, n.409, Silvagni, vol. 1, pl. xii, Nash Williams, Appendix 1). It may be combined with a broken cross-bar. Its use continues in some eighth century inscriptions and it is an important letter in the vocabulary of Insular manuscript letter-designers (see Chart 3); it is used on Anglo-Saxon pennies (Dolley) and in Anglo-Saxon inscriptions (Okasha).

In the Romanesque period it is used on inscriptions, (Naumberg) painting (Segovia), metalwork and mosaic (San Clemente, Rome), along with many other experimental forms. It is in the fifteenth and sixteenth centuries however that the letter is most characteristic – one of the Romanesque forms revived at this time, in manuscripts (Fouquet), on Hispano-Moresque ceramics, and on many inscriptions (see Fig.163).

In the late nineteenth century the form was again revived in commercial display type design and advertising. In this century it has been used by Ben Shahn and David Jones, and by Rudolf Koch in his type design *Wallau*. It is used in slab-serif type designs such as *Memphis* and *Rockwell*.

B with separated bowls

B made with two separated semicircular bowls would seem to be a simple logical form of the letter corresponding to the early Greek (Corinthian) form of the letter *epsilon* made with two triangles, a form adopted in the Runic alphabet. When the bowls are joined the letter is more difficult to carve, and the craftsman's more subtle form was evolved with the join prolonged into a line, into which the lower bowl moves with a flattened curve, to make the classical Roman letter. The lower bowl is also enlarged to give the letter greater stability. In the twentieth century in some sanserif designs the bowls are again equal, with semicircular contours, except that these are elongated by straight lines where they join the stem.

The form with separated bowls is found on some early Republican inscriptions (Degrassi, n. 64, 77) and later in the Museum at Aquileia. It disappears in the classical period but is found in early Greek Christian inscriptions (Guarducci, fig. 108, Ferrua, vol. IV, tav. XVI). It appears also in early Christian Latin inscriptions, presumably copied from Greek sources (Silvagni, vol. 1, fasc. 1, tav. XXXI). In the period before the end of the seventh century it is in fact found throughout the once Roman world; in Gaul (Le Blant, n. 540a, 621 and reproduced pl. 48), on the Rhine (Bauer, ab. 29), in Spain, now in the Museum at Cordoba, in Africa (Ennabli, n. 103, 105), Britain (Collingwood and Wright, n.1091). It is found in Italian and Visigothic manuscripts (British Library, ms Harley 1775, CLA VII n. 592), and in Merovingian titling. It is also used on South Italian coins. Nowhere does the form seem to have been used exclusively, but it is usually definite and conspicuous.

The use survived the Carolingian revival of the classical letter and is found in early Romanesque manuscripts such as that from Montmajeur (Fig. 108) and Bibliothèque Nationale lat. 7, and later in lat. 10. It is also used in the titling of the Spanish Beatus manuscripts (see Fig. 81). An extreme form with small bowls very wide apart is used in eleventh century Spanish inscriptions. It appears on the St Genis relief (Fig. 84) and later on the Cathedral at Santiago. It is used on the paintings at San Vincenzo, Galliano of 1007 and is found in Rome as late as 1221 (Silvagni, vol. 1, pl. XXXV).

In more mature Romanesque manuscripts it is the version where the bowls curl away from one another in the centre which interests designers; this is a version found earlier, for instance in the Leningrad Gospels (Fig. 61) and as early as 533 in S. Pietro in Vinculi, Rome. It is used in the twelfth century Winchester and Bury Bibles and seems a stage in the evolution of the great initial B, characteristic of many Psalters (Fig. 130). The normal Gothic capital B is based on an oval counter divided on the right side by a pointed intrusion which indicates the join between the bowls; in early examples

however the bowls are often forms based on circles (often filled with intertwined circles), these may meet at the centre to divide again before the contours meet the stem. This is surely a way of thinking derived from the tradition which produced B made with separated bowls.

The letter R is also found with the bowl and leg separated at the stem (see Fig. 108 and p. 96) but not so often as the kindred B.

Square C and square G

These letters are found in Latin inscriptions round about the fifth to sixth century AD. Square C is found earlier in Greek inscriptions, for instance in the market dedication from Miletus of 165 AD now in the Pergamon Museum in East Berlin, where it is used as *sigma*—the usual Byzantine form is like a round C—it occurs also in Greek inscriptions in Rome in this century (Guarducci, p.533). An early Latin example is in an inscription in Milan of 487 (Silvagni, vol. II, fasc. I, tav. 111.6). By the seventh century it is more widespread, in Gaul (Le Blant, n. 586), Spain, Germany (Bauer, ab. 36, 40) Wales (Nash Williams, n. 62). It is the usual form of C in Insular manuscripts (see Chart 3), and is found on ivories, and on Anglo-Saxon inscriptions (Okasha) and coins (Dolley).

In the tenth century square C is a characteristic form on Italian, French (Deschamps, pl. 14) and English inscriptions. Its use continues in early Romanesque work, in German and French inscriptions (see Fig. 102) also in the capital lettering used in Ottonian and Spanish manuscripts (Bibliotheque Nationale lat.9394, the Apocalypse of Gerona). It is particularly important in one style of Anglo-Saxon manuscript decoration (Fig. 87) and survives in the lettering of the Bury Bibles and that of one of the artists of the Winchester Bible. In the fifteenth century it was revived and is seen on inscriptions in the Campo Santo, Pisa, in the paintings of Van Eyck and on the medals of Pisanello.

Square G is less common, but clearly related to the C, and often used in the same pieces of lettering. Normally it is made by adding an upright to the lower limb; sometimes a further one or even two strokes may be added to this at right angles. (In some early examples the extra stroke projects downwards). The form is found in Merovingian manuscript titling and in inscriptions (Gose 29). The angular form in Insular manuscripts (Ch. 4) seems to have a different derivation, from the half-uncial tradition.

The form recurs in ninth century Beneventan and tenth century North Italian inscriptions, and in early Romanesque painting (Sant'Angelo in Formis) and mosaics (San Marco, Venice); it is found in inscriptions at Moissac and in some Citeaux manuscripts.

G with detached spur

G is a Roman letter, not derived from any Greek or Etruscan
prototype. To represent this sound in their language the Romans
added a vertical stroke to the letter c, probably in the fourth
century BC.

G is a letter which at various periods, for various reasons acquired
a great variety of forms. The spur could be replaced by curves moving
inwards or outwards, or by a downward stroke moving vertically or
diagonally, or by a right-angle (see also Fig. 164). Of these versions
that with a detached spur is interesting because it is logical and
geometrical; the spur is drawn as a semicircle related to the open
circle of C.

The earliest example of this form which I have found is one dated
408 (Ferrua vol. IV, pl. XI). The obvious derivation is from the early
cursive form where the spur is drawn as an outward moving stroke.
From the fifth to the seventh century the form is fairly common
throughout the once Roman West. It is found in inscriptions on the
Rhine (Gaultier, 1.175, Bauer, ab. 24), in Milan and Como (Silvagni,
vol. 11 fasc. I pl. 1.111, fasc. 11, pl. 111) in Rome (Ferrua vol. IV, pl.
111, V), in Arles Fig. 49, in Britain (Collingwood and Wright, n. 1065),
in Africa (Ennabli, 102b), in Wales (Nash Williams, Appendix 1).
In Italy it is still in use in the eighth century (Silvagni, vol.1, tab.
XXXVI.7). It is used also in Merovingian manuscripts (Bibliothèque
Nationale lat. 12021) and in Visigothic books (CLA VII. n. 592), and
it provides a basis for transformation into compass-constructed birds
and fishes (see p. 52, e.g. Vatican ms, reg. lat. 317). It is found in
Insular manuscripts (Alexander, pl. 141) but is not a common form. It
is used on Merovingian rings (Le Blant, n. 412A).

With the Carolingian Renaissance the form disappears. In the
fifteenth century however Fouquet introduces a detached spur, but
right-angular, not circular, in the hours of Etienne Chevalier (Fig.
164). A similar form is used in the Cappella Palatina at Palermo in
1482. The same construction, only with the right-angled spur joined
to the main curve, is used in modern sanserif type designs such as
Bertold Standard, monotype Grot 150, Haas Helvetica.

The Letter M

Of all the letters of the alphabet M is perhaps the most problematic in its structure. The Republican M is simple; it consists of two inverted Vs side by side. A wide and ungainly letter. In the classical period, with the introduction of differentiation between thick strokes and thin, we find the second and fourth strokes as thick, but neither vertical nor parallel, the emphasis deriving from that of the underlying pen or brushstroke. The letter seems to be now constructed round a central V; an idea carried a step further when the two outer limbs are parallel as in the Filocalian letter (Fig. 27) and in the construction of the Modern Face type design.

In the dark and middle ages various solutions were tried. The central v was often shortened and the splay of the legs exaggerated. This design reached its most extreme form in Italian early fifteenth century inscriptions (Fig. 151). The stress however remains a problem, particularly apparent in some Romanesque examples (Fig. 109). One solution was to make *both* outer limbs vertical, and stressed, and both diagonals of the v element thin, thus creating a logical letter of reasonable width. The same proportions are used in Gill sans. This idea was developed in several ways. The Apices could be serifed; or the v moved downwards to begin below the top of the verticals (Silvagni, vol. 11, fasc.111 pl. 1.8, a fifth century inscription in Pavia). Or one side of the v may be prolonged sideways or downwards as in the inscription of Gregory 1 of 604 (Silvagni 1, fasc. 1, tav. XII.1) or in some Merovingian titling. Or the sides of the v may be curved, as in the inscription of Siguald at Cividale. Or its tip may be serifed; or this may be prolonged vertically. This prolongation often combined with curved sides to the v, is a common Greek form found in inscriptions, manuscripts and mosaics dating back at least to the sixth century. It is found also in Spanish inscriptions in the seventh century, in the Beatus manuscripts and in the cloister at Moissac (eleventh century). This idea is taken one step further, when the v is reduced to a straight line. This seems again to be a Greek idea (see S. Morison, 'Byzantine Elements in Humanistic Script' illustrated from the *Aulus Gellius* of 1445, *Occasional Paper of the Newbury Library*). This version is found in Italian manuscripts (British Library Add. 22318 and Bodleian Canon Ital. 85), on fifteenth century Spanish paintings in the Prado, and the Vatican; on Hispano Moresque plates; and in the Cappella Palatina in Palermo (Fig. 165).

One wonders whether there is any connection between this form and the oddest form of all, that found in Insular manuscripts where the most common form consists of three verticals with a cross-bar, horizontal or tilted. On the Ruthwell Cross this bar is stepped. The link, if any, must be Greek or perhaps Runic (see p. 62); minuscule and uncial m seem remote from this geometric idea.

Q with an interior tail

The Greek letter *koppa* which has a small circle with a central tail below did not outlast the sixth century BC in the east, though it survives longer in early Corinthian inscriptions. This shape conforms to the normal letter height of the alphabet whereas the Roman version, a circle with the tail projecting below the lower limit of the letter size, creates an anomaly.

In the late Antique and early Christian periods, in modest inscriptions, there was experiment with various forms, the uncial form (reversed P), a snail-like curved form, and circular forms with tails projecting in various ways. It is at this time that the Q with an interior tail is first found, first as far as I know in the fifth century in Italy (Silvagni, vol. 11, fasc. 111, tab. 1) in Pavia and France (Le Blant, vol. 1, preface p. XXV, dated 487 and 494). Other examples occur in the sixth and seventh centuries and the form is typical of the Court school of Pavia of the eighth century. The greatest currency was however after the Carolingian period, or during that period in circles where the classical revival was only partial. It is found in Rome and South Italy in the ninth century and North Italy in the tenth; also in Ottonian manuscripts and metalwork. Unlike letters such as B with separated bowls, or G with a detached spur, it is an orderly letter fitting into a regular pattern; more so indeed than the classical form. It was used again at the Renaissance on the medals of Nicolaus, and in this century in the painted inscriptions of David Jones.

Basic Round Gothic

All letters are of equal width. If the letter is drawn around the inside outline the outer outline can be ornamented in any way desired. The letter can also be compressed or expanded.

A The formation of A by two diagonals in the traditional pattern presented the greatest problem, and there are more variations for A than for any other letter. Indeed no satisfactory form was evolved. The diagonal is usually eliminated by making the right leg vertical. The left leg is then also vertical or either slightly diagonal or curved; the top is flat. It can be treated as N reversed, i.e. as U upside-down. Occasionally both sides are rounded, particularly in Italy. The pointed apex virtually disappears, except when it has a horizontal extension to the left. The cross-bar may still be broken, but no longer extends beyond the left leg.

B In some early examples, particularly initials, the bowls are drawn as two equal circles (Fig. 126). More commonly, the junction of the bowls does not meet the stem, so that the counter is an oval with a nick in the right side. The stem may be shorter than the height of the letter.

C The serifs are extended vertically to close the bowl.

D As with B, except that there is no nick in the side of the oval. The uncial form of D is less common; when used, the extension is not diagonal but horizontal.

E As with C, the serifs are extended to close the counter. This round form is usual, but the square form occasionally survives.

F The vertical serifs are extended to join the two arms, also possibly to meet the serif along the base line.

G The lower termination curves inwards; the upper vertical serif may meet it to close the counter, or it may curve upward. G is never spurred.

H Normally the uncial form is used, with a curved lower limb ending in a curl or closed by the base-line serif.

I The serifs top and bottom may be extended to give the letter the width of other letters.

K The arms are curved to form two arcs closed by serifs top and bottom.

L The top horizontal serif is extended to meet the lower vertical serif and enclose a counter. The letter with a curved lower limb disappears.

M The outer curves of the uncial form meet at a central stem. This is often reduced to a horseshoe form with no break in the top curve but with a horizontal serif at the base. An earlier form consists of an oval with a curve added on the right. The Roman form remains as an occasional alternative.

N The round form ending in a curl or a horizontal serif is normal.

O The pointed form disappears.

P The bowl is enlarged.

Q The tail may be horizontal in either direction; it does not cross the interior outline. The uncial reversed-P form disappears.

R The leg is given a double curve and does not necessarily start from the stem. It normally ends in a curl. The gap on the stem between the bowl and the beginning of the leg disappears.

S The upper and lower curves are equal and the movement between is horizontal. Upper and lower counters are often closed by serifs.

T The round form is common, and the horizontal cross-bar may be curved on top like a hat. The Romanesque form, in which a very short stem turns into a curve, disappears. The serifs of the arms may, however, be prolonged vertically to make a lugubrious letter.

U is as N reversed; but the V form is sometimes retained.

W is double V.

X Sometimes one member is straight, the other curved. The final form consists of two reversed semicircles.

228

Select Bibliography

There are very few books on the history of lettering, as distinct from those on the related subjects of printing and calligraphy, palaeography, epigraphy and manuscript illumination, or from practical guides to the craft of lettering. The following books may however be found useful on particular aspects, or because they contain relevant illustrations.

General

D. M. Anderson, *The Art of Written Forms* (New York, 1969)
Lewis Day, *Alphabets Old and New* (London, 1898)
Lewis Day, *Lettering as Ornament* (London, 1902)
H. Degering, *Die Schrift* (Berlin and London, 1929; rev. edn. 1965)
Hoffmann, *Schriftatlas* (Stuttgart, 1952)
Donald Jackson, *The Story of Writing* (New York and London, 1981)
G. Knuttel, *The Letter as a Work of Art* (Amsterdam, 1951)
'Massin', *Letter and Image* (London and New York, 1970)
S. Morison, *Politics and Script* (Oxford and New York, 1972)
S. Morison, (ed. D. McKitterick), *Selected Essays* (Cambridge, 1981)
F. Musika, *Die schöne Schrift* (Prague, 1965)
A. Nesbitt, *The History and Technique of Lettering* (New York, 1950)
J. Tschichold, *Treasury of Alphabets and Lettering* (New York, 1966)

Books on the history of architecture sometimes cover the whole, or part of, the period since the Roman empire:

A. Bartram, *Lettering in Architecture* (London and New York, 1975)
N. Gray, *Lettering on Buildings* (London and New York, 1960)
J. Kinnier, *Words and Buildings* (London and New York, 1980)
G. Scheja and E. Holscher, *Die Schrift in der Baukunst* (Berlin/Leipzig, 1938)

On Roman inscriptions there is a vast literature, but it is primarily concerned with the text and its historical importance. The most useful

study is A. E. Gordon, *An Illustrated Introduction to Latin Epigraphy* (University of California, 1983), with a good bibliography. Also useful is G. Susini, *The Roman Stonecutter* (London, 1973). A. E. Hübner, *Exempla Scripturae Epigraphicae Latinae* (Berlin, 1885), is still the most comprehensive work on the variety of letter forms used by the Romans. Other books with useful illustrations are:

A. Degrassi, *Inscriptiones Latinae Liberae Rei Publicae* (Berlin, 1965)
E. Diehl, *Inscriptiones Latinae* (Bonn, 1912) (includes some medieval inscriptions)
A. E. Gordon and J. S. Gordon, *Contributions to the Paleography of Latin Inscriptions* (Berkeley, 1957)
A. E. Gordon and J. S. Gordon, *Album of Dated Latin Inscriptions* (Berkeley, 1958)
A. E. Gordon, *Illustrated Introduction to Latin Epigraphy* (Berkeley, 1983)
R. Ireland, 'Epigraphy' in M. Henig (ed.), *A Handbook of Roman Art* (Oxford and Ithaca, 1983)

On the inscriptions on the Trajan column in Rome see:

E. M. Catich, *The Trajan Inscription* (Davenport, Iowa, 1961)
E. M. Catich, *The Origin of the Roman Serif* (Davenport, Iowa, 1968) (controversial)
L. C. Evetts, *Roman Lettering* (London, 1938, reprinted 1979) (a study of the letters at the base of the Trajan column)

Late Antique and Early Christian inscriptions are treated separately, and by different scholars. Works in this field are from the point of view of letter forms usually more interesting. The great work on this period in Rome, by de Rossi, is not illustrated, but the continuation by A. Ferrua, *Inscriptiones Christianae Urbis Romae* (Vatican, new series, 1922) includes photographs. See also:

L. Ennabli, *Les inscriptiones funéraires chrétiennes de Carthage*, vols. 1 and 2 (Rome, 1975 and 1982)
A. Ferrua, *Inscriptiones Latinae Christianae Veteres* (Vatican, 1981)
A. Ferrua, *Epigrammata Damasiana* (Vatican, 1940)
E. Gose, *Frühchristliche Zeugnisse im Einzugsgebiet von Rhein und Mosel* (Trier, 1965)
H. Grisar, *Analecta Romana* (Rome, 1899)
F. Grossi Gondi, *Trattato di Epigrafia cristiana latina e greca* (Rome, 1920)
A-E. Hübner, *Inscriptiones Hispaniae Christianae* (Berlin, 1871)
E. le Blant, *Inscriptions chrétiennes de la Gaule antérieures au VIIIᵉ siècle* (Paris, 1856). (This fundamental work, which has engraved illustrations, is in the course of revision: vols. 1 and 2, *Première Belgique*, ed. N. Gaultier, have been published (Paris, 1975, 1977).)
E. le Blant, 'La Paléographie des Inscriptions Latines du IIIᵉ siècle à la fin du VIIᵉ', *Revue Archéologique*, série III, vols. XXIX, XXX, XXXI, 1896–7

R. A. S. Macalister, *Corpus Inscriptionum Insularum Celticarum* (Dublin, 1945, 1949)

O. Marucchi, *Epigraphia Christiana* (Milan, 1909)

O. Marucchi, *Museo Cristiano Pio Lateranense* (Rome, 1910)

V. E. Nash Williams, *Early Christian Monuments of Wales* (Cardiff, 1950)

E. Okasha, 'The Non-Runic Scripts of Anglo-Saxon Inscriptions', *Transactions of the Cambridge Bibliographical Society*, IV, 1968

W. Reusch, *Frühchristliche Zeugnisse im Einzugsgebiet vom Rhein und Mosel* (Trier, 1965)

J. Romilly Allen and J. Anderson, *Early Christian Monuments of Scotland* (Edinburgh, 1903)

A. Silvagni, *Monumenta Epigraphica Christiana saeculo XIII antiquiora quae in Italiae finibus adhuc exstant* (Vatican, 1945). (Excellent photographs; includes early medieval inscriptions.)

J. Stuart, *The Sculptured Stones of Scotland* (Aberdeen, 1856)

H. Zilliacus, *Sylloge Inscriptionum Christianarum Veterum Musei Vaticani* (Helsinki-Helsingfors, 1963)

On Roman script and its relation to inscriptions:

A. K. Bowman and J. D. Thomas, *Vindolanda: The Latin Writing Tablets* (London, 1983)

J. Mallon, *Paléographie Romaine* (Madrid, 1952)

J. Mallon, R. Marichal, C. Perrat, *L'Ecriture Latine* (Paris, 1939)

On palaeography there is again a very large literature concerned primarily with book or charter hands. Useful is the article on palaeography in the *Encyclopaedia Britannica*, 1963, by Professor T. J. Brown; also:

C. Cenetti, *Paleografia Latina* (1978)

C. Cenetti, *Lineamenti di Storia della Scrittura latina* (Bologna, 1956)

M. Drogan, *Medieval Calligraphy* (London, 1980)

R. Seider, *Palaeographie der lateinischen Papyri* (Stuttgart, 1972)

For reproductions see the facsimiles of the Palaeographical Society, London, 1873–94; new series 1903–12, 1913–32. Also:

E. Chatelain, *Uncialis Scriptura Codicum Latinorum* (Paris, 1901)

E. A. Lowe, *Codices Latini Antiquiores* (Oxford, 1934–66)

R. Marichal and A. Bruckner (eds.), *Chartae Latinae Antiquiores* (Basel, 1954–66)

E. Monachi (ed.), *Archivio Paleografico Italiano* (Rome, 1932)

On the capital letter in manuscripts:

J. J. G. Alexander, *The Decorated Letter* (London and New York, 1978)

K. Nordenfalk, *Die spätantiken Zierbuchstaben* (Stockholm, 1970)

A. Schardt, *Das Initial; Phantasie und Buchstabenmalerei des frühen*

Mittelalters (Berlin, 1938)
E-A. Van Moë, *Illuminated Initials in Medieval Manuscripts VIII to XII Century* (London, 1950, Paris, 1943)

On particular manuscripts and schools in which capital lettering is important:

J. J. G. Alexander, *Insular Manuscripts* (London and New York, 1978)
E. H. Alton and P. Meyer, *The Book of Kells* (Berne, 1951)
H. Dembowski, *Initium Sancti Evangeli* (Kassel, 1959)
F. Henry, *The Book of Kells* (London, 1974)
T. D. Kendrick, T. J. Brown et al., *The Lindisfarne Gospels* (Olten and Lausanne, 1956 and 1960)
K. Nordenfalk, *Vergilius Augusteus facsimile* (Graz, 1976)
B. Teyssèdre, *Le Sacramentaire de Gellone* (Toulouse, 1959)
E. H. Zimmermann, *Vorkarolingische Miniaturen* (Berlin, 1916)

On Carolingian capitals:

W. K. Loehler, *Die karolingischen Miniaturen* (Berlin, 1930–60)
H. Omont, *Peintures et Initiales de la première et deuxième Bible de Charles le Chauve* (Paris, 1921)

Books on post-Carolingian manuscripts may include some illustrations of lettering, for instance:

C. R. Dodwell, *The Canterbury School of Illumination 1066–1200* (Cambridge, 1954)
E. B. Garrison, *Studies in the History of Medieval Italian Painting* (Florence, 1953)
W. Oakeshott, *The Two Winchester Bibles* (Oxford and New York, 1981)
M. Salmi, *Italian Miniatures* (Milan, 1956, London, 1957)

Gothic capitals will be found in A. F. Johnson, *Decorative Initial Letters* (London, 1931) and O. Jennings, *Early Woodcut Initials* (London, 1908)

Books on mosaic usually include illustrations which show some lettering—though often also this is cut out:

S. Bettini, *Mosaici antichi di San Marco a Venezia* (Bergamo, 1944)
O. Demus, *The Mosaics of San Marco in Venice* (London and Chicago, 1985)
W. Oakeshott, *Mosaics of Rome, Third to Fourteenth Century* (London and New York, 1967)
M. van Berchem and E. Clouzot, *Mosaiques chrétiennes du IV^e au X^e siècle* (Geneva, 1924)
J. Wilpert, *Römische Mosaiken und Malereien der kirchlichen Bauten vom IV. bis XIII. Jahrhundert* (Freiburg im Breisgau, 1916)

Reproductions showing lettering can also be found in some books on ivories, stained glass, metal work and sculpture. On inscriptions, there are specialist studies:

P. Deschamps, 'Paléographie des inscriptions de la fin de l'époque mérovingienne aux dernières années du XII^e siècle, *Bulletin Monumental*, 1929
N. Gray, 'Paleography of Latin Inscriptions in Italy, VIII, IX, X Centuries', *Papers of the British School at Rome* (London, 1943)
R. M. Kloos, *Einführung in die Epigraphik des Mittelalters und der Frühen Neuzeit* (Darmstadt, 1980)
W. Weimar, *Monumental-Schriften 1100–1812 auf Stein, Bronze und Holzplatten* (Vienna, 1898)

On Renaissance lettering there are also specialist studies:

D. M. Anderson, *A Renaissance Alphabet* (University of Wisconsin, 1971)
D. Covi, 'Lettering in fifteenth-century Florentine painting', *Art Bulletin* XLV, 1963 (Providence, Rhode Island)
A. Dürer, *On the Just Shaping of Letters, 1535* (Dover Press, New York, 1965)
F. Feliciano (ed. G. Mardersteig), *Alphabetum Romanum* (Verona, 1960)
N. Gray, 'Sans serif and other experimental inscribed lettering of the early Renaissance', *Motif* 5 (London, 1960)
G. Mardersteig, 'Leon Battista, Alberti e la Rinascita del carattere Romano nel Quattrocento', *Italia medioevale e umanistica* (Padua, 1959)
M. Meiss, 'Towards a more comprehensive Renaissance Paleography', *Art Bulletin* XLII, 1960
J. Mosley, 'Trajan Revived', *Alphabet* (London, 1964)
G. Tory, *Champ Fleury 1529* (New York, 1967)

On the Writing Masters there is again an extensive literature as well as the books of the masters themselves. Most useful are:

W. Doede, *Schön Schreiben eine Kunst* (Munich, 1957)
P. Jessen, *Meister der Schreibkunst* (Stuttgart, 1923; reissued New York, 1981)
A. S. Osley, *Scribes and Sources; Handbook of the Chancery Hand in the Sixteenth Century* (London and Boston, 1980)
J. Tschichold, *Schatzkammer der Schreibkunst* (Basel, 1945; London, 1946)
J. I. Whalley, *The Pen's Excellence* (Tunbridge Wells and New York, 1980)

On inscribed lettering:

A. Bartram, *Tombstone Lettering in the British Isles* (London, 1978)
F. Burgess, *English Churchyard Memorials* (London, 1963)

F. H. Crossley, *English Church Monuments: An introduction to the Study of Tombs and Effigies 1150–1550* (London, 1921)
E. V. Gillon, *Early New England Gravestone Rubbings* (New York, 1966)

Nineteenth Century

On advertising type design:

A. Bartram, *Fascia Lettering in the British Isles* (London, 1978)
A. Bartram, *Street Name Lettering in the British Isles* (London, 1978)
N. Gray and R. Nash, *Nineteenth-Century Ornamented Typefaces* (London, 1973; Berkeley, 1976)
P. Handover, 'Black Serif', *Motif* 12 (London, 1965)
R. R. Kelly, *American Wood Type 1828–1900* (New York, 1969)
J. Mosley, 'The Nymph and the Grot; The Revival of the Sans Serif Letter', *Typographica* 12 (London, 1956)
J. Mosley, 'The English Vernacular', *Motif* 11 (London, 1963/4)
R. V. Ridler, 'Artistic Printing', *Alphabet and Image*, 6

Art Nouveau

A. Demeure de Beaumont, *L'Affiche illustrée* (Toulouse, 1897)
E. Holscher, *R. von Larisch und seine Schule* (Berlin, 1938)
R. von Larisch, *Unterricht in ornamentaler Schrift* (Vienna, 1909)
R. von Larisch, *Beispiele künstlerischer Schrift* (Vienna, 1900, 1902, 1906)
P. Wember, *Die Jugend der Plakate 1887–1900* (Krefeld, 1961)
Plakate um 1900, Katalog der Plakat-Sammlung des Hessischen Landesmuseums (Darmstadt, 1962)

Some interesting lettering is usually to be found in books on posters, and in periodicals of the period such as *Dekorative Kunst, Ver Sacrum, Jugend*. Of particular interest are:

Het Nederlandse Boek en de Nieuwe Kunst 1892–1906: Exhibition in Rijksmuseum Meermanno-Westreenianum, September 1965
R. Riegger-Baurmann, 'Schrift im Jugendstil', *Börsenblatt für den deutschen Buchhandel* xiv (Frankfurt, 1958)

Twentieth-century calligraphy and inscribed lettering has been extensively published in a series of books:

J. Brinkley, *Lettering Today* (London, 1964)
H. Child, *Calligraphy Today* (London, 1963)
M. Gullick and I. Rees, *Modern Scribes and Lettering Artists* (London, 1980)
C. A. Holme, *Lettering of Today* (London, 1937)
R. Holme and K. M. Frost, *Modern Lettering and Calligraphy* (London, 1954; revised edn. 1976)

Edward Johnston, *Writing, Illuminating and Calligraphy* (London, 1906; New York, 1977)

H. Zapf (foreword), *International Calligraphy Today* (New York, 1982)

For other twentieth-century lettering see:

M. Constantine, *Lettering by Modern Artists* (Museum of Modern Art, New York, 1964)

F. H. Ehmcke, *Schrift: Die historische Entwicklung der abendländischen Schriftformen* (Hanover, 1925)

W. Gardner, *Alphabet at Work* (London and New York, 1982)

Evan Gill, *The Inscriptional Work of Eric Gill* (London and New York, 1964)

N. Gray, *The Painted Inscriptions of David Jones* (London, 1981)

R. Harling, *Letter Forms and Type Designs of Eric Gill* (Westerham, 1976; Boston, 1977)

D. Kindersley and L. Lopes Cardozo, *Letters Slate Cut* (London, 1981)

R. Koch, *Das Schreiben als Kunstfertigkeit* (Leipzig, 1921)

R. Koch, *Das Schreibbüchlein* (Offenbach am Main, 1930)

D. Mahlow (ed.) *Schrift und Bild* exhibition catalogue (Baden Baden, 1963)

D. Peace, *Glass Engraving: Lettering and Design* (London, 1985)

I. Reiner, *Grafika* (St Gallen, 1947)

I. Reiner, *Alphabets* (St Gallen, 1948)

Ben Shahn, *Love and Joy about Letters* (London and New York, 1969)

S. Steinberg, *The Passport* (London, 1954)

S. Steinberg, *The Labyrinth* (London and New York, 1961)

W. M. Wingler, *Lettering at the Bauhaus* (London, 1969)

H. M. Wingler, *The Bauhaus*, Cambridge, Mass., and London, 1969

H. Zapf, *Mit Feder und Stichel* (Frankfurt am Main, 1950)

On digital typography:

C. Bigelow and D. Day, 'Digital Typography' in *The Scientific American*, August 1983

Chart 1 The Alphabets Used by the Romans

The Romans evolved different alphabets for different purposes largely formed by the tools by which they were written and the materials upon which they were written.

1. The formal alphabet used for inscriptions cut in stone. I have called it 'Trajan' because this is unambiguous; it refers to the type of letter used on the inscription on the column of Trajan in Rome which is a beautiful and well-known example of this style, which reached a standard form at this time. It is sometimes called 'square capitals' despite the fact that few letters are exactly square.

2. Rustic capitals, evolved apparently as a brush-written letter but used for less formal inscriptions and as the normal Roman book-hand.

Many Roman inscriptions are carved in a style somewhere between these two styles in proportion of width and height; in these variant letter-forms may be introduced.

3. In the later Roman empire new styles were introduced: a more sophisticated cursive, used for letters and documents written with a reed pen on papyrus, and uncial used for writing books. 'Half uncial' was a less formal book-hand using more or less the same forms as the new cursive.

The earlier form of cursive is not shown here as the primary purpose of this chart is to show the letter-forms from which the later styles, or ideas of lettering, were developed. An example is shown in Fig. 7.

Trajan Transitional and Variants	Rustic	New Roman cursive	Half Uncial	Uncial

Chart 2 Letter-forms Found in Inscriptions AD 300–700

In the fourth century the Romans gradually ceased to erect grand official inscriptions and the 'Trajan' letter became obsolete. Instead many Christian epitaphs and inscriptions were carved; the language of the early Church was Greek, and a proportion of these were in Greek and certain Greek letter-forms were taken over:

Many of these inscriptions were made for humble, uneducated people and letter-forms were also taken from the the other Roman alphabets (see Chart 1). Different forms of each letter might be used in one inscription. A new idea of lettering develops; an idea which is inherited by the barbarian peoples who are now taking over the lands of the Western empire. This chart shows the range of letter-forms current in such lettering in different places.

The chart does not include the letter-forms which continued in use in papal and other more formal inscriptions which preserved, in less skilled work, the classical and Filocalian traditions (see Figs. 27, 39).

SOURCES: personal study in many collections. For ITALY: A. Silvagni, *Monumenta epigraphica Christiana saeculo III antiquiora quae in Italiae finibus adhuc exstant* (1945); A. Ferrua, *Inscriptiones Christianae Urbis Romae* (n.s. 1922–); O. Marucchi, *Epigraphia Christiana*; H. Grisar, *Analecta Romana* (1899). GERMANY: N. Gaulthier, *Inscriptions Chrétiennes de la Gaule I (Trier)* (1975); R. Conrad, *Niederrheinische Epigraphik*; K. F. Bauer, *Mainzer Epigraphik* (1926); E. Gose, *Inschriften in Trier*; W. Reusch, *Frühchristliche Zeugnisse vom Rhein u. Moselle* (1965); Boppert, *Frühchristliche Inschriften* (1971). FRANCE: E. Le Blant, *Paléographie des Inscriptions Latines du IIIᵉ siècle à la fin du VIIᵉ* (1896–7, 7 vols. 29–31); P. Deschamps, *Étude sur la paléographie des inscriptions lapidaires de la fin de l'Epoque Mérovingienne aux dernières années du XIIᵉ siècle*. SPAIN: A. E. Hübner, *Inscriptiones Hispaniae Christianae* (1871); J. Vives, *Inscripciones Christianas de la España Romana y Visigoda* (1942). WALES: V. E. Nash Williams, *Early Christian Monuments in Wales* (1950). N. AFRICA: L. Ennabli, *Sainte Monique à Carthage* (1975, 1982).

Italy	France	North Africa

Germany	Spain	Wales
A ʁ ⋀ A ⋁	A ⋀ A A A A	A ⋀ ⋁ A A
B B β	B B B	B B B
⊏ C	C	C ⊏
ꓭ ⊿ Ρ D	D ꓭ Þ	D ᑯ
Ε Є E	E E	E E Є ə
Ϝ ϝ Ϝ ↑	ϝ Ϝ ↑	Ϝ E Ϝ Ϝ
Ϟ Ϟ Ϟ G Ϟ ⊑ G G	G Ϟ Ϟ G Ϟ	Ϟ Ϟ Ϟ Ϟ
ʜ h H	H	H h h
		I
⊥ ʌ ᴸ ᴸ ᴸ ⊦	L ᴸ ᴸ ⊦ ᴸ ʌ	ᴸ ᴸ ᴸ L
ᴍ ᴍ ᴍ ᴍ ᴍ ⍩	ᴍ ᴍ ᴍ ᴎ	ᴍ ⊓ ᴴᴴ ⍕ ᴍ ᴴ
ʜ N	N N	N H
◇ O ◇ ◈	O	O
Þ Þ Ρ	Ρ Ρ	Þ Þ Þ Þ
Q ꟼ ϙ ᴄ Q ϙ ꟼ	ϙ ᴄ ϙ ꟼ Q	ꟼ ꟼ
ʁ ʁ ʁ ʁ ʁ ꟼ ʁ	ʁ ꟼ ʁ ꟼ	ʁ ꟼ ꟼ ʁ ʁ ꟼ
ꟃ Ʂ	S	ꟃ Ʂ Ꞔ ꟃ ⌐
T �	T	⊤ ⴕ T T
Ч ᴜ V	V ⋁	V ⋁ ᴜ ⋎ Ч ⋁
↑	X ↑	X

Chart 3 Capital Letter-forms in Insular Manuscripts

The formal vocabulary of each manuscript is usually so individual that manuscripts have been entered separately. The chart includes the letters found on the great incipit pages in the important examples of this school, also titling where this occurs separately as in the Leningrad, Barberini and Kells manuscripts.

The manuscript letters are variable in execution: some are coloured, some drawn in outline, some pen-drawn, etc. (see the illustrations to Ch. 4). A completely accurate chart would include a very great many examples, some differing very slightly. Here I have concentrated on formal differences rather than on differences in execution or termination. This is the aspect in which change and innovation is most important, and individual idiosyncrasies matter less. All significant divergencies have been included.

(Chart overleaf)

The Book of Durrow	Echternach Gospels	Durham Cathedral A. 11.17	Lindisfarne Gospels

St Gall ms. 51	Macregol Gospels	Cologne Cathedral ms. 213	C.C.C. Cambridge 197. B.	Gospels of St Chad

Vatican Library Barberini ms. lat 570	Leningrad Public Library cod. F.V 1.8 f 18	f 78, 119, 177

Stockholm Royal Library A 135	British Library Royal I. E. VI	The Book of Kells

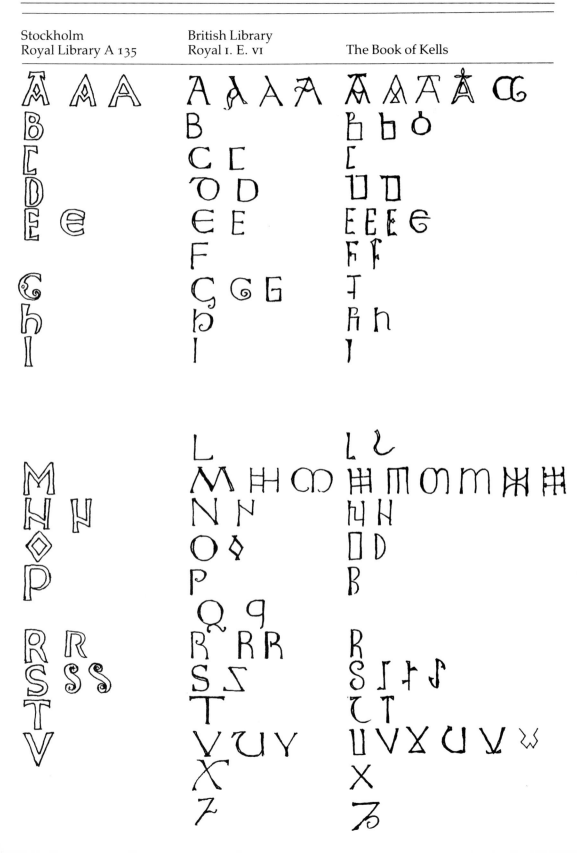

Chart 4 Letter-forms in Material more or less Contemporary with Insular Manuscripts

1. Capital letters used in Merovingian manuscripts.
2. Letters found in Anglo-Saxon inscriptions of the seventh to the ninth centuries (from Okasha).
3. Letters engraved on the Ardagh chalice.

Merovingian manuscripts	Anglo-Saxon manuscripts	The Ardagh chalice

(Chart of comparative letterforms — handwritten alphabet glyphs arranged in rows A through X)

Glossary

'Artistic Printing' a late nineteenth-century style of layout.

Baskerville, John writing-master, letter-cutter, printer, type-designer, 1706–75. Also the name of a type design.

Behrensschrift type designed by the architect Peter Behrens.

Book-hand script used for transcribing books in the middle ages. Includes all types of script used for this purpose, i.e. reasonably formal hands.

Bowl the curved part of a letter as with B, R, P.

Calligraphy beautiful handwriting. The craft of writing.

'Carpet' pages pages of abstract design in some Insular manuscripts.

Codex a manuscript in book form.

Corvinus display type-design by I. Reiner 1929–34.

Counter the space enclosed, or more or less enclosed, by the outline of a letter.

Cuneiform inscriptions the writing of the Sumerians and Babylonians. Characters made from combinations of wedge-shapes.

Cursive running, informal writing.

Ductus the direction of the movements by which letters are drawn.

Eckmannschrift type designed by Otto Eckmann.

English round hand another name for the 'copper-plate' style of handwriting; called 'anglaise' on the continent.

English Vernacular traditional late eighteenth/ early nineteenth-century English lettering, in particular capital letters based on the style of Baskerville.

Epigraphy the study of inscriptions.

Even-line a letter in which the line does not vary from thick to thin.

Face used for type-face; derived from the face of the metal letter which was inked and printed. Used to mean the design of a particular alphabet of type.

Foundational hand a style of pen lettering taught by Edward Johnston; based on tenth-century Anglo-Saxon book-hand.

Fraktur (broken) a Gothic script, later a category of type design.

Futura name of type design by P. Renner 1928–30.

Gothic (Broken Gothic) a capital letter made out of discontinuous lines, evolved in the fifteenth century.

Gothic (Round Gothic) a capital letter evolved in the thirteenth century.

Grotesque another name for sanserif type design.

Hair-line serif thin, unbracketed termination; characteristic of Modern face type design.

Hammer Uncial name of type design based on uncial script, designed by V. Hammer 1923.

Incipit the opening page or words of a book or gospel.

Insular the Irish–Anglo-Saxon art of the seventh and eight centuries.

Interstices the spaces between letters.

Italic letters sloping forwards.

Kufic an early form of Arabic script, said to have originated in the town of Kufah.

Ligatures letters joined together.

Lithography the art or process of printing impressions either from a slab of stone or from a zinc plate.

Lombardic a term used by the palaeographer Mabillon to describe round Gothic capitals, usually only applied to those with wide proportions.

Majuscule capital letter.

Matura calligraphic sanserif type design by I. Reiner 1938.

Mercurius Italic script display type design, by I. Reiner 1957.

Minuscule small letter, or style of lettering with ascenders and descenders.

New Roman cursive informal style of writing used by the Romans.

Ogham an alphabetic script made by lines drawn across a vertical. Used by Celtic peoples.

Old Roman cursive informal style of writing used by the Romans.

Optima a sanserif type design with modulated line-width, designed by H. Zapf.

Ordinator a Latin word meaning the man who laid out an inscription.

Palaeography the study of ancient scripts and letter forms.

Papyrus writing material made from papyrus plant.

Reiner-script calligraphic display type design by I. Reiner, 1952.

Romain du Roi a type design produced for the Imprimerie Royale, Paris; forerunner of Modern face design.

Roman appertaining to the people or City of Rome. The letters, in particular the square capital letters evolved in the second century AD.

roman letters derived from Roman capitals but often considerably different in detail. Used also of lower-case type design in distinction to Gothic and Italic.

Rotunda a round semi-Gothic book-hand practised in Italy, later a category of early type design.

Rubricator the scribe who wrote the rubrics in a manuscript, sometimes applied to whoever wrote the capitals at the beginning of a section.

Rule printer's rule. A straight line of varying width and length.

Runes an angular alphabet used by Nordic peoples.

Rustic a style of lettering used by the Romans.

Sanserif a letter without a serif, ending therefore without any thickening at the termination.

Serif a finishing-off stroke at the termination of letters.

Squeeze an impression from an inscription made with paper or plastic material.

Stem the upright stroke of a letter.

Textura a Gothic book-hand, used also in inscriptions.

'Trajan' the type of Roman capital used in the inscription on the base of Trajan's column in Rome. Often used as the archetype of Roman lettering.

Titling the capital letters often used for the first words at the beginning of a section in a manuscript.

Tuscan a letter with bifurcated, often curled terminations.

Uncial a late Antique book-hand.

Vellum a prepared animal skin used for writing.

Versal simple capital letters used as initial letters to verses or sentences in Romanesque manuscripts. The word used seems to have been introduced as a description of a type of built-up letter by Edward Johnston.

Wedge-serif slightly flaring terminations to letters.

Wood-engraving a process of printing from an end-grained wood block engraved with a burin. In the mid-nineteenth century this technique was used for reproducing drawings, therefore using a black line.

Writing-masters professional teachers of writing. They produced manuals showing the various styles which they taught.

Index

Numbers in italics refer to pages on which pictures occur. Numbers followed by a bold **n** refer to pages on which notes occur.

Aachen Cathedral pulpit *85*, 87
Abbess Uta of Niedermünster, Gospels of *84*
Adelberga, epitaph of at Tours *68*, 70
advertising
 display type 164, *167*; logotype *213*; nineteenth-century 164-74
Aesthetic movement 175
Aix-en-Provence, neon sign *213*
Alberti, Leon Battista, inscriptions designed by *127*, *128*, *129*, 133
Alexander, Margaret 202
Amalfi Cathedral, Romanesque inscription *94*
America 175, *176*, *178*, 186, 191, 197, 202, 205, 211
 Arts and Crafts calligraphy 186; nineteenth-century design 175, *176*, *178*; type design 191
Amsterdam, stained-glass 205, *206*
Anglaise style *161*, 162, *169*, 173
Anglo-Saxon style 81-3, 87, 221, 223, 246, 247
 Arundel Psalter 82; Benedictional of St Ethelwold 82, *83*, 107; capitals 82, *83*; Church 56; Junius Psalter 82; minuscule 82; titling 82, *83*; Winchester school 82
Appleby, ceramic lettering *166*
Apt, twentieth-century lettering *213*
Aquileia, inscription from *19*
arch of Constantine 29
arch of Titus 22
Ardagh Chalice *57*, *63*, *246*, *247*
Art Deco 191
Art Nouveau 10, 164, 175, *177*-83, 221
 influence 211
Art Workers Guild 191
'artistic printing' 177
Arts and Crafts movement 175, 191
Arundel Psalter 82
Aurelius Gemellus, epitaph of *34*

Ayres, J., *A Tutor in Penmanship* *155*, *156*

Barbatus, L. Cornelius Scipio, tomb of 14, *14*
Barberini ms. lat 570 241, *244*
Baroque style *140*, 151, 154-8
Baskerville
 English Vernacular style *152*; Fry's Baskerville 162; Virgil *152*
Bastarda *131*, *132*, 135, 140
Basu, Hella *208*, 211
Bath
 carved street names 168; Walcot Chapel 173
Bauhaus 197, 202
Bayer, Herbert, Universal typeface *196*, 197
Bayeux tapestry 90
Beatus of Liebana, *Commentary on the Apocalypse* 49, *79*, 81
Beatus manuscripts *114*
Behrens, Peter Behrensschrift *184*, 186
Beispiele Künstlerischer Schrift *180*, *181*, 183
Benedictional of St Ehtelwold 82, *83*
Beneventan script *80*, 81
Benson, John Howard 25, 205
Berlage, H. P. 183
Berlin, illuminated lettering 212
Bertold Standard type design 224
Beyer, Ralph, Coventry Cathedral, lettering at 211
Bible of Bury St Edmunds 96, 222, 223
Bible of Charles the Bald 72, *75*
Bible of San Callisto, 72, *73*, 86
bibliophiles, first books made for 29, *34*
Bickham, *Universal Penman* *161*, 162
Billettes, G. F. des, letter designs 162
Birrens, Roman inscription *23*
Bobbio 43
 epitaph of Irish monk *46*, *49*, 55
Bodoni, *Manuale Tipografico* *152*
Bohun Psalter *110*

Book of Durrow 56, 242
Book of Kells 55, 61, 63, 65
Bosworth Psalter 82, *83*, 107
Bowles, manual of alphabets 162
Bracciolini, Poggio, evolution of humanist book-hands 122
Bramante, Donato, Sta Maria della Pace 133
Brecon, English Vernacular lettering *165*
Brenninger, Georg 212, 215
Bridgenorth St Leonards, Arts and Crafts lettering *190*
Bristol Cathedral, Glass-fibre letters 215
Broom magazine *194*
Brown, Peter, *Society and the Holy* 61
Burgess, William, *English Churchyard Memorials* 174
Burgos
 Casa Miranda 147; Cathedral 135, 147
Bury Bible 222, *223*
Byzantium 29, 223

Caelius, M., cenotaph *20*, *21*
Cambridge, letters on Gonville and Caius College gates 147
Canterbury
 Cathedral gateway 147; Gospels 43
capital letters 25, 28**n**, 82, 108**n**, SEE ALSO majuscule
 Anglo-Saxon 82, *83*; Broken Gothic 82, 109; Insular school 56, 61; Lombardic 109; Ottonian 86; Roman Square capitals 11**n**, *15*, *16*, *21*, *23*, *24*, 25-6, *27*, 28**n**, 29, 35, 44, 151, 236-7; Round Gothic 109
Carolingian Renaissance 67-77, 222, 224
 Ada school 70; arrow terminated letters 72, *74*; Bible of Charles the Bald, 72, *75*; Bible of San Callisto 72, *73*, 86; capitals 70; classical letter forms, revival of 10, 67; colour use

72; decorative initials 72, 74, 76, 77; diplomas 72, 77; Godescalc Gospels 70; Grandval Bible 68; influence 78, 82, 205; inscriptions 68-9, 70, 76; Insular influence 74, 76, 77; Lorsch Gospels 69, 70; metal letters 70; Metz Gospels 70, 72, 73; minuscule 67, 68, 70; origins 32

Carroll, Lewis, *Alice in Wonderland* 197

Carthage, Antiquarium, inscription from 18

Cassandre, A. M., type designs 200, 205

Castle Ashby, Northamptonshire 145, 147

Cathach of St Columba 55, 56

Catich, Father E. M. 15
The Origin of the Serif 25

Ceefax alphabet 217

ceramics 159
drug jars 140, 142; Hispano-Moresque 140, 143, 221, 225; nineteenth-century letters 166, 168, 175, 178; panels 175, 178; terracotta 175, 178; Textura used on 140; twentieth-century 205, 206

Chancery script 137, 139

Charter of King Stephen 106, 108

Chichester Cathedral 148

Christianity
Anglo-Saxon 56; early SEE early Christian; Insular school 51, 53-65; monasteries 42, 43-4, 50, 51, 52, 55, 62, 64, 78, 108; Mozarabic 81

Cione, Nardo di, Gothic letters in painting by 112, 117

Cissarz, J. V. 180, 183

Cocorico journal 182

Codex Aureus (Canterbury) 59, 63

Codex Aureus (Munich) 72, 86

coins and medals
Italian Renaissance 125, 131; Visigothic 44, 45

Cole, Sir Henry 191

Cologne, Cathedral Library Cod. 213 243

commercial letter-design
nineteenth-century 164-74, 175, 178, 179; twentieth-century 192, 193, 194, 198, 205, 206, 212, 213, 215

Commodus, carved dedication to 18

computer-aided design 162

concrete letters 212

concrete poetry 197, 211

Constantia, epitaph of 33

Constantine Chlorus, inscription 23, 26

Constructivist movement 197, 202

Copenhagen, relief lettering 189, 191

copper-plate style 161, 162, 169, 173

Coptic manuscripts

Córdoba, nineteenth-century ceramic letters 166

Coventry Cathedral 211

craftsmen
division into specialists 109; guild organization 109; lay 108; monks 42, 43-4, 50, 51, 52, 55, 56, 62, 64, 78, 108, 109; Romanesque 108; study of

letter-design 156; type designers 137; writing-masters 137, 140, 141, 142

Craighead, Meinhard 205

Cranach Press 202

Crane, Walter 191

Cresci, G. F. 139, 147, 162
Il Perfetto Scrittore 144

cuneiform 12

curled terminations 20, 23, 35, 41, 52, 70, 100, 111, 112
Tuscan letters 164, 166, 167, 168

cursive capitals 149, 150

cursive handwriting SEE script

Dada movement 192

Damasus, Pope, inscription of verses by 30, 32

Darmstadt, Garden of Hochzeitsturm 183

Day, Lewis 191
Alphabets Old and New 189; *Lettering in Ornament* 191

De Stijl 197

Delamotte alphabet-book 175

Devizes, slab-serif lettering 165

Didot, Modern Face fount designed by 162

Die Fläche magazine 211

Die vier Grundrechnungsarten 194

digital letter-design 10, 214, 215, 216, 217

Dijon, Romanesque inscription 94

display type 164

Dobson, Frank 205, 206-7

Donatello, inscription by in Siena Cathedral 125, 126

Doyle, Richard 177
The Foreign Tour of Messrs. Brown, Jones and Robinson 171, 173, 174

dry transfer printing 215

Dublin, St Patrick's Cathedral 160

Duchy of Burgundy 133, 135
Bastarda 131, 132, 135

Dürer, Albrecht
Apocalypse 140; *On the Just Shaping of Letters* 140

Durham
Cathedral, aluminium letters 210, 211, 215; Durham Cathedral ms. A.11.17 242

early Christian lettering 29, 31-42, 222, 226, 238-9
books 36, 38; Greek influence 49; well-head inscriptions 47, 49

Echternach Gospels 51, 56, 61, 242

Eckmann, Otto, Eckmannschrift 184, 186

Edinburgh, nineteenth-century shop lettering 168

Egypt, Roman papyrus rolls found in 14

Egyptian letters 164, 165, 168

Ehmcke, F. H. 205

El Lissitzky 192, 194, 197

embroidery designs 214, 217

enamel

Merovingian 52; Romanesque 99, 100; Visigothic 44, 45

England
Anglo-Saxon 82, 83; Art Nouveau 177, 178, 186, 187, 189, 191; eighteenth-century 152, 153, 157, 160, 161, 162; English round hand 161, 162, 169, 173; Gothic 112, 113, 115, 118, 119, 121; Insular school 53, 55-6; nineteenth-century 162, 164-74, 184, 185; Restoration period 151, 155, 156, 158, 159; Romanesque 90, 96, 101, 105, 107; sixteenth- and seventeenth-century 137, 138, 140, 144, 146, 147-8, 149, 150; twentieth-century 192, 198, 202, 205, 207, 211, 213, 215, 216

English Vernacular style 151, 152, 162, 165
nineteenth-century use 164, 165, 168, 202; tombstones 162

Ernst, Max, 'secret writing' pictures 192

Etruscan writing 12, 13

Evesham Psalter 112, 113, 115

Evetts, L. C., *Roman Lettering* 25

Expressionist movement 10, 205

Eyck, van SEE van Eyck

Fabriano, Gentile da, lettering on frame of painting by 124, 125

Fairbank, Alfred 202

fat face letters 164, 168, 173

Felbrigg Hall, Norfolk 147

Feliciano 111, 133
alphabet designed by 133, 140

Filocalus 32, 34, 35, 41, 70, 225
'Calendar of 354' 32, 35, 38; Filocalian tradition 44; inscriptions of verses by Pope Damasus 30, 32

Fischel, K. A. 183

Florence
Sta Maria Novella, inscription by Alberti 129, 133; San Pancrazio Cappella Rucellai, inscription by Alberti 128, 133

Fouquet, Jean
Hours of Etienne Chevalier 132; portrait of *Charles VIII* 132, 135

Fournier type 168

Fraktur 137, 139
nineteenth-century revival 177

France 38, 43, 64, 65, 80, 81
Art Nouveau 175, 177, 183; Carolingian Renaissance 67-8, 72, 74, 75; eighteenth-century 156, 157, 162, 163; fifteenth-century 132, 134, 135, 149; Gothic 112; Merovingian 49, 51, 52, 55; nineteenth-century 168, 169, 171, 172, 173, 174; Romanesque 89, 90, 92, 93, 95, 96, 97, 100, 104, 107; seventeenth-century 150, 156, 162, 163; sixteenth-century 137, 139, 140, 147; twentieth-century 213

Franck, Paul, *Schatzkammer Allerhand Versalien* 140, 141

Fry's Baskerville 162

Futura 196, 197, 202
Futurism 197, 205

Garamond 138
Gelasian Sacramentary 52
geometric basis
 Augusteus initials 35; Carolingian 72;
 Gothic 111, 119, 227-8; Insular 56,
 61-2; Merovingian initials 52;
 Renaissance 133, 140, 144, 147;
 Roman 25; seventeenth-century 162,
 163; twentieth-century 197
Germany
 Art Nouveau 175, 186; Carolingian
 70, 72; eighteenth-century 151, 154,
 159; fifteenth-century 127, 142, 149;
 Gothic 120, 151; Ottonian 82, 84, 86-
 7; Romanesque 90, 91, 92, 99, 107;
 sixteenth- and seventeenth-century
 137, 139-40, 141, 142, 143, 145, 147;
 twentieth-century 197, 199, 205, 212,
 212, 215
Gill, Eric 25, 192
 Four Gospels 198, 202; letter-carving
 202; type designs 202, 225;
 Westminster Cathedral, inscriptions
 at 202; W. H. Smith shop fascia 202
Giorgio, Francesco di, inscriptions at
 Urbino 133
glass
 Dutch engraved 156, 157; etched 167,
 168; gilded 167, 168, 176;
 nineteenth-century 175, 176;
 plexiglass 206-7; stained-glass 191,
 192, 120, 204, 205, 206
Godescalc Gospels 70
Gospels of St Chad 54, 62, 63, 243
Gothic revival 164, 173, 177, 186
Gothic style 10, 88, 109-21, 175, 177, 221
 Baptistery doors, Florence 114;
 Bohun Psalter 110, Broken Gothic
 capitals 82, 109, 137, 139-40, 141;
 capitals 21, 82, 108n, 109, 110, 111,
 121, 227-8; construction 111; curled
 terminations 111, 112; decorative
 use in seventeenth- and eighteenth-
 century 151, 153, 154; Evesham
 Psalter 112, 113, 115; Fraktur 137,
 139, 177; increased demand for
 books 109; inscriptions 116, 117;
 Lombardic capitals 109; mosaics
 119; new cursive script 118, 121;
 origins and development 109, 111,
 112; Oscott Psalter 112, 116; Queen
 Mary Psalter 110; representational
 initials 111; Romanesque origins 88,
 99, 107, 108; serifs 111, 112; Sienese
 record tablets 112, 115; stained-glass
 120; survival in Germany 151;
 Textura 55, 109, 110, 112, 118, 119,
 121, 135, 140
Grandjean, Romain du Roi 162
Grandval-Moutier Bible 68, 70
Greek lettering 12, 13, 14, 20, 21, 26, 61,
 62, 221, 223, 226
Greenwich
 Hospital 156; Painted Hall 156
Gregory of Tours, History 52

Grotesque letters 173
Guimar, Hector 183

Haas Helvetica 224
Hadrian I, epitaph for 67, 68
Hague, The, nineteenth-century shop
 front 175, 178
half-uncial script 36, 37, 236-7
Hammer, Victor, Hammer Unziale
 type 200, 205
Hampton Court 147
Hardwick Hall, Derbyshire 147
Harvey, Michael 211
Hawksyard Church, Cumbria 148
Hechle, Ann 209, 211
Hispano-Moresque ceramics 140, 143,
 221, 225
historiated initials 111
Holden, Charles 190, 191
Holland 151, 154, 156, 157, 175, 178,
 193, 195, 197, 212, 215
Horfei, Luca, inscription, Piazza
 Laterano 144, 147
Hughes, Arthur, book binding 172, 174
Hugo, Victor, entwined initials 172,
 174
Humanist book-hand 122, 123, 125
Hupp, Otto 184
Hurm, Otto 205

illumination signs 215
 back-light 212; interior 212; neon
 tubes 213
illustrators, nineteenth-century 174
Image, Selwyn 186, 187, 191
incipit pages 51, 53, 54, 56, 57, 58, 59,
 61, 65, 241
 Carolingian 69, 71, 73; Ottonian 84,
 86; Romanesque 96, 97
initials 52, 55
 Carolingian 72, 74, 76, 77; Gothic
 110, 111, 113, 114; Hugo, Victor 172,
 174; Insular school 61; Merovingian
 52; monograms 49; Romanesque 82,
 96
Insular school 32, 51, 53-65, 87, 175,
 221, 223, 225, 243
 Book of Durrow 56, Book of Kells 55,
 61, 63, 65; capitals 56, 61, 241-5;
 carpet pages 56; Codex Aureus 59, 63;
 contemporary material 56-7;
 Echternach Gospels 51, 56, 61;
 epigraphic material 54, 62; Gospels
 of St Chad 54, 62, 63; incipit pages
 51, 53, 54, 56, 57, 58, 59, 61, 65, 241;
 influence 56, 74, 76, 77, 82, 86; initial
 letters 61; Lindisfarne Gospels 53,
 56, 61, 62; MacRegol Gospels 62, 63;
 majuscule 55, 61; minuscule 55, 62;
 monasteries 56, 72; origins 55, 61,
 62; script 55; uncial 55, 56
International Specimen Exchange 177
Ionic (Eastern) alphabet 12
Ireland 43
 Insular school 55, 56, 57, 61-4, 65
Istanbul, Santa Sophia 54, 62
Italian Renaissance 9, 122-31, 133, 226
 archaeological studies 133;

Humanist book-hand 122, 123, 125;
 italic style 122; Roman letter, revival
 of 133; Romanesque influence 125,
 127, 133
italic style 137, 138, 162, 163
 computer-aided design 162;
 development 122; engraved glass
 156, 157; twentieth-century revival
 122
Italy 12-14, 15-28, 29-42, 43-44, 52, 81
 Carolingian 70, 76, 77; eighth-
 century 49; Etruscans 12; Gothic 111,
 114, 115, 117, 118, 119, 122; Lombard
 kings 45, 46, 49; Ottonian 86, 87;
 Renaissance SEE Italian Renaissance;
 Romanesque 88, 90, 92, 93, 96, 98,
 100, 125; Rotunda 112, 122, 139;
 seventeenth-century 154, 156;
 sixteenth-century 139, 140, 141, 144,
 147; twentieth-century 205, 215

Japanese influence 177
Jaugeon, Jacques 156, 162
Johnston, Edward 186, 187, 202
 London Transport, letters designed
 for 35, 198, 202; revival of
 calligraphy 82; type designs 202;
 Writing and Illuminating and Lettering
 198, 202
Jones, David 32, 192, 205, 208, 211, 221,
 226
Jones, Owen
 Plans, Elevations, Sections and Details
 of the Alhambra 188; Victoria Psalter
 191
Josephus, De Bello Iudaico 123, 125
Jouarre, sarcophagus of Abbess of 49,
 50
Junius Psalter 82
justified lines 32

Kindersley, David 211
King's type 184, 186
Kirchner, Ernest Ludwig, Manifesto
 for Die Brücke 205
Klee, Paul, secret writing pictures 192,
 205
Klerk, M. de 195, 197
Klinger, Max 180, 183
Klosterneuburg, Altar of St Nicholas of
 Verdun 99, 100
Koch, Rudolf 140, 192, 203
 calligraphy 205; Neuland type 199;
 tapestry design 201; Wallau type 221
Krautheimer, R., Rome: Profile of a
 City, 32
Krenek 183
Kufic inscriptions 62

La Ferte, Bernard 147
Larisch, Rudolf von 205
 Beispiele Kunstlerische Schrift 180,
 181, 183; Unterricht in Ornamentaler
 Schrift 186
Lechter, Melchior 181
Lectionary of Chelles 52
Lectionary of Luxeuil 50, 52

Lectionary of Montmajour 96, 97
Leiden
 Hooglandskerk 151, 154; nineteenth-
 century shop front 175, 178; St
 Peter's Church 146, 148, 157;
 twentieth-century ceramic lettering
 205, 206
Lemmen, Georges 181, 183
Leningrad Gospels 59, 222
lettering
 as an art 9; definition 9;
 recognizability 10
Lettristes 197
Lewes, ceramic panel 175, 178
ligatures 32, 34, 112
Lille, Maison Coilliot 183
Lincoln
 Cathedral 119; perspective lettering
 165
Lindisfarne Gospels 53, 55, 56, 61, 62,
 242
Lisbon
 Art Nouveau shop fascia 175, 176;
 Cathedral 129, 133; nineteenth-
 century gilt letters 167
Llandaff Cathedral 215
Lombard kings, inscriptions 45, 46,
 49
Lombardic 109, 121n
London
 Belgrave Children's Hospital 190,
 191; Chester Terrace 168; Hay's
 Wharf building 205, 206-7, Law
 Courts signing system 177; London
 Monument 156; nineteenth-century
 terracotta cartouche 175, 178
loops, introduction 121
Lorsch Gospels 69, 70
lower case 28, 67
Lucca, Romanesque inscription 89, 92
Luxeuil 43, 72
 Lectionary 50, 52

MacRegol Gospels 62, 63, 243
Madrid, twentieth-century sign 213
Mainz Cathedral 85, 87, 90
majuscule 55, 61
Maler zu Schwartz, Hans, inscription
 from painting by 148, 149
Mantegna, Andrea, inscriptions on
 paintings 129, 133
Manutius, Aldus
 Hypnerotomachia 136, type design
 136
marble 46, 49
Marinetti, Filippo, Words in Freedom
 197
Massin, Letter and Image 170-1, 174
Matthews, Elkin, Shilling Garland 186,
 187
Mazarin Bible 96, 98, 100
Melissenda Psalter 112
Merovingian Franks 67, 81, 222-5, 246,
 247
 inscriptions 47, 48, 49, 50, 52;
 manuscripts 50, 51, 52, 56
metal letters 22, 26, 29, 70, 147-8, 154,
 156, 166, 168, 190, 210, 213, 215

metal work 160
 Ardagh Chalice 57, 63; Baptistery
 doors, Florence 114; cast-iron
 tombstones 146, 147-8; enamel 44,
 45, 99, 100; Merovingian 47, 49;
 sixteenth-century German dishes
 140, 143; Visigothic 44, 45
Metz Gospels 70, 72, 73
minuscule 36, 55, 62
 Anglo-Saxon 82; Carolingian 67, 68;
 development 15
Modern Face 151, 152, 159, 160, 225
 French use 169, 173; influence 162,
 169; nineteenth-century use 164;
 Romain du Roi, forerunner of 162
Moissac 223, 225
 Romanesque inscription 89, 92
Mollyus, alphabet book 140
Monaco, Lorenzo, lettering on frame of
 painting by 118
monasteries 42, 43-4, 50, 51, 52, 55, 56,
 62, 64, 78, 81-2, 108
 Carolingian 67, 72, 77; Cluniac 90,
 96; Insular 56, 72; Mozarabic 81;
 Romanesque 90, 96
monograms, Greek 49
monotype Grot 150 type face 224
Morison, Stanley 32, 44, 202
Morris, William, Troy type 184
mosaics 29, 37, 44, 191
 Carolingian 77; early Christian 36,
 38, 40, 41, 44; Gothic 119;
 Romanesque 92, 93; San Clemente,
 Rome 122; Sta Maria Maggiore,
 Rome 122
Moser, Kolo, poster by 179, 183
Mosley, James 151
 'Trajan Revived' Alphabet 11n
mouvementé designs 156
Mozarabic
 Commentary on the Apocalypse 79, 81;
 initials 81; inscriptions 79, 80, 81;
 Romanesque 94, 96, 98, 100
Mucha, Alphonse 182, 183
Munich
 Bürgersaal Church 156, 158;
 Frauenkirche 199; Peterskirche 154;
 University 212, 215

Namur, Modern Face inscription 159
Nelaton, Moreau 181, 183
Netherlands 86
 fifteenth-century 131, 132, 133, 135;
 Gothic 118, 121; sixteenth- and
 seventeenth-century 139, 139, 141,
 146, 148, 156
Neudörffer, Johann, Eine gute Ordnung
 139, 142
Neuland type 199
Nibelungen-Schrift 184
Nordenfalk, Die spätantiken
 Zierbuchstaben 38
North Walsham Church, Norfolk 148,
 149
Northampton, All Saints Church 156
Northern European Renaissance 133-5,
 140, 147
Northumbrian Renaissance 81

Norwich
 Cathedral 156, 158; nineteenth-
 century metal letters 166, 168

Oakeshott, Walter 107
Ogham alphabet 61, 62
Optima type 125, 173, 200
Orange, nineteenth-century lettering
 169
Orcagna, Andrea, Triumph of Death 119
Oscott Psalter 112, 116
Ottonian style 82, 84-7, 223, 226
 Aachen Cathedral pulpit 85, 87;
 capitals 86; colour or pattern filled
 letters 51, 52, 55; Gospels of Abbess
 Uta of Niedermünster 84; Gothic
 112; incipit pages 84; Italy 86, 87;
 Mainz Cathedral, inscription 85, 87,
 90; Sacramentary of Henry II 84, 86
Oxford, Sheldonian Theatre 156, 159

Pace, George 210, 211, 215
Pacioli, Luca, alphabet book 140, 144
pagan priestess, stele of 24
Palermo, Cappella Palatina 134, 135
papyrus 14, 15, 17, 18, 21, 25, 29
Paris
 Church of Val de Grâce 150; gilt
 letters 175, 176; Métro entrances 183;
 shop sign 213
pen and chisel, influence on Roman
 lettering 21
pen nibs and development of new
 styles 26, 38, 109, 121
'perspective lettering' 165, 168
perspex 215
Phoenician writing 12
pictorial letters 169, 173
Pisa, Campo Santo 223
Pisanello, Antonio 223
Pisano, Andrea, Baptistery doors,
 Florence 112, 114
Pisano, Nicola and Giovanni,
 sculptures 112, 117, 122
plastic 213
Plato 9
Plutarch, Renaissance manuscript 124
Poggi, Mauro, Alphabeto di Lettere
 Iniziali 155
Pompeii, lettering 15, 17, 21, 26
printing
 invention of 135, 137; Printing
 Historical Review 162; Private Press
 movement 175, 186; type design,
 problems posed by 10, 137
Ptolemy, Cosmography 130

Queen Mary Psalter 110

Ravello, Romanesque inscription 89,
 92
Ravenna, script from 36
'Rebus Charivariques' 170
Reiner, Imre 205, 208, 211
Renaissance SEE Carolingian
 Renaissance; Italian Renaissance;
 Northern European Renaissance

Renner, Paul, Futura type *196, 197*, 202
Reynolds, Lloyd 202
Rhinoceros magazine 211
Ricketts, Charles *185, 186*
 King's type *184*, 186
Riemerschmid, R. 183
Ripon Cathedral 156, *158*
Robbia, Luca della, Cantoria Frieze *125, 126*
Roller, Alfred 205
 poster by *179*, 183
Romain du Roi type 162
Roman lettering 9, 15-28, 221-6
 alphabet 11**n**, 12-14, *14*, 28; books 14, 14**n**, *15, 17, 18*, 21, 29, 35-6, *36*, 38, 39; carving tools 21; compressed style 21, *24*; decline 29; early Christian 29, 31-2, *33, 34*, 35-6, *37, 38*, 40, 41-2; flexibility 151; layout 25, 27, 28; meaning 11**n**, 147; metal letters 22, 26, 29; milestones *33, 34*; mosaics 21, 29, 37; New Roman cursive 29, *34*, 36, 49, 236-7; North African style *24, 26*; Old Roman cursive 14, 14**n**, *15, 17, 21*, 36; *ordinators* and carvers, relationship between 25-6; painted inscriptions 21; pen and chisel, influence of 25-6; Republican 21, 25, 133, 221, 222; revivals 10, 25, 67, 122, 133, 151, 192; rustic 14, *15, 17, 18*, 21, *24, 27, 28, 34, 35*, 49, 236-7; script 14, 14**n**, *15, 17, 18*, 21, 35-6, *38, 39*; square capitals 11**n**, *15, 16*, 21, *23, 24*, 25-6, *27, 28*, 29, 35, 44, 151, 192, 202, 236-7; tenth-century inscriptions *87*; Trajan SEE ABOVE square capitals; Trajan Column 11**n**, *15, 16*, 21, *23, 24*, 25-6, 236; wax tablets *15*
Romanesque 88-108, 221, 222, 223, 225
 Bayeux Tapestry *90*; Bible of Bury St Edmunds *96*, 222, 223; Cartularies 96; incipit pages 96, *97*; influence of 125, *127*, 133, 135, 148; influences on *90, 92*, 96, 100, 107; initials *82*, 96; Lectionary of Montmajour 96, *97*; ligatures 112; Mazarin Bible *96, 98*, 100; monasteries *90*, 96; mosaics *92, 93*; Mozarabic *94, 96, 98*, 100; proliferation of work 108; rustics *101*, 107; stained-glass *91, 92*; use of enamels *99*, 100; waisted letter forms *89, 92*, 100
Rome *41, 44, 92*
 arch of Titus 22; catacomb of San Callisto *30*; Colosseum *30*; Mausoleum of Augustus 25; obelisks erected by Pope Sixtus V *144*, 147; Piazza Laterano *144*; Ponte Fabricio *19*; S Giovanni a Porta Latina *47*; SS Giovanni e Paolo *98*, 100; San Lorenzo fuori le Mura *40, 41*; Sta Maria in Trastevere *119*; Sta Maria Maggiore *119*; San Paolo fuori le Mura *119*; St Peter's 147; Sta Sabina *36, 38, 41*; Sistine Chapel 133; Trajan Column 11**n**, *15, 16*, 21, *23, 24*, 25-6, 236
Roper, F. *210*

Rossellini, Tomb of Beata Villana 125, *126*
Rossetti, Christina, *Speaking Likenesses* *172, 174*
Rotterdam
 illumination signs *212*, 215
Rotunda 112, 122, 139
Roussillon, St-Genis-des-Fontaines *80, 81*
rubrics 81
runic alphabet 61, 62, 222, 225
'rustic' letters made of twigs *174*
rustics SEE Roman lettering; Romanesque; script
Ruthwell Cross 62, 66**n**

Sacramentary of Gellone 52
Sacramentary of Henry II *84, 86*
St Augustine, letters of *103*
St Gall ms. 51 *243*
St Gregory, dialogues of *102*
St-Lizier, inscription from *20, 21*
Salisbury Cathedral 148
Salvin Book of Hours 112, *113*
sanserif 12, *169, 173, 177, 198*, 205, 224
Saracen letters *166, 168*
Saragossa
 Cathedral 147; Palace of Al Jaferia *134, 135*
Sattler, Joseph, type design *184*
Schedel, Hartmann, *Chronicle 142*
Scheidler, F. Ernst 205
Schmidt, Hans 192, *206-7*, 211
Schmidt-Rottluff, Karl 205
School of Avignon, *Three Prophets* 148, *149*
Schwabacher script 140
script
 Bastarda *131, 132, 133, 135*, 140; Beneventan *80*; copper-plate *161, 162, 169, 173*; cursive 28; Gothic *118, 121*; half-uncial *36, 37*, 236-7; Insular *55*; *litterae caelestes 36*; minuscule 36, *55, 62, 67, 68, 70, 82*; New Roman cursive *34, 36*, 49, 236-7; Ogham *61, 62*; Old Roman cursive 14, 14**n**, *15, 17, 21*, 36; rustic 14, *15, 17, 18*, 21, *24, 28, 34, 35*, 49; Schwabacher 140; secretary-hand *138*; uncial *36, 39*, 49, *55, 56, 92*, 108**n**, 236, 237
secretary hand *138*
serifs
 Bastarda 135; bifurcated *32, 40, 41, 70*, 100; bracketed 162; curled *70, 166, 167*, 168; Gothic 111, 112; Roman inscriptions *20*; Roman rustic *15*; Roman square capitals 25; Romanesque 88, *98*, 100, 108; sanserif 12, *169, 173, 177, 198*, 205, 224; slab-serif *160, 162, 164, 165, 168*, 221; *The Origin of the Serif 25*; triangular 100; unbracketed 162; wedge 12
Sèvres, Castel Henriette 183
shadow, twentieth-century use of 215
Shahn, Ben 192, 211, 221
 Love and Joy about Letters 211

Siegburg, Church of SS Mauritius and Innocentius *99*, 100
Siena Cathedral 125, *126*
Sienese record tablets *115*
Silvestre, alphabet-book 175
Simons, Anna 186, 205
Sistine Chapel, inscriptions 133
Skelton, John 211
Skipton Castle, Yorkshire 147
Spain 38, *43, 44, 45*
 early Christian 32; fifteenth-century *133, 134, 135, 143*; Gothic 112, 119; Mozarabic 79, 81; nineteenth-century *166, 167*, 175; Roman inscriptions 26, *27*; Romanesque 90, *92*; sixteenth-century 140, *146, 147*, 148
Stacoll, alphabet-book 175
Standard, Paul 205
Steeple Aston Church, Oxfordshire 160
Steinberg, Saul 197
Steinlen, T. R. 183
Stone, Reynolds 25, 211
Straubing, tomb of Johannes Ghainer 148, *149*
Symbolist movement 175

Tagliente, Giovannantonio 139, *141*
tapestries
 Koch, Rudolf *201*; Textura lettering *119*, 140
Tavistock, inscription on tombstone *170*
technology, impact of 10
Temple Newsam, Leeds 147
Terence, plays of *100*
text content affecting style 9
Textura 55, 109, *110*, 112, *118*, 119m 121, 135, 140
 revivals 119, 177, *203*
The Dial magazine *184*, 186
titling 52
Toledo, Fuensalida Palace *146*, 148
tombstones 164
 cast-iron *146*, 147-8; eighteenth-century use of Gothic letters 151, *153, 154*; English Baroque 156, *157, 158*; English Vernacular 162; nineteenth-century English *170, 174*
tools 10, 21, 26, 38, 109, 221
Torrigiano, inscriptions in Westminster Abbey 147
Toulouse
 Cathedral *157*; nineteenth-century street names *169*
Tours, epitaph of Adelberga *68, 70*
Toyne, Ken, logotype *213*
Trajan alphabet SEE Roman lettering
Trajan Column 11**n**, *15, 16*, 21, *23, 24*, 25-6, 236
Trier, Rotes Haus *145*, 147
Troy type *184*
Truchet, Père Sebastien 156
Tschichold, Jan, type design *196, 197*, 202
Tuscan letter 164, *166, 167*, 168
twentieth-century materials and techniques 215

Tymms and Wyatt, *The Art of Illumination* 186, 187

uncial script 36, 39, 49, 55, 56, 92, 108n, 236, 237
 half-uncial SEE half-uncial script
'Universal' type 196, 197

Van Doesburg 197
Van Eyck, Hubert and Jan, *Adoration of the Holy Lamb* 132, 135, 223
Velde, Henry van de 182, 183
Velde, Jan van der, *Spieghel der Schrijfkonste* 139, 141
vellum 29, 35
Venice
 Church of the Frari 154; Romanesque mosaic 92, 93; San Marco 119, 223
Ver Sacrum magazine 179
Vergil (Virgil)
 Eclogue IV 208; printed by Baskerville 152; *Vergil Augusteus* 34, 35, 52, 56

Vicenza, inscription from Arena 20
Vienna
 Art Nouveau 183; Arts and Crafts movement 186; Cathedral 204, 205; Stadtbahn 183; *Ver Sacrum* magazine 179
Vienne, Romanesque inscription 95
Visigothic lettering 44, 45, 49, 79, 222, 224
Vivarini, lettering on frame of painting by 124, 125
Volubilis, inscription from 24
vowels, introduction of 12

Wadebridge, Devon, tombstone 170
Wadhurst, Sussex, cast-iron tombstone 146, 147-8
Wellington, Irene 202
Wells
 Cathedral 148; St Cuthbert's Church 160
Wendingen magazine 195, 197
Westminster
 Abbey 147; Cathedral 202

Winchester
 Bible 104, 105, 107-8, 222, 223; Cathedral 148, 156, 157; Romanesque manuscripts 104, 105, 106, 107-8; school 82
wooden writing tablets 14
Wright, Edward 211
writing-masters 137, 140, 141, 142
 Amman, Jost 140; Arrighi, Ludovico Vicentino degli 139; Ayres, J. 155, 156; Baildon, Francesco 139; Beauchesne, J. 139; Brechtel, Christoph Fabius 140; Cresci, Giovan 139, 144, 147, 162; English Baroque 156; Fanti, Sigismondo 139; Franck, Paul 140; French Baroque 156; Hamon, Pierre 139; Neudörffer, Anton 140; Poggi, Mauro 155; Tagliente, Giovannantonio 139, 141; Velde, Jan van der 139, 141

Zapf, Hermann 205
 Optima type 125, 173, 200
Zwart, Piet 193, 194, 197

Acknowledgements

With the exception of the following all the photographs reproduced in this book were obtained from the Central Lettering Record, the Phaidon archives and the author:

82 MAS, Barcelona; 103 Musée Archaéologique de Dijon; 294 Dean and Chapter of Durham Cathedral; 38 Alinari, Florence; Frontispiece, 100, 143 Corpus Vitrearum Medii Aevi Deutschland, Freiburg i. Br.; 50 Conway Library, Courtauld Institute of Art, London; 214a, 214b St Bride's Printing Library, London; 177, 179 Reproduced by Courtesy of the Board of Trustees of the the Victoria and Albert Museum, London; 93 Bildarchiv Foto Marburg; 42a, 42b Hirmer Fotoarchiv, Munich; 71 Prestel Verlag, Munich; 78, 120, 124, 173, 174 Bodleian Library, Oxford; 222 Institute of Agricultural History and Museum of English Rural Life, University of Reading; 178 Paris, Cliché des Musées Nationaux; 133 Foto Grassi, Siena; 122 The Dean and Chapter of Winchester Cathedral. The photograph on page 6 is © John Mills.